Harry Potter

FILM WIZARDRY

...STRY OF MAGIC

UNDESIRA
№ 1

HARRY POT

CONTACT THE MINISTRY OF MAGIC IMMED
HAVE ANY INFORMATION CONCERNING HIS W
FAILING TO REPORT WILL RESULT IN IM

REWARD
10,000 GALLEONS ON HIS HEA

...STRY OF MAGIC

UNDESIRABLE
№ 1

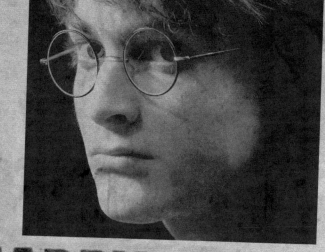

HARRY POTTER

CONTACT THE MINISTRY OF MAGIC IMMEDIATELY IF YOU
HAVE ANY INFORMATION CONCERNING HIS WHEREABOUTS.
FAILING TO REPORT WILL RESULT IN IMPRISONMENT.

REWARD
10,000 GALLEONS ON HIS HEAD

MINISTRY OF MAGIC

PUBLIC NOTICE

THE MUGGLE COMMUNITY IS CURRENTLY UNDER THREAT FROM A BOOK CALLED

Harry Potter

FILM WIZARDRY

FROM THE CREATIVE TEAM BEHIND THE CELEBRATED MOVIE SERIES

AN INSIGHT EDITIONS BOOK

WRITTEN BY ✳ DESIGNED BY
BRIAN SIBLEY MINALIMA DESIGN

HARPER DESIGN
An Imprint of HarperCollinsPublishers

Explosive W Enterprises

CONTENTS

FRED WEASLEY'S

YOUR OFFICIAL RECEIPT

TO

FOREWORD
by DANIEL RADCLIFFE, RUPERT GRINT, *and* EMMA WATSON

sometimes belligerently, but there nevertheless. He's also the comic relief in stressful situations; the funny guy with a great one-liner. And no matter how scared he may be, he will put aside his fears to support and protect the people he loves. To me, that represents true courage.

I really wouldn't change much about my experience playing Ron Weasley for the past ten years . . . well, apart from the odd, itchy, knitted jumper (Ron really does need a makeover), and perhaps losing continually to Emma at table tennis on set. I am immensely proud to have been part of this world and to have played Ron Weasley—brother, son, best friend, and, let's be honest, the ultimate "ginger!"

—**Rupert Grint**

I have often been asked about the impact the *Harry Potter* films have had on my life. What's it like growing up on a film set? How have the films changed/shaped you? What's it like being a celebrity? Have you missed out on a "normal" childhood? These questions and similar ones have preoccupied the world for many years. The simple truth is that I have never known any different, and so what the world views as unusual is my normality, and I have loved every minute of it.

The cast and crew of the *Harry Potter* films have been my second family for half my life. I have gone from a young ten year old to a man of twenty-one years, and every film holds different memories for me, as each marks a transition along the way. And how many men my age can boast that they have speared a huge snake, nearly lost their lives playing chess, narrowly avoided being eaten by a gargantuan spider, nearly fallen out of a flying car, fought dragons, swam underwater for forty hours, dodged a dangerous maze, kissed a girl, kissed another girl (OK, maybe that isn't so unusual), and not to mention gone head-to-head with the most evil wizard of all time?

But, most importantly, for me *Harry Potter* is all about the people. I have been privileged to have met and worked alongside the most creative and generous people in the industry. And I have met and made friends for life. I have learned so much as an actor and as a person throughout these ten years and this book is a tribute to them—thank you.

—**Daniel Radcliffe**

I was nine years old when I first auditioned for the role of Hermione, and just ten when we started filming—and it feels like such a long time ago it's hard to believe I am the same person! I suppose in many ways I am not, having grown from child to woman, but the one thing that remains constant is my passion for these stories and my love for Hermione. She has got to be one of my all-time favorite literary heroines. (And I get to play her! I am so lucky!)

It's funny, when I look back at those early years I remember being so emphatic that I had nothing in common with the character of Hermione, especially with her tweed skirts and thick tights. Being a nerd back then just wasn't cool. But, as I grew older I realized how alike we really are, and that a comparison of any sort was a compliment and not a jibe. She is a true and loyal friend, feisty and determined, and not afraid to pursue what she believes. And she is, of course, a dedicated scholar. I absolutely share her passion for knowledge, and if I can lay claim to half of her other attributes then I am extremely happy. Girls should never be afraid to be smart!

Growing up in the world of *Harry Potter* meant my upbringing was a little unconventional and hard work at times, but I wouldn't change any of it for a second. I will always be proud to have been part of these films and I want to thank everyone—all the directors, all the crew, and all my co-stars—for teaching me so much and for giving me so many memories to treasure. And of course, thank you to Jo Rowling for giving me this opportunity in the first place.

—**Emma Watson**

If there is one thing of which I am most proud, it's that I made being ginger cool! But, seriously, how do I sum up what these films have meant to me? I suppose I could just say that I would do it all again—in a heartbeat. I have loved playing Ron, loved being part of the Weasley family, and loved coming to the set every day and hanging out with my best friends. I feel so proud to have been entrusted with this role.

When I was much younger, I was often asked in what ways I thought I was similar to Ron. My stock answer usually included something similar to: "I like sweets, I'm scared of spiders, I've got ginger hair" or "I come from a big family." But, the truth is that Ron is my hero. He's always there for his friends—

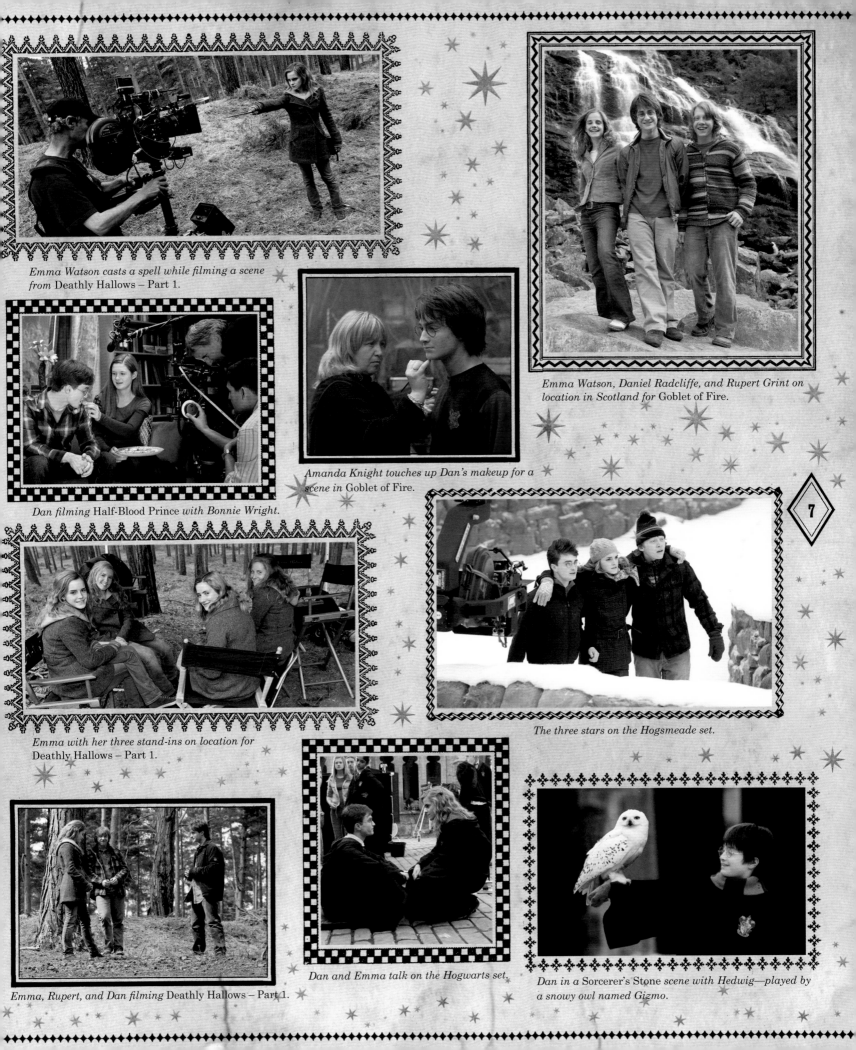

Emma Watson casts a spell while filming a scene from Deathly Hallows – Part 1.

Dan filming Half-Blood Prince *with Bonnie Wright.*

Amanda Knight touches up Dan's makeup for a scene in Goblet of Fire.

Emma Watson, Daniel Radcliffe, and Rupert Grint on location in Scotland for Goblet of Fire.

The three stars on the Hogsmeade set.

Emma with her three stand-ins on location for Deathly Hallows – Part 1.

Emma, Rupert, and Dan filming Deathly Hallows – Part 1.

Dan and Emma talk on the Hogwarts set.

Dan in a Sorcerer's Stone *scene with Hedwig—played by a snowy owl named Gizmo.*

INTRODUCTION

by David Heyman

It all began one winter morning in 1997. My assistant Nisha came into my office to recommend an unpublished manuscript by a first-time novelist that she had enjoyed. "What is it called?" I asked. "*Harry Potter and the Philosopher's Stone*," she replied. "Mmmm," I mumbled skeptically. "What is it about?" "A young boy who goes to wizard school." Little did I realize that this young boy and wizard school were about to change my life forever!

That evening, I decided to read a few pages before going to sleep. I read and I read and I read, and by the time I lay the book down and looked at my watch, it was 4:00 a.m. Jo Rowling's writing was so vivid, her imagination so rich, and she had conjured a magical world and characters that were so accessible and relatable. I had been to an English boarding school like Hogwarts myself (though unfortunately without the magic!) where there were teachers I admired and others I disliked. I knew a Harry, Ron, and Hermione, and I knew about making friends and finding a place where one feels like one belongs. I absolutely loved it and knew immediately that I wanted to make it into a film.

The following morning I sent a copy to my childhood friend Lionel Wigram, who was an executive at Warner Bros. where I had a "first look" deal. A few weeks later, negotiations to acquire the rights were underway.

Even with Warner Bros.' backing, I thought that this would be a modestly sized British film. I had no idea that it would grow to the scale it has, with well over two thousand people working together to bring it to the screen. Nor did I have any sense of the remarkable success that the books, and subsequently the films, would enjoy.

I met Jo several months later, the deal now closed and the book published, though still not the phenomenon it would soon become. It was an exciting moment, but I was nervous. I wanted her to feel comfortable with the prospect of my producing the film adaptation. I needn't have worried. Jo was delighted about the possibility of a film. I assured her that it was important to me that we remain as faithful as possible to what she had written. She has been the greatest collaborator a producer could ask for. Unfailingly supportive, she is insightful and generous in her comments on the script, and always there to answer questions and to prevent us from taking a wrong turn!

After meeting Jo, I set about finding a screenwriter. Copies of the book, all first editions (no one realized how valuable they would become), were sent to various writers. They all passed, but they held on to their first editions!! Everything happens for a reason though, because Steve Kloves read the book and put himself forward. Though he had never written a film for children, he is an extraordinary writer who is brilliant at capturing an author's voice, as he had with his adaptation of Michael Chabon's *Wonder Boys*. Steve is a writer's writer, and Jo was thrilled when he was chosen (he has written all the films except *Order of the Phoenix*). Looking back on it now, I am incredibly grateful that all those other writers said "no."

Next we had to find a director, and in March 2000 we hired Chris Columbus—whose passion for the books and remarkable talent for working with children and connecting with an audience made him our first choice. It was Chris's vision and direction that established the foundations upon which all subsequent directors built. And it was Chris who helped create the wonderful family spirit that has continued amongst the cast and crew over ten years of production.

The making of the *Harry Potter* films has been unique. On a normal film, cast and crew work together for thirty, sixty, sometimes one hundred days and then go their separate ways—but we have been together for ten years. We have seen marriages and births. I met my wife on the third film, we married on the fifth, and we had a baby boy on the sixth. There have also been divorces and deaths. Our child actors, who started as nine-, ten-, and eleven-year-olds, have sat for their end-of-school exams, and some have gone to university. In the meantime, many of those on the other side of the camera have gone through their own education, starting out in one job and moving onwards or upwards to some new skill, evolving, progressing, and taking on greater responsibilities. And unquestionably we have all learned, and continue to learn, so much each and every day.

It's going to be incredibly hard when it comes to an end. Everybody involved in these eight films knows that we have been part of something very special, and that there will never be another experience like this one. In the pages that follow, you will discover some of the reasons why we feel that way.

SCALE OF MAGICAL FUN

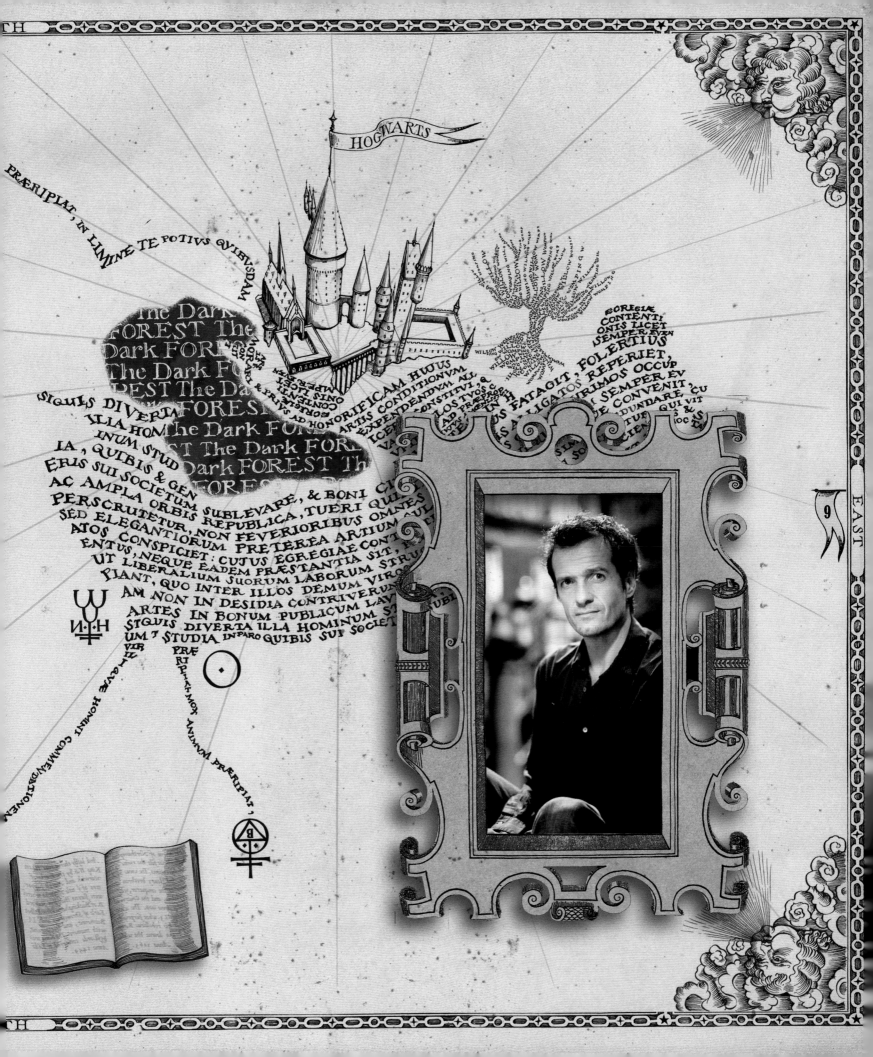

HOGWARTS

The Dark FOREST The Dark FOREST The Dark FOREST The Dark FOREST The Dark FOREST The Dark FOREST The Dark FOREST

EAST

9

MUGGLES MAKING MAGIC

by Brian Sibley

Believe it or not, the wizarding world imagined by J. K. Rowling became an on-screen reality at the site of a former Rolls-Royce factory where aircraft were made during World War II! The sprawling collection of buildings and ramshackle sheds at Leavesden Film Studios in Hertfordshire (less than twenty miles northwest of London) has been home to Hogwarts, Diagon Alley, the Ministry of Magic, The Burrow, and many more of the magical locations seen in the *Harry Potter* films. Allow me to take you on a brief tour.

After passing through security, we begin in the art department, where the places and artifacts described on the page begin to take shape for the screen with sketches, paintings, and intricate scale models. The attention to detail is astounding.

A corridor lined with Ministry of Magic WANTED posters, front pages of the *Daily Prophet*, advertisements for various Weasleys' Wizard Wheezes products, and a Quidditch World Cup program reminds us of the level of creative work that went into things only *glimpsed* on film.

In the hair and makeup room downstairs, we find trays of eyebrows, moustaches, and beards, and containers labeled "Old Age Stipple" and "Hairy Moles" that help turn actors into witches, wizards, werewolves, and goblins. Rows of head-shaped blocks display familiar-looking wigs—from Hagrid's unkempt tangles to Rita Skeeter's tight blonde curls. If you look closely, on one of the makeup tables, you will see a mask-like piece of plastic with a lightning-shaped gash. Although Harry's famous scar is often hidden by his hair, it must be there for every shot, and this stencil ensures that it always looks exactly the same on Daniel Radcliffe's forehead.

Moving on to the costume department, we find rack upon rack of leather Quidditch gear, Death Eater armor, and wizard robes. Every costume—down to its accessories, like shoes and gloves—must be made not once, but up to four times over: for the principal actor, his or her stand-in, a stunt performer, and an extra for emergencies. Keep in mind, too, that if a costume is muddied or bloodied in a scene, all of the others must be muddied or bloodied in *exactly* the same way.

Not surprisingly, one of the most fascinating areas of the studio is the creature effects workshop, where the magical creatures in the films are so realistically brought to life. Hanging on chains just inside the door is an enormous Basilisk head, and further inside the workshop is an astonishingly real-looking, life-sized model of Buckbeak the Hippogriff—complete with a seemingly razor-sharp beak.

This weird and wonderful menagerie continues into the next room where we find merpeople, Thestrals, werewolves, Fawkes the phoenix (covered with thousands of hand-painted feathers), the head and shoulders of Grawp, a crop of Mandrakes, several Petrified schoolchildren, and, standing in one corner, Mad-Eye Moody's artificial leg—with his magical eye on a table nearby.

Outside the creature effects workshop and just past the end of Grimmauld Place, we discover a small army of people carving chunks of polystyrene, which they then coat with latex and roll in sand to create a vast mountain of masonry rubble for the scene in which Voldemort's army begins destroying Hogwarts. We then find the prop makers busily "minting" thousands of Galleons, Sickles, and Knuts for the vaults of Gringotts Wizarding Bank—one of many new sets built for the final two films.

10

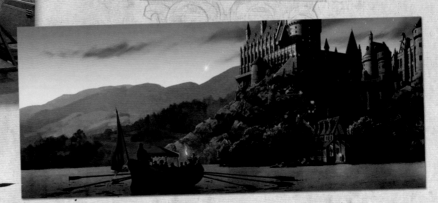

(above) *Awaiting use in the model shop, Buckbeak and a Thestral are flanked by Death Eater dummies used by Dumbledore's Army for target practice.* **(left)** *A Mandrake.* **(right)** *Concept art of Hogwarts by Andrew Williamson.*

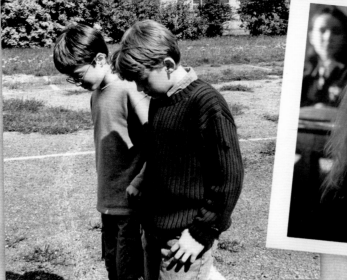

Sculptor Bryn Court works on a Hogwarts boar.

(above) A photo of Daniel Radcliffe and Rupert Grint taken on the day they first met. *(above right)* A young Emma Watson.

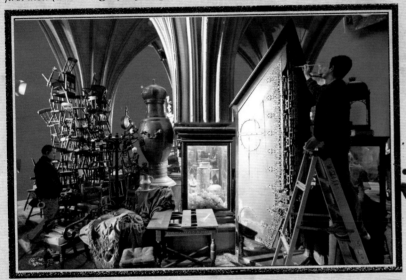

To reach the Gringotts set, we must pass Hogwarts' magnificent Great Hall, which has been standing since filming began in 2000. One path off the Great Hall leads us to the door to the Chamber of Secrets, with snakelike locks that actually work, while another path takes us to Dumbledore's office—where every book on the shelves has its own handwritten title. Nearby is the Room of Requirement, cluttered with twenty-foot-high pyramids of chairs, desks, cabinets, statues, trophies, and bric-a-brac.

As you might expect, Gringotts is simply massive. It is impossible not to be impressed by its highly polished marble floor, towering columns with gold capitals, and enormous chandeliers made of twenty-five thousand specially made crystals. Today, a talented crew of 140 artists from all over Europe (speaking seventeen different languages among them) has spent four hours applying the makeup and other elements—including prosthetic pointy ears and hooked noses—needed to turn sixty petite actors into Gringotts' staff of goblin bankers.

Our whistle-stop introductory tour was just the beginning. I'd like to invite you now to turn the page and set off on an amazing in-depth journey through the creation of these films—in company with the actors, writers, directors, producers, artists, and craftspeople that have brought Harry's story to life on screen.

And remember, as you read on—all of them are mere Muggles!

11

(above) Dressing the Room of Requirement set for Half-Blood Prince.

(right) Three identical jackets in the costume department. *(below)* Graphic artists Lauren Wakefield, Miraphora Mina, and Eduardo Lima give their work a read-through. *(bottom right)* Gringotts goblins.

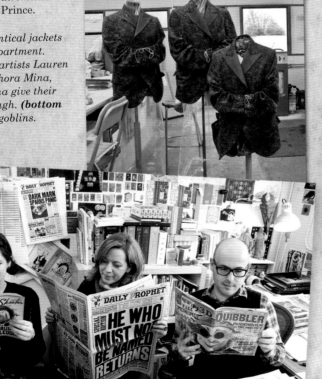

Harry Potter and the Sorcerer's Stone

I n 1997 Warner Bros. agreed to work with British film producer David Heyman to make a film of an unpublished novel called *Harry Potter and the Philosopher's Stone* (eventually published as *Harry Potter and the Sorcerer's Stone* in the United States). Once screenwriter Steve Kloves came on board, the project needed a director.

Chris Columbus, director of *Home Alone* and *Mrs. Doubtfire*, had been introduced to the book by his daughter and instantly knew he wanted to make a film of it. "I saw the movie in my head, and I saw the world," said Chris. But when he asked his agent to look into the possibility, the answer wasn't encouraging: "My agent said, 'You're going to have to get in line; there are about fifty other directors who also want make this into a movie!'"

Some of those already standing in that line were Steven Spielberg, Terry Gilliam, Jonathan Demme, and Alan Parker. However, after a meeting with David Heyman and Warner Bros. in which Chris talked passionately about his vision for how the story could be adapted to the screen, the job was his.

"There's not an author in the world who cares about their characters who isn't nervous when it's taken on to the big screen," J. K. Rowling told an American radio interviewer. The filmmakers were eager for Jo Rowling's involvement, and in the early stages conducted several sessions among the novelist, director, writer, designers, and producer.

"We really formed a great group," remembers Chris. "Everyone involved was committed to the material and committed to finding a way to make that material not only cinematic, but also magical. Jo would give us amazing insights." The author allowed them a sneak peak of the finished manuscripts for the third and fourth books, sketched the exact position and shape of Harry's "razor-sharp" scar, drew a plan of Hogwarts, and explained the rules of Quidditch.

By the time production was underway, there was a huge and enthusiastic audience eager to see Harry Potter's story on film, but who would be highly critical if it failed to live up to their hopes and expectations. It was an exciting but daunting challenge.

"Fans would have been crushed if we had left too much out," Chris told *Time* magazine later. But while the film remained faithful to the story, some episodes in the book still had to be compressed or deleted to keep the film at a manageable length. Several scenes in Harry's life with the Dursleys were lost, along with Snape's potion/logic test that Harry and Hermione must solve before Harry can reach the Sorcerer's Stone.

With the director and a script in place, a major casting quest was begun to find a Harry, a Ron, and a Hermione for the film. There were thousands of hopefuls. "Any kid who had done a school play," Chris recalls, "wanted to be in *Harry Potter!*"

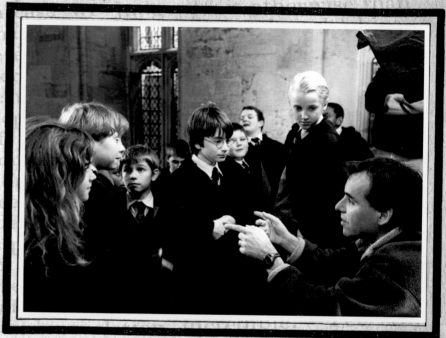

Chris Columbus directs his young cast in Sorcerer's Stone. *He has been praised for his patience with children on the set.*

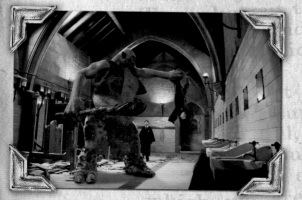

Harry (Daniel Radcliffe) and Ron (Rupert Grint) fend off a troll in the girls' bathroom.

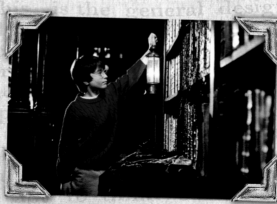

Harry (Daniel Radcliffe) takes a look in the Restricted Section of the library.

Ten years after all those auditions and screen tests, Chris still remembers the qualities that determined who would be cast. "Emma Watson was phenomenal," he says. "She had Hermione's sense of humor, she was bright—sharp as a whip—and the camera loved her. Emma was Hermione and that was that! As for Rupert Grint, he had this devilish, mischievous quality, and his face was a wealth of all these emotions. He had a wonderful sense of humor but also a real sense of soul."

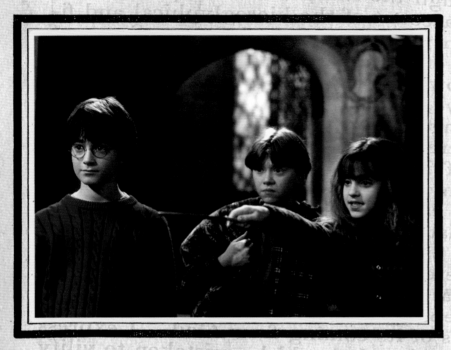

What the team saw in Daniel Radcliffe was, Chris says, something unique: "Dan's screen test was amazingly charming, but there was one thing that he had that you couldn't teach anyone, which was this sort of haunted quality that Harry Potter had in the books. I don't know where it came from, I just saw it in his eyes in more serious moments; and when we saw that screen test, we all decided to hire Dan as Harry Potter."

A veritable "who's who" of British actors joined the cast, and some of the most experienced and talented people working in the British film industry were brought onto the project to head up the various departments. The choice of three-time Oscar winner Stuart Craig as production designer would prove a key appointment in successfully bringing Rowling's world to life on film. "Stuart creates a universe," says Chris Columbus, "that seems like what you've read. But it's not *exactly* what you've read. He's taken that as a starting point and he's dared to dream."

The production team recognized that the first *Harry Potter* book is about discovery: Harry's discovery that he is a wizard, his discovery of the wizarding world—first in Diagon Alley and then at Hogwarts—and his discovery of the truth about his family's history and his connection with He Who Must Not Be Named. Key to the success of the first film, then, would be establishing on screen a world where Harry's boyhood experiences and discoveries could be believably grounded, but where just as believably a hat could talk, a mirror could reveal one's deepest desires, and the body of a human could be taken over by a monstrous force of evil.

RUPERT ✳ GRINT ✳ LOOKS BACK

Rupert Grint describes himself as having a lot in common with his character, Ron Weasley. When he first stepped into the role at age ten for *Harry Potter and the Sorcerer's Stone*, he admits that, like Ron, he wasn't always the most attentive student. One day, while filming a classroom scene, he amused himself by doodling with the quill pens and ink on the desks, and ended up drawing a likeness of Alan Rickman that was, Rupert says, "rather unflattering."

Unfortunately, he couldn't conceal the portrait from its subject before Alan—who was almost always "in character," according to Rupert— sneaked up behind him in a Snape-like manner and discovered the caricature. To Rupert at the time, Alan was "quite the presence," and he was rather scared to see his reaction. Much to Rupert's surprise, Alan professed to like the drawing and ended up keeping it. "I think," admits the artist, "that I exaggerated a few of his features . . . I won't go into detail."

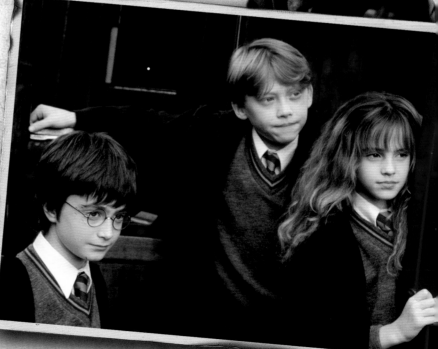

DME-05 No

MAPPING HOGWARTS

PRODUCTION DESIGNER'S NOTEBOOK

Name: *Stuart Craig*

During my first meeting with J. K. Rowling, I started by asking some very basic questions about the world of *Harry Potter*. In answer, Jo took pen and paper and, in just a few minutes, drew a very simple map of Hogwarts and its surroundings—showing it in relation to the Quidditch pitch, Hogsmeade, the black lake, the Whomping Willow, the Forbidden Forest, and the railway station. Jo didn't pause once before she filled the page—she knew exactly how the place should look. Everything grew out of that one sketch, and I've kept a copy of it pinned on my office wall throughout the making of the films.

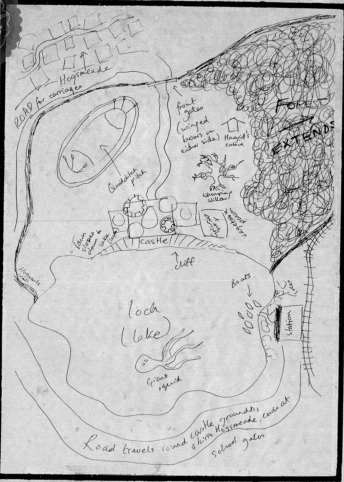

The sketch of Hogwarts that J. K. Rowling drew for Stuart Craig, which contains notes such as "front gates (winged boars on either side)."

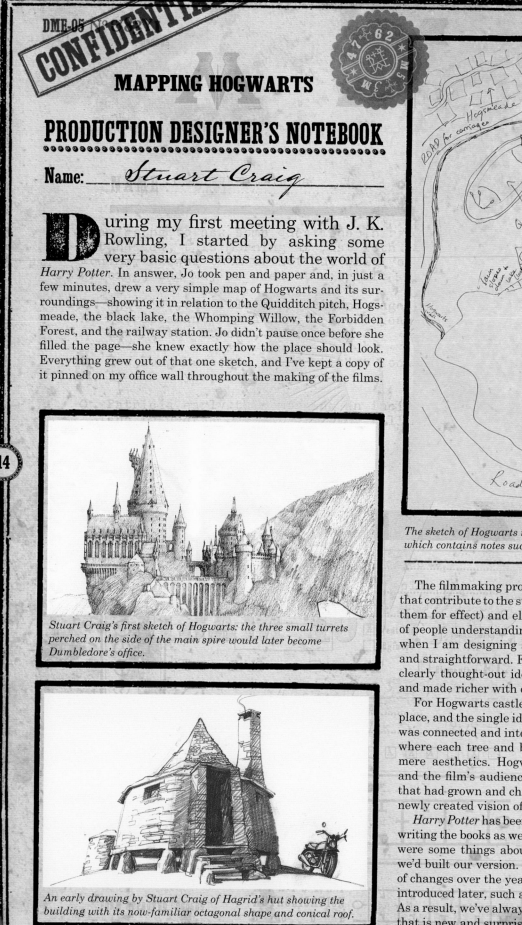

Stuart Craig's first sketch of Hogwarts: the three small turrets perched on the side of the main spire would later become Dumbledore's office.

An early drawing by Stuart Craig of Hagrid's hut showing the building with its now-familiar octagonal shape and conical roof.

The filmmaking process is about giving the audience images that contribute to the storytelling (sometimes even exaggerating them for effect) and eliminating anything that gets in the way of people understanding and following that story. That is why, when I am designing a film, I like to keep the designs simple and straightforward. For that to work, I must think of a single, clearly thought-out idea for each set that can be embellished and made richer with color and decorative details.

For Hogwarts castle and grounds, Jo's map was my starting place, and the single idea was that everything in that landscape was connected and intentionally placed. I had to create a world where each tree and building had a reason for being beyond mere aesthetics. Hogwarts has been evolving for centuries, and the film's audience needed to be able to see it as a place that had grown and changed over the years, rather than as the newly created vision of a designer like myself.

Harry Potter has been a unique experience because Jo was still writing the books as we were filming much of the series, so there were some things about Hogwarts that we only learned after we'd built our version. Because of this, we've had to make a lot of changes over the years, adding things to the castle that were introduced later, such as the Owlery and the Astronomy Tower. As a result, we've always been able to give audiences a Hogwarts that is new and surprising as well as old and familiar.

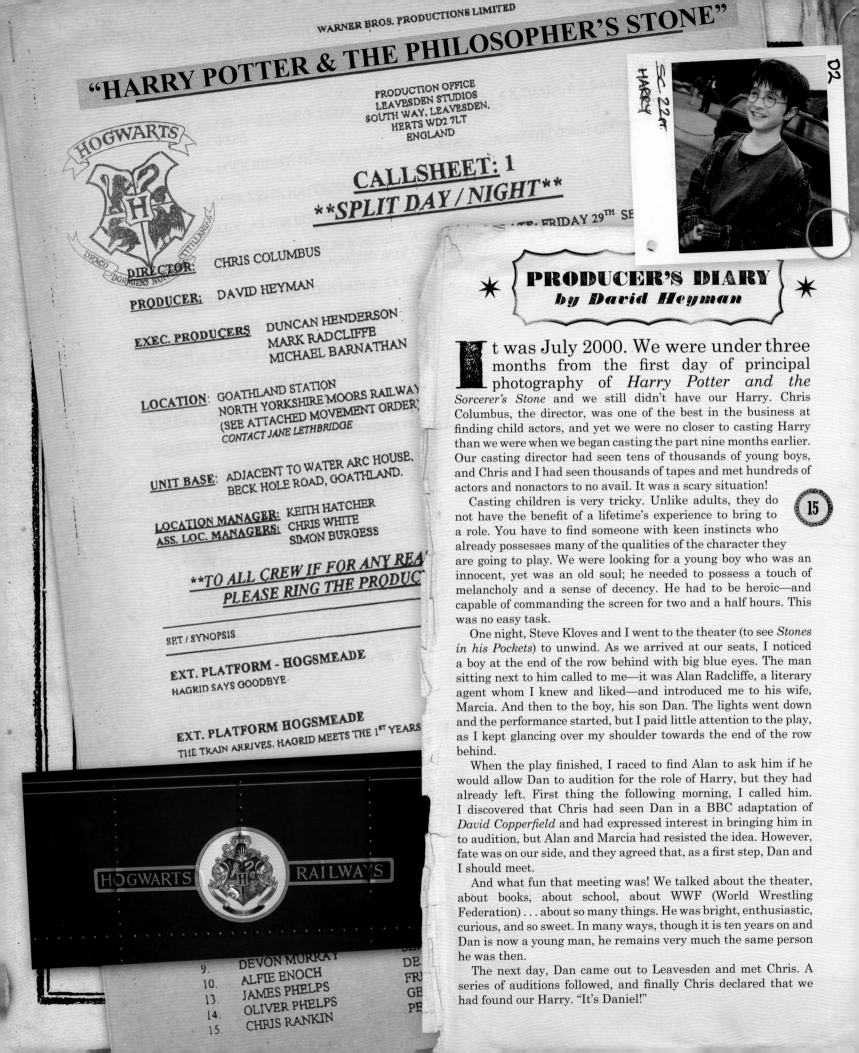

WARNER BROS. PRODUCTIONS LIMITED

"HARRY POTTER & THE PHILOSOPHER'S STONE"

HOGWARTS

PRODUCTION OFFICE
LEAVESDEN STUDIOS
SOUTH WAY, LEAVESDEN,
HERTS WD2 7LT
ENGLAND

CALLSHEET: 1
SPLIT DAY / NIGHT

~~DATE:~~ FRIDAY 29TH SE~~...~~

DIRECTOR: CHRIS COLUMBUS

PRODUCER: DAVID HEYMAN

EXEC. PRODUCERS DUNCAN HENDERSON
MARK RADCLIFFE
MICHAEL BARNATHAN

LOCATION: GOATHLAND STATION
NORTH YORKSHIRE MOORS RAILWAY
(SEE ATTACHED MOVEMENT ORDER)
CONTACT JANE LETHBRIDGE

UNIT BASE: ADJACENT TO WATER ARC HOUSE,
BECK HOLE ROAD, GOATHLAND.

LOCATION MANAGER: KEITH HATCHER
ASS. LOC. MANAGERS: CHRIS WHITE
SIMON BURGESS

**TO ALL CREW IF FOR ANY REA~~...~~
PLEASE RING THE PRODUC~~...~~

SET / SYNOPSIS

EXT. PLATFORM - HOGSMEADE
HAGRID SAYS GOODBYE

EXT. PLATFORM HOGSMEADE
THE TRAIN ARRIVES. HAGRID MEETS THE 1ST YEARS

HOGWARTS RAILWAYS

9. DEVON MURRAY
10. ALFIE ENOCH
13. JAMES PHELPS
14. OLIVER PHELPS
15. CHRIS RANKIN

SC. 22m
HARRY

D2

★ PRODUCER'S DIARY ★
by David Heyman

It was July 2000. We were under three months from the first day of principal photography of *Harry Potter and the Sorcerer's Stone* and we still didn't have our Harry. Chris Columbus, the director, was one of the best in the business at finding child actors, and yet we were no closer to casting Harry than we were when we began casting the part nine months earlier. Our casting director had seen tens of thousands of young boys, and Chris and I had seen thousands of tapes and met hundreds of actors and nonactors to no avail. It was a scary situation!

Casting children is very tricky. Unlike adults, they do not have the benefit of a lifetime's experience to bring to a role. You have to find someone with keen instincts who already possesses many of the qualities of the character they are going to play. We were looking for a young boy who was an innocent, yet was an old soul; he needed to possess a touch of melancholy and a sense of decency. He had to be heroic—and capable of commanding the screen for two and a half hours. This was no easy task.

One night, Steve Kloves and I went to the theater (to see *Stones in his Pockets*) to unwind. As we arrived at our seats, I noticed a boy at the end of the row behind with big blue eyes. The man sitting next to him called to me—it was Alan Radcliffe, a literary agent whom I knew and liked—and introduced me to his wife, Marcia. And then to the boy, his son Dan. The lights went down and the performance started, but I paid little attention to the play, as I kept glancing over my shoulder towards the end of the row behind.

When the play finished, I raced to find Alan to ask him if he would allow Dan to audition for the role of Harry, but they had already left. First thing the following morning, I called him. I discovered that Chris had seen Dan in a BBC adaptation of *David Copperfield* and had expressed interest in bringing him in to audition, but Alan and Marcia had resisted the idea. However, fate was on our side, and they agreed that, as a first step, Dan and I should meet.

And what fun that meeting was! We talked about the theater, about books, about school, about WWF (World Wrestling Federation) . . . about so many things. He was bright, enthusiastic, curious, and so sweet. In many ways, though it is ten years on and Dan is now a young man, he remains very much the same person he was then.

The next day, Dan came out to Leavesden and met Chris. A series of auditions followed, and finally Chris declared that we had found our Harry. "It's Daniel!"

15

DANIEL RADCLIFFE as

"Children's book characters don't grow up in real time, normally," J. K. Rowling's first editor, Barry Cunningham of Bloomsbury, said in a documentary about the author. "To have a character developing in real time, as his age developed, was a really interesting idea." It is similarly rare and special to watch a young film actor grow and develop over several years of playing the same role, but that is just what Daniel Radcliffe has done in his decade of playing Harry Potter.

Dan won the part of "The Boy Who Lived" at the tail end of a casting search to rival that of Scarlett O'Hara. The enormous popularity of the books meant that when the film version of *Harry Potter and the Sorcerer's Stone* was announced, the world was dying to know what little boy would step into the title role. Dan says he "wasn't aware" of most of the hoopla. But, before he knew it, he, Emma Watson, and Rupert Grint were posing for photographs and being quizzed by reporters. Dan remembers one reporter asking him Voldemort's real name, which he didn't remember.

"And Emma and Rupert," he says, "to both sides of me, were trying to write down the name and slide it across!"

Dan, Rupert, and Emma have become close over their years playing the young wizards. "I get to spend every day with some of my best, best friends," Dan says—speaking not only of Rupert and Emma, but of the extended cast and crew. "I love the camaraderie of a film set."

Dan has grown tremendously as an actor over the years, and recognizes how much he has benefited from working with an extraordinarily gifted group of actors—especially Gary Oldman. "I think the two best performances that I've given in these films so

Sketches for the costumes that Dan wore in Goblet of Fire.

A Harry Potter timeline—Dan has grown up with his character.

SC. 12 HARRY

SC. 84A HARRY [END WORK.] T CLOAK OFF STRAIGHT

2001

2002

2004

2005

HARRY POTTER

far are three and five," he says reflectively, "and I think that is in part to do with the fact that I had Gary Oldman around."

Dan also praises the four directors he's worked with on the series, noting that they all have unique strengths and styles. He reserves particular praise for the director who started it all, Chris Columbus: "He managed to get us smiling and energized and happy and up for filming every single day over those eight months. And he did the same thing on the second film." Chris is complimentary of Dan as well. "Dan, at his core, is a really good person," he has said, "and I felt that that's what Harry was."

When ten-year-old Dan was asked whether he was anything like Harry, he said: "I think I'm a tiny bit like Harry. I'd like to have an owl." The answer was completely charming and completely ingenuous. The young Radcliffe was reminiscent of the young Potter—humbly oblivious to fame and thrilled by something as novel as a pet owl.

Throughout his extraordinary experience filming the series, Dan seems to have kept that humility—and developed a sense of humor about his relationship as an actor to the role of Harry. When Australian TV host Rove McManus asked him if it would be strange to continue his acting career without the famous round glasses, Dan replied, "I'm just going to have it written in my contract that any character I play has to have glasses—or at the very least a monocle."

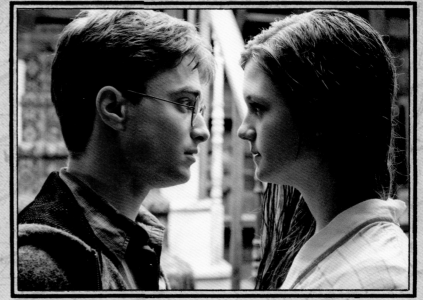

Harry (Daniel Radcliffe) and Ginny (Bonnie Wright) share a moment in Half-Blood Prince.

2010

2009

2007

17

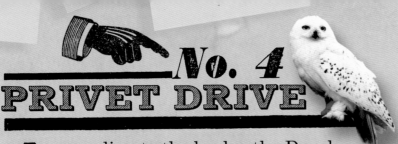

No. 4 PRIVET DRIVE

According to the books, the Dursley home at number four, Privet Drive, Little Whinging, is located south of London in Surrey. But when Chris Columbus wanted to capture, in a single, sweeping image, the full misery and desperation of Harry's situation, the filmmakers had to find an actual street where they could shoot exterior scenes of the house. They found one—in an endless sprawl of identical, modern houses; thousands of little boxes stretching as far as the eye could see. "Chris's idea," says Stuart Craig, "was to create a vast urban jungle" with Harry's cupboard under the stairs "right in the center of it."

The residents of the street used in the first film all gave permission for filming, but when production ran over the initial schedule, the neighborhood requested too much money to make the location available again for *Chamber of Secrets*. The filmmakers therefore had to build Privet Drive on studio grounds at Leavesden. This "studio" version of Privet Drive was used on all subsequent films, with the exception of *Prisoner of Azkaban*, when, to accommodate a specific shot of Harry walking away from the Dursley house, they had to film at a practical location just across the road from the studio that had been built from scratch while the first two films were being made.

In designing the Dursley home's interiors, the set decorators kept in mind that Petunia Dursley is fastidiously house-proud, and that her home is always immaculately clean. Stuart Craig points out, however, that the décor chosen by Petunia is "not particularly tasteful." Set decorator Stephenie McMillan embellishes: "Highly polished furniture," she says, "upholstered in acrylic fiber—in really nasty colors."

A completely different approach was taken for Harry's famous cupboard under the stairs—incidentally the smallest set created for any of the films. Because of its size, its four walls had to be removable so that the camera could access the cramped, cell-like room which Harry shares with pipes, cabling, and power meters. "The ordinariness of the cupboard," says Stuart, "became a feature. It was sparse and austere, but we gave Harry part of a shelf where he kept a few precious treasures."

The way Stuart sees it, those treasures were a way to express Harry's longing for a different life—one that would begin in the film with the arrival of a barrage of letters addressed to Mr H. Potter, The Cupboard under the Stairs, 4 Privet Drive, Little Whinging, Surrey. Penned on behalf of Professor McGonagall by props concept artist Miraphora Mina, a number of those letters had to be printed on paper light enough for real owls to carry; and for the scene in which a blizzard of letters blasts though the living room at Privet Drive, ten thousand envelopes were printed on even lighter paper (the kind used for bank notes) so that they could be easily blown all over the place.

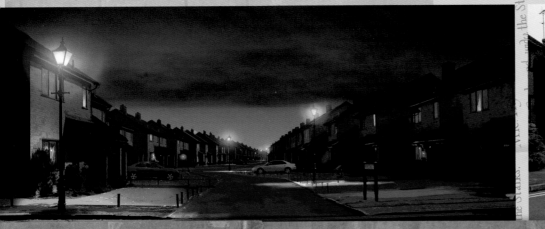

(above) Concept art of Privet Drive by Andrew Williamson. *(above right)* The real-life location for Privet Drive.

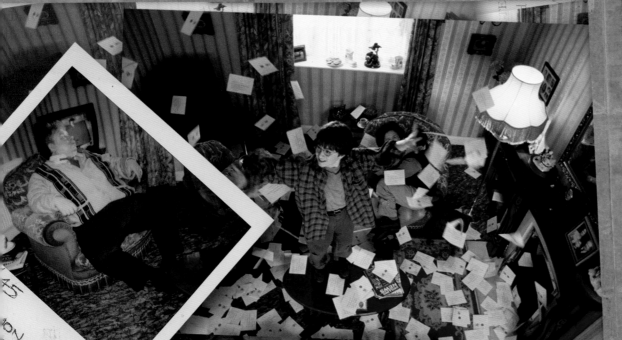

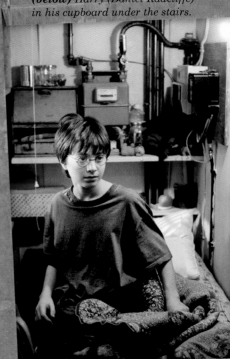

(below) Harry (Daniel Radcliffe) in his cupboard under the stairs.

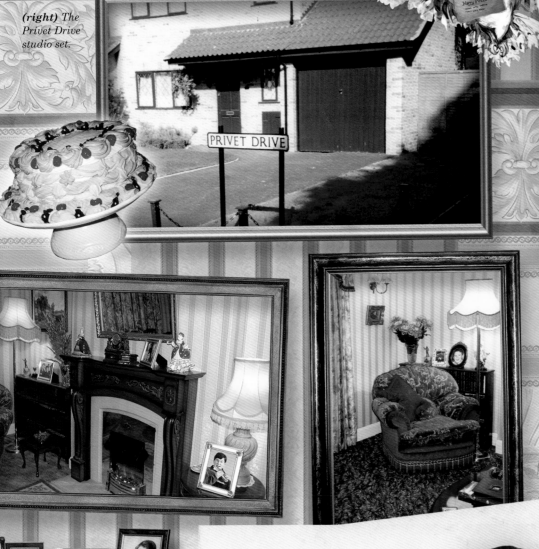

(right) The Privet Drive studio set.

To: Mr Harry Potter
The Cupboard Under the Stairs,
4 Privet Drive,
Little Whinging,
SURREY.

Dear Mr Potter,

We are pleased to inform you that ... have ...
Hogwarts School of Witchcraft and Wizardry ...

... be required to report to the Char...
... s for which shall be duly adv...

... the utmost attention be mad...
... hed herewith

... forward to receiving you...
...warts' heritage.

MR H POTTER
The Cupboard ...
4 Privet ...
Little W...
SURR...

Set decorator Stephenie McMillan jokes that she's given the town of Watford a bad name by admitting that she bought much of the Dursleys' furniture there.

... of WITCHCRA...
...dore, D.Wiz., X...

...d to inform you ...
...ool of Witchcraf...

...be required to re...
...s for which s...

...the utmost ...
...ed herew...

...rward ...
...s' her...

...ely.

McGonagall

... McGonagall

THE DURSLEYS

"The Dursleys represent normality," says Fiona Shaw, who plays Harry's aunt, Petunia Dursley. "In the context of a magic film, *they* represent the 'other.'" For Fiona, the role of Petunia was quite a departure. "I often play much grander, historical characters in the theater," she says, "so I actually grew very fond of her because it's great fun to play the stress of the everyday housewife."

For Richard Griffiths, who plays Petunia's husband—the insensitive, magic-hating Vernon Dursley—the role also presented a challenge: "It's been really tough to try and act through a state, mood, feeling that is basically the same in all the movies, but to somehow keep it changing and chugging and moving and twisting," he says. At one point, Richard invented scenes that would allow his character to get closer to the world of magic. "I went to Joanne Rowling," he recalls, "and said, 'I've a brilliant idea. Wouldn't it be great if there was an open day at Hogwarts—a parents' day, a prize-giving day, something like that—and the Dursleys show up and all kinds of terrible things happen to them? Wouldn't that be funny?'" Jo diplomatically rejected the idea, Richard says, "So that was the end of that."

(top) The family that Professor McGonagall called the "worst sort of Muggles." (above) Scenes from Sorcerer's Stone *and costume sketches for Vernon and Petunia Dursley.*

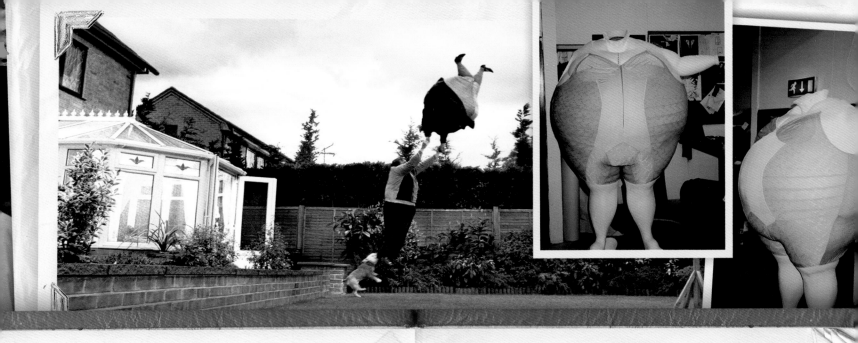

One memory that particularly stands out for Richard is the scene in *Harry Potter and the Prisoner of Azkaban* when Vernon tries to stop his sister Marge—who has been inflated into a giant balloon of a person—from floating away. "I was tethered to Aunt Marge," he recalls, "and we were lifted thirty, forty feet in the air . . . and Ripper the dog was just hanging on with his teeth—to my ankle! And, boy, were they strong teeth! And as we got higher in the air, I was thinking, 'I just want to die now!'" Richard jokes that he really earned his paycheck that day!

Petunia and Vernon's spoiled son Dudley, played by Harry Melling, is their pride and joy, so the *Harry Potter* set decorators created props that reinforced the notion that he was the center of attention. They designed a lot of framed photographs of Dudley and school certificates that he had earned for things like "swimming five meters" and "always eating up his lunch." Playing Dudley "really has been fun," laughs Harry. "There's always the school bully who goes around with his gang and rules the playground," he says. "That was my main association with the part." Harry also points out sagely that "any bully is insecure in some way," and believes Dudley's behavior can be explained simply by "look[ing] at his parents!"

21

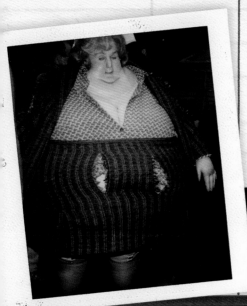

Filming the scene when Aunt Marge inflates like a balloon was an ordeal for actress Pam Ferris, who had to wear a great deal of prosthetic makeup and a huge body suit. Pam makes light of the arduous stunt work: "Let me tell you," she laughs, "you need to eat an awful lot of baked beans and fizzy drinks to be able to lift off like she does!"

As to what happens to Marge, Pam says, "I think she becomes a satellite or possibly another moon and people will say, 'Ah, there's a lovely Marge out tonight!'"

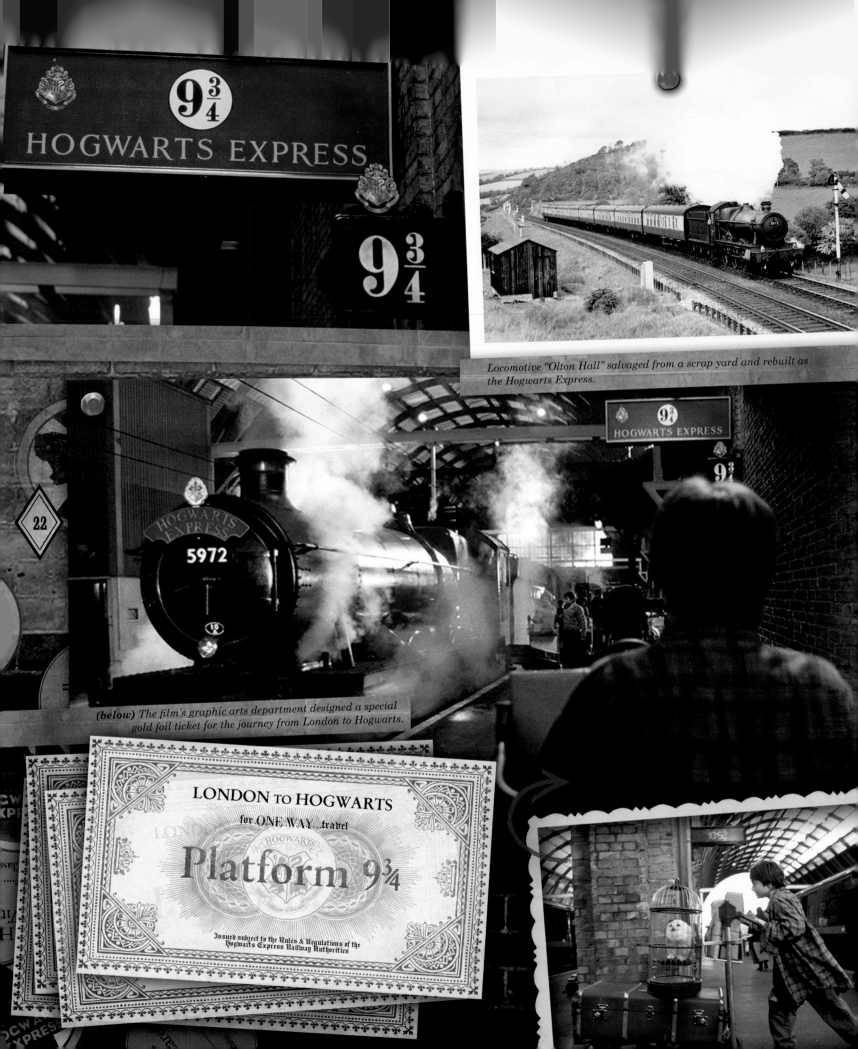

Locomotive "Olton Hall" salvaged from a scrap yard and rebuilt as the Hogwarts Express.

(below) The film's graphic arts department designed a special gold foil ticket for the journey from London to Hogwarts.

LONDON to HOGWARTS

for ONE-WAY travel

Platform 9¾

Issued subject to the Rules & Regulations of the Hogwarts Express Railway Authorities

PLATFORM 9¾

While platform nine and three-quarters was invented by J. K. Rowling, its supposed location, King's Cross, is a major London station. Although the station is busy at any time of the day, the filmmakers hoped that filming there would be a relatively simple matter. It soon became clear, however, that shooting those scenes was not going to be a straightforward experience. "Platforms nine and ten," explains Stuart Craig, "are not in the main station building, but in a little annex to the side." Wanting to take advantage of the more impressive architecture of the main building, the production team decided to use the area between real-life platforms three and four instead.

Another problem was that the barriers in the station didn't match up with the description in the books. "We chose a platform," says Stuart, "that had these big brick piers—supporting arches with a substantial wall—to run at, hit, and magically Apparate through to the other side. So we didn't quite keep faith with the book. But hopefully, as in everything, we've tried to keep faith with the spirit of the book."

Chris Columbus generally preferred creating magic with physical effects wherever possible, rather than using computer-generated visual effects. A practical hollow brick wall was built for Harry to run through, but, ultimately, the route and journey to platform nine and three-quarters was achieved using digital effects.

The students heading to Hogwarts were going away for quite a while and required a great deal of luggage. "All the main characters have their own trunks with their initials and the school crest on the top," says Stephenie McMillan, "and then we had to have cages for owls, rats, cats, and other pets. I remember our shopping assistant trolling around the pet stores trying to find as many different shapes of cat baskets as possible."

Filming at the station for *Sorcerer's Stone* took place on a Sunday because it was the least busy day at the terminal. With the Hogwarts Express standing at one of the platforms, there was soon a huge crowd of onlookers who could scarcely believe their eyes. "It was," says Chris Columbus, "a historic day for *Harry Potter* fans."

The Hogwarts Express is, in reality, an authentic locomotive named "Olton Hall" (No. 5972), which was built at the Great Western Railway's Swindon Works in 1937 and remained in service until 1963. Like hundreds of other vintage steam locomotives, it ended up in a scrap yard in South Wales. It was rescued in 1997 and rebuilt for its role in the *Harry Potter* movies. According to Gloucestershire Warwickshire Railway press officer Ian Crowder, "It's nothing more than a fluke that it wasn't broken up and turned into razor blades."

23

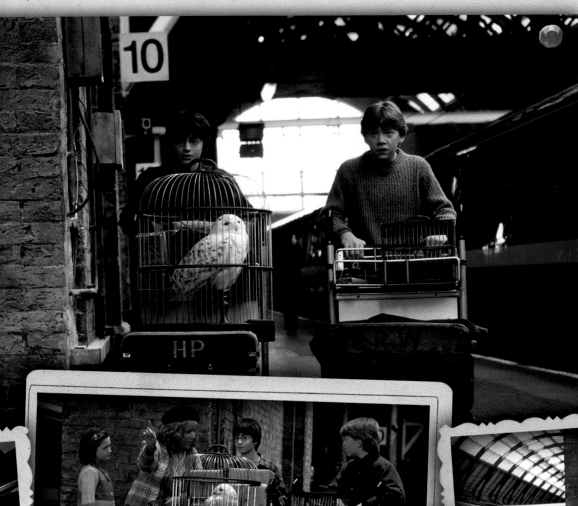

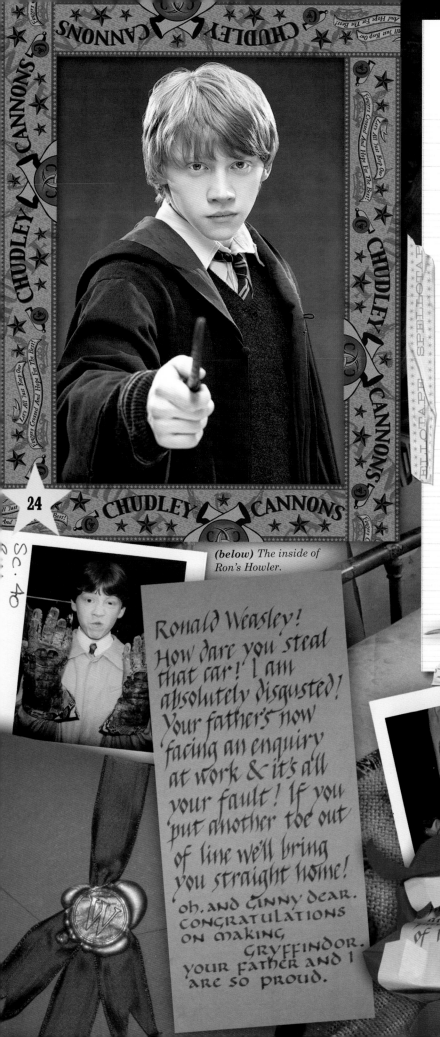

Rupert Grint as

RON WEASLEY

While getting to know Daniel Radcliffe, Emma Watson, and Rupert Grint, *Harry Potter and the Prisoner of Azkaban* director Alfonso Cuarón asked the three actors to write essays about their characters. He was amazed to find that they responded to the task very much in the way that their respective characters would—Dan wrote a couple of pages, while Emma's essay was very long and very thorough. Perhaps the most in character, however, was Rupert's response: he forgot to do it.

Prior to being cast as Ron, Rupert's only acting experience was in school plays and a local children's theater group. He had the presence of mind, however, to make the audition tape he filmed for the *Harry Potter* casting agents stand out among the crowd. "I made it a little bit different," he recalls. "I did a little rap."

Rupert was a fan of the books before being cast and has subsequently read each new volume in the series as it came out. And while he reads the books because he enjoys them, he says, they also help him with his portrayal of Ron—a character he feels he's really come to know over the ten years that he's played him. "There's a lot to him, really," Rupert says. "He's always in the shadow of his brothers, being in a big family, and he feels that a little bit with Harry because Harry's so famous—he's kind of in the background a lot there. I think he's quite jealous sometimes."

Being Harry's best friend, he says, "isn't the easiest thing."

Scabbers

(below) The inside of Ron's Howler.

Ronald Weasley! How dare you steal that car! I am absolutely disgusted! Your father's now facing an enquiry at work & it's all your fault! If you put another toe out of line we'll bring you straight home!

oh, and GINNY DEAR. CONGRATULATIONS ON MAKING GRYFFINDOR. YOUR FATHER AND I ARE SO PROUD.

Sc. 40

33/34 - RON (SLEEVE REF.)

Rupert says, however, that the complete opposite is true of Daniel Radcliffe—the two get on famously. According to him, Dan and Emma are "good mates" despite the fact that they don't get to see each other much outside of filming. "Obviously we've been through a lot together," he says, "and we have quite a strong bond in that sense. And we do have a really good time on the set."

Rupert has very much relished the acting challenges that have presented themselves in the *Deathly Hallows* movies—particularly all the disguises and concealment. "There are a lot of disguises in this film," he says, "because the Dark people know who we are now." One scene in particular has Ron, Harry, and Hermione taking Polyjuice Potion to transform themselves into Ministry of Magic employees in order to infiltrate the Ministry. "We had to act out the scene first with [the actors who play the Ministry employees] watching us to see how we move and how we talk," Rupert explains. "They would mimic it on the next take. It's really weird watching someone pretend to be you! But he did it really well—got all [my] posture and everything down." Later in the film, Rupert donned a long coat, beard, and dark curly hair when Ron must disguise himself to visit Gringotts. In his makeup tests, no one recognized him!

As Ron, Rupert often provides comic relief—which isn't much of a stretch from his true personality. He's glad, though, that in later films Ron has been allowed to grow up a bit. "Ron's an interesting guy," Rupert says in all seriousness. "This film [*Deathly Hallows*] is quite a contrast to the earlier ones."

LOVE POTION

25

Ron (Rupert Grint) holds a box of chocolates spiked with love potion.

EST. 1753

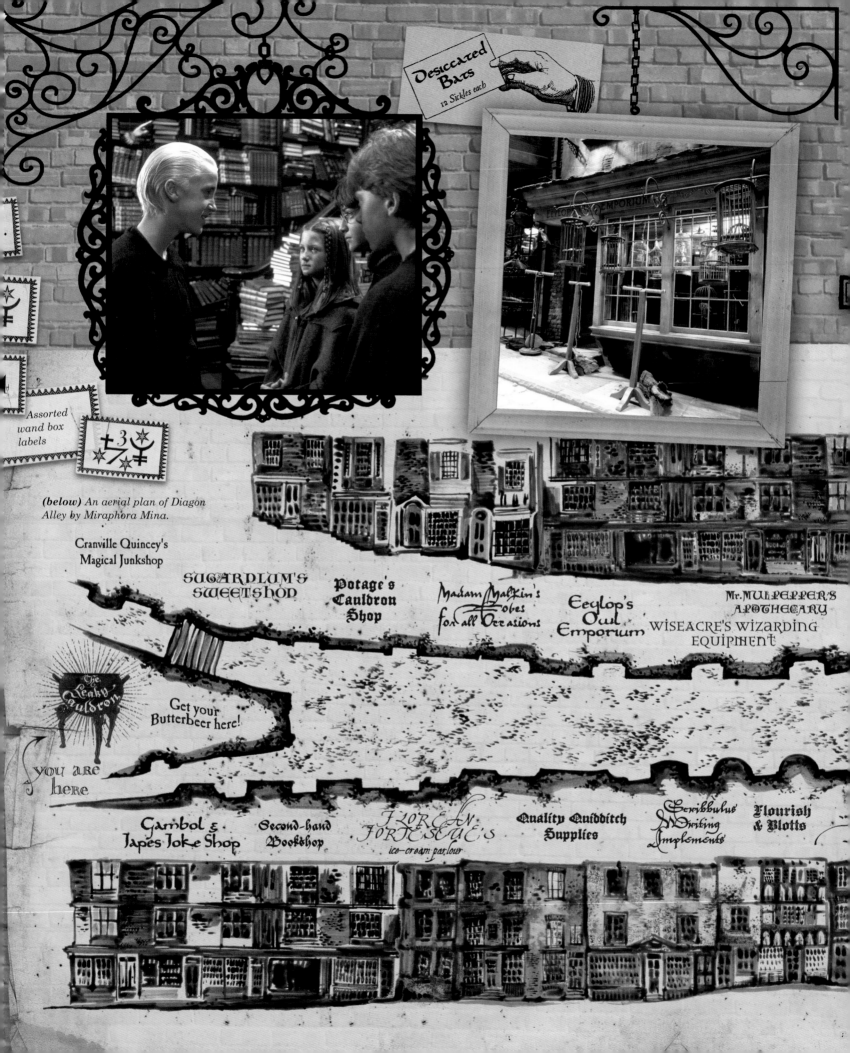

Desiccated
Bats
12 Sickles each

Assorted
wand box
labels

+3
7

(below) An aerial plan of Diagon
Alley by Miraphora Mina.

Cranville Quincey's
Magical Junkshop

SUGARPLUM'S
SWEETSHOP

Potage's
Cauldron
Shop

Madam Malkin's
Robes
for all Occasions

Eeylop's
Owl
Emporium

Mr. MULPEPPER'S
APOTHECARY

WISEACRE'S WIZARDING
EQUIPMENT

The Leaky
Cauldron

Get your
Butterbeer here!

you are
here

Gambol &
Japes Joke Shop

Second-hand
Bookshop

FLOREAN
FORTESCUE'S
ice-cream parlour

Quality Quidditch
Supplies

Scribbulus
Writing
Implements

Flourish
& Blotts

OLLIVANDER'S

DIAGON ALLEY ★ LONDON

Describing the young Daniel Radcliffe's portrayal of Harry Potter in Harry Potter and the Sorcerer's Stone, *veteran actor John Hurt recalls that "Dan was good-humored, inquisitive, curious, and eager to understand and learn."*

Of all the experiences that amaze Harry on his first visit to Diagon Alley in *Harry Potter and the Sorcerer's Stone*, one of the most memorable is his visit to Ollivanders wand shop. "The wand chooses the wizard, Mr. Potter," Mr. Ollivander tells Harry. "It's not always clear why." When Ollivander reminisces about selling Harry's parents their first wands, we (the audience) and Harry realize that Harry is now part of a grand tradition.

While Ollivanders has been in business since 382 BC, the prop-makers at Leavesden Studios, though skilled craftsmen, were relatively new to wand-making when filming began. But, as requests for wands of various shapes and sizes piled up, their job became its own decade-long tradition. "If you're talking about props on *Harry Potter*," says prop maker Pierre Bohanna, "the wands are probably one of the most important. Everybody in the magic world has a wand that's a part of their character."

To represent the full scope of Ollivanders' inventory on screen, Stephenie McMillan populated the shop with seventeen thousand wand boxes. "Think of a normal-sized shop," she says, "and then think of storerooms at the back with shelves going up seventeen feet, and all of those shelves stacked with wand boxes." Furthermore, each of these wand boxes was individually embellished with labels carrying numbers, runes, and various forms of identification. Many had to be coated with what appeared to be centuries of dust, and all had to be arranged in an idiosyncratic, slightly chaotic order that could only be understood by the shop's rather eccentric proprietor.

For Mr. Ollivander, the filmmakers turned to the incomparable John Hurt. According to John, getting the part right was entirely an exercise in imagination. As he points out, "You can't do research into wandmakers—there aren't many around!"

'HARRY POTTER' EXT DIAGON ALLEY (BUILDING- ⓖ)
'EXT LEAKY CAULDRON' (ELEVATION)

Diagon

UNDER CONSTRUCTION

"**W**e began by asking: Is there anywhere in London where we can actually shoot Diagon Alley?" Chris Columbus, director of the first two *Potter* films, recalls. "In reality, while we think that Dickensian world still exists somewhere, very few places look like that. And, if they do, then there's always something modern that would prevent you filming. So we realized we'd have to build it."

Stuart Craig started with the idea of London as depicted in the works of the great Victorian novelist Charles Dickens, and began researching how the city looked in the early 1800s. "The further back you go into the history of old London, the better your sense of the look and feel of it," he says. That look included buildings that have a tendency to lean this way and that—a tendency that was expanded on in the films to comprise alarming angles. "In the Muggle world," says Stuart, "any building with such a gravity-defying lean would simply fall over!"

Stuart adds that they wanted to include elements in Diagon Alley that would "push toward the magical." Each shop presented its own unique opportunities for capturing this sensibility: the tottering pile of cauldrons of all shapes and sizes that snake

HOGWARTS
CASTLE & GROUNDS

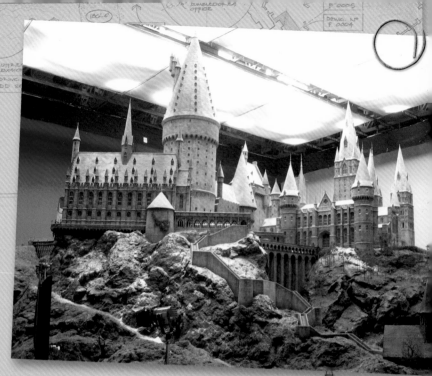

"**H**ogwarts castle is a character," says Stuart Craig. "Sometimes it's a rather frustrating character, when we are trying to adapt it to fit a new situation in a film and it won't have it!"

Because Hogwarts has existed for over one thousand years and has an enduring history, the filmmakers wanted it to look like a real place, as opposed to a newly constructed castle from a fantasy. For inspiration, they studied the oldest educational institutions in Britain—the two great universities of Oxford and Cambridge. They also looked at several of Britain's imposing medieval cathedrals, among them Westminster, Canterbury, and Salisbury. The final result of these explorations was an architectural style based on Medieval Gothic, characterized by soaring columns, high, pointed arches, and elaborate carvings.

(below) Draftsman's plans (drawn to a scale of ½ inch to 1 foot) by Gary Tomkins for the model of Hogwarts filmed for all the aerial shots of the castle in films one to six.

(left) The model makers putting finishing touches on the scale model of Hogwarts give a good idea of the actual size and the impressive level of detail featured on this "miniature."

DIAGON ALLEY

The Magical Menagerie

Gringotts
Wizard Bank

GRINGOTTS WIZARDING BANK

Dominating Diagon Alley is the leaning, three-story building that is Gringotts Wizarding Bank. For the first film, the bank's interior was filmed in Australia House in London. For its later appearance in *Deathly Hallows*, it was recreated as an elaborate studio set.

To establish the proper look and feel of a wizard bank, the films' graphic artists created specific ledgers, credit slips, and stationery. Meanwhile, the props department minted a small fortune in Galleons, Sickles, and Knuts. For *Sorcerer's Stone*, the money was made with real metal. Quite a few of these coins went missing, so, to avoid further "runs on the bank," wizard money was replicated in plastic for later films.

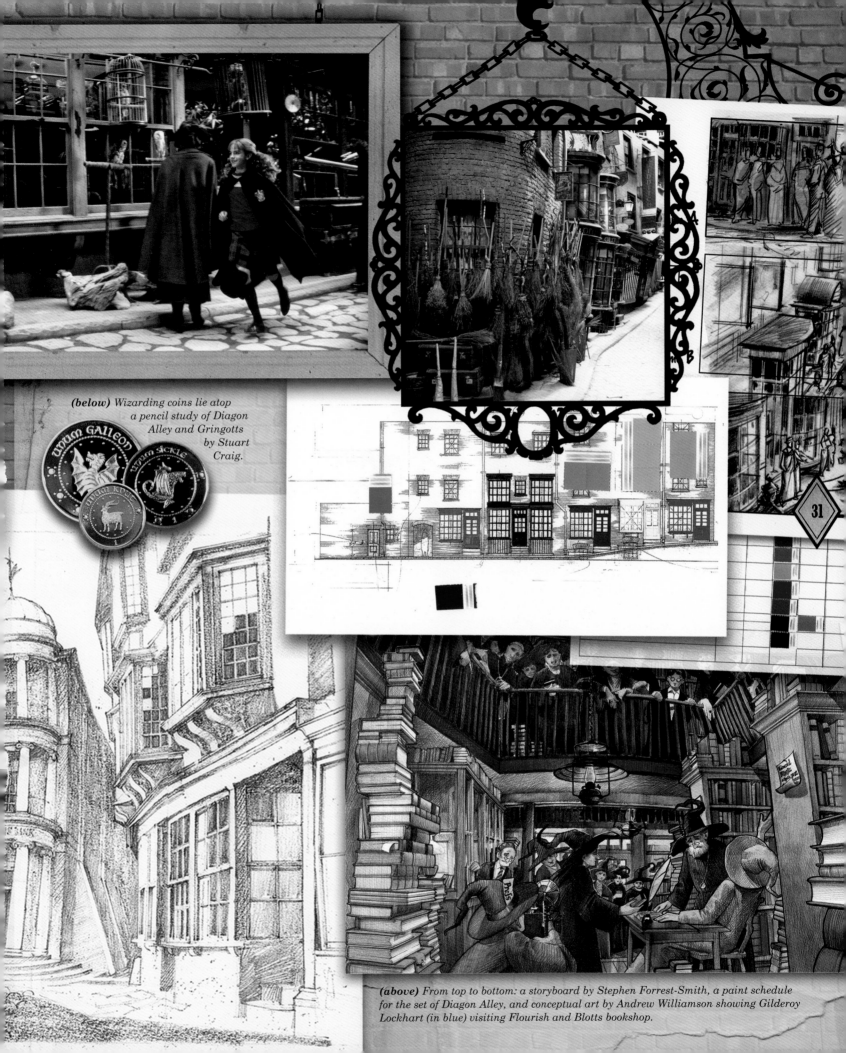

(below) Wizarding coins lie atop a pencil study of Diagon Alley and Gringotts by Stuart Craig.

(above) From top to bottom: a storyboard by Stephen Forrest-Smith, a paint schedule for the set of Diagon Alley, and conceptual art by Andrew Williamson showing Gilderoy Lockhart (in blue) visiting Flourish and Blotts bookshop.

Alley →

up the front of Potage's Cauldron Shop, the slightly impossible spirals of books in Flourish and Blotts bookshop in the second film, and the potions cupboard with shelves ten feet wide and twenty-four feet high inside Mr. Mulpepper's Apothecary (a shop created for the films). Recalls set decorator Stephenie McMillan, "Only one prop man could dress the set at a time because you had to use a crane lift [to] put the jars on the shelves."

A similar mix of the familiar and the fantastic infused the costume designs for the supporting characters populating the alley. Judianna Makovsky, the first film's costume designer, wanted the feel to be something akin to *The Wizard of Oz*: "I felt it should be like the Emerald City, with Harry as the only one in Diagon Alley who is from the outside world. I wanted the audience to feel Harry's awe at entering this whole new world that he could never have imagined."

The Leaky Cauldron

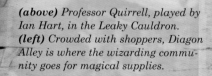

(above) *Professor Quirrell, played by Ian Hart, in the Leaky Cauldron.*
(left) *Crowded with shoppers, Diagon Alley is where the wizarding community goes for magical supplies.*

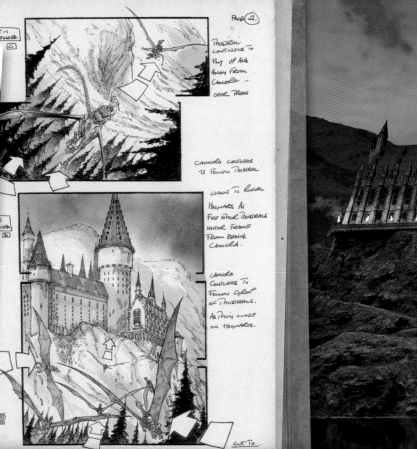

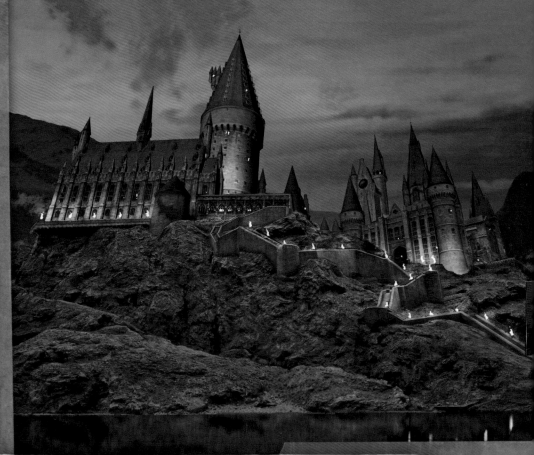

Durham Cathedral, one of the finest examples of Norman architecture in Europe, was the inspiration for Hogwarts' twin square towers, to which the designers added a pair of spires you might expect to see in the wizarding world. The cathedral also provided several film locations—including its twelfth-century Chapter House, which served as Professor McGonagall's classroom in the first film. Gloucester Cathedral's fourteenth-century cloisters provided the corridor where the chilling message "The Chamber of Secrets has been opened" appears in blood.

Oxford College's grand staircase with its famous "fan-vaulted" ceiling—covered with ornate fan-shaped decorations—was used as Hogwarts' entrance staircase in the first two films. "The Gothic style," says Stuart, "is strong and dramatic."

For the Hogwarts grounds, the filmmakers looked to the Highlands of Scotland and, in particular, Glencoe, Rannoch Moor, and Loch Shiel (which became the black lake). Another location they used was Glenfinnan Viaduct, across which the Hogwarts Express steams its way toward the castle.

Stuart Craig's sketches of the exterior of Hogwarts castle were developed into architectural drawings and then into a one-twenty-fourth-scale model. The model, built at Shepperton Studios, would be used for exterior establishing shots of the castle in films one to six.

"It's an iconic model," says art director Gary Tomkins, describing the intricate level of detailing. "Each and every tower, window, and doorway had to be recreated to scale. Everything—right down to the pin heads that represent the bolts that fix the hinges to the doors." There are even minute owls for the interior of the Owlery and a tiny replica telescope that sits in Dumbledore's office.

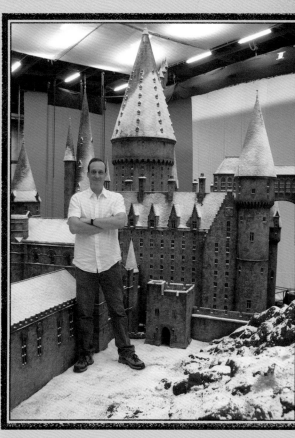

(above left) Storyboard by Jim Cornish showing the flight of the Thestrals in Order of the Phoenix. *(above right) Art director Gary Tomkins standing in front of the scale miniature of Hogwarts. (right) The Owlery's miniature owls.*

33

Robbie Coltrane as RUBEUS HAGRID

"**H**agrid is not a father substitute," says Robbie Coltrane of his role in the *Harry Potter* films, explaining with a chuckle, "Hagrid's not quite smart enough to be that! He's just a kind, decent 'uncle' who has Harry's best interests at heart."

Reflecting on casting Robbie in the part, producer David Heyman says, "Hagrid is a larger-than-life character, and we wanted somebody to play him who we knew could be tough and strong but, at the same time, warm, vulnerable, and very funny. And Robbie Coltrane had all those qualities."

Although Robbie can certainly be considered "larger-than-life" himself, Hagrid is, literally, part giant. So, the filmmakers had to employ various techniques to make Hagrid tower above those around him. For example, in long shots, a Hagrid double has stood in for Robbie—a task frequently undertaken by six-foot-ten-inch former British rugby player Martin Bayfield—wearing a huge body suit and an animatronic prosthetic mask based on Robbie Coltrane's face.

(far left) Hagrid's boots next to Dobby's red shoes from Deathly Hallows. *(left) Two of Hagrid's books:* Dragon-Breeding for Pleasure and Profit *and* The Monster Book of Monsters.

(right) Martin Bayfield as the large-scale Hagrid with Robbie Coltrane.

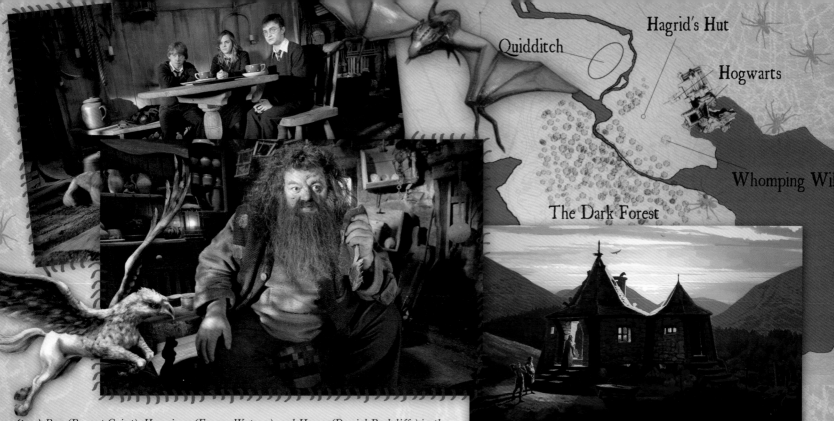

(top) Ron (Rupert Grint), Hermione (Emma Watson) and Harry (Daniel Radcliffe) in the large-scale version of Hagrid's hut with giant-sized furniture. (above) Robbie Coltrane in the Hagrid-scale hut where the furniture is normal-sized in relation to the actor. Such scenes—especially ones where other characters had to interact with Hagrid—were complex to film.

H aving two different scale Hagrids required the creation of regular- and large-scale versions of Hagrid's hut and everything inside—furniture, bottles, plates, mugs, spoons, and forks had to be duplicated in two sizes. As filming in Hagrid's hut has progressed over the years, it has become something of a routine: the set decorators buy whatever is needed, and then the prop-makers create an enlarged copy of each item for the shots featuring the large-scale Hagrid. A London umbrella maker was even specially commissioned to make Hagrid's pink "umbrella-wand" in two sizes.

The special effects department's ingenuity was tested with the scenes featuring Hagrid's motorbike. Robbie's "giant" scale double sits astride the seemingly diminutive real bike, but an accurate smaller-scale copy had to be built for Robbie to make it look as if the bike is too small for him. The illusion is seamless, and the audience never detects when one Hagrid becomes another.

Similar difficulties existed with Hagrid's costumes, which also had to be made in two sizes. "Whatever fabrics you choose," explains costume designer Jany Temime, "you have to be able to blow up the pattern to a larger size. And you must make bigger buttons and create bigger stitches. It's a nightmare! But we all love Hagrid—he is big and cuddly."

"Children like [Hagrid] because he's big and strong and kind and that's what children want," Robbie explains. "They want somebody who could protect them and somebody who's nice to them—and a lot of children don't have a person like that in their lives, which is very sad."

SHOT 2 TIGHTER AS HARRY APPROACHES HAGRIDS HUT.

(top) The evening of Buckbeak's execution as depicted by concept artist Adam Brockbank. (above) A storyboard by Jim Cornish for Order of the Phoenix. *(below) A scene from* Half-Blood Prince *showing Professor Slughorn (Jim Broadbent), Hagrid (Robbie Coltrane), and Harry (Daniel Radcliffe) gathered around the recently departed Aragog.*

THE GREAT HALL

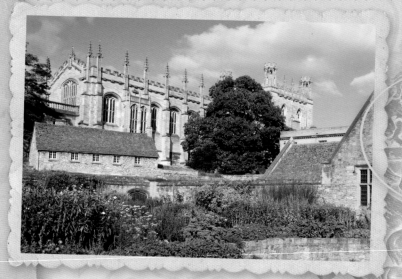

The set for the Great Hall at Hogwarts is a rarity in today's film industry: it has been in use for almost ten years. When it was built for *Harry Potter and the Sorcerer's Stone* in 2000, no one imagined that it would be a key set for six more films (the Great Hall does not appear in the first *Deathly Hallows* film).

Incredibly, Stuart Craig had the foresight to invest a significant amount of his design budget on flagstones for the Great Hall so that its floor could be made of real York stone. While this decision was questioned at the time, it proved to be a wise one. The York stone has been durable enough to withstand the footsteps of hundreds of actors and several camera crews for almost a decade.

The inspiration for the interior design of the Great Hall came from a sixteenth-century hall in one of the most famous Oxford colleges, Christ Church, and from Westminster Hall in the Houses of Parliament in London. While the Great Hall at Christ Church provided the ideal image of the traditional school or college hall—with its wood-paneled walls, high windows, and long tables and benches—some changes were made when adapting it to the Great Hall at Hogwarts. Although the basic dimensions were retained—an impressive 120 feet by 40 feet—the windows were elongated and doors were disguised in the wood paneling to make it easier to move four hundred extras in and out during filming. Gargoyles of the heraldic creatures—the lion, snake, raven, and badger that represent the four houses in the films—are mounted on the walls.

Because the studio stages are not high enough, visual effects were used to build the dramatic wooden roof, based on the fourteenth-century hammerbeam structure in Westminster Hall,

36

(above) The Great Hall at Christ Church, Oxford, as seen from the gardens. This sixteenth-century hall inspired the one at Hogwarts.
(below) This "non-magical" roof is the one that the cast and crew see.

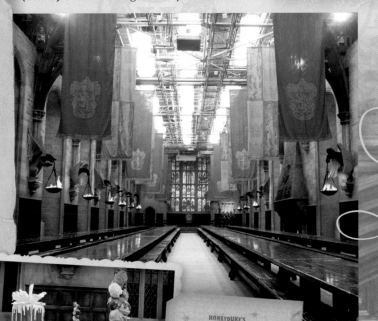

(right) Wizarding world breakfast cereals. (below right) An O.W.L. examination paper.

HONEYDUKE'S
PixiePuffs
THEY'RE GOBLING GREAT!

LUNFREY'S
CHEERI OWLS

MINISTRY OF MAGIC
Wizarding Examinations Authority
O.W.L. EXAMINATIONS -Year 5
EXAM
Name
House
QUESTIONS 1-13

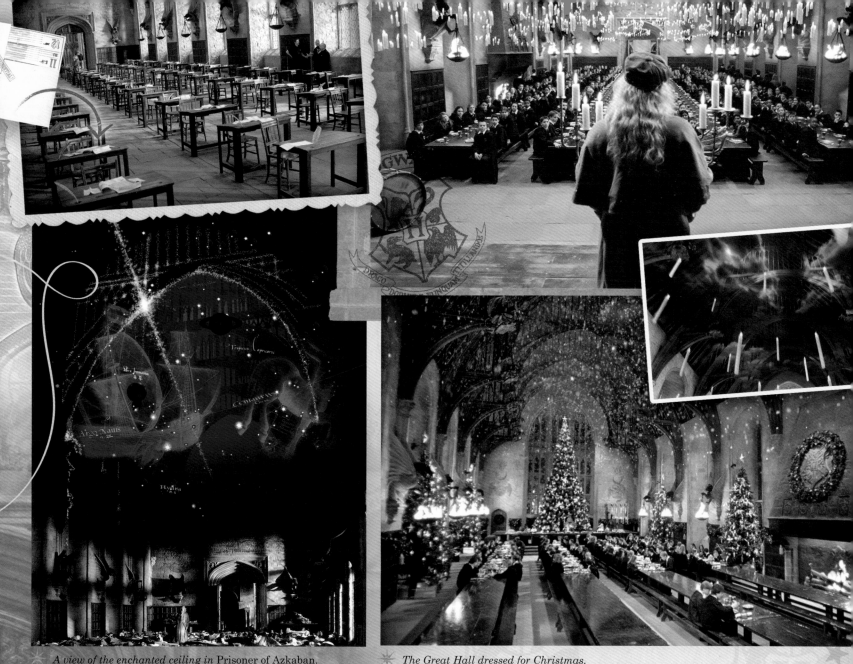

A view of the enchanted ceiling in Prisoner of Azkaban.

The Great Hall dressed for Christmas.

as well as the enchanted sky that can be seen between the roof's beams. "You still want a hint that there's a roof there," says visual effects producer Emma Norton, "so you see the structure, almost like a ghost, through the sky." The Great Hall has had a number of different skies featuring moonlit clouds, falling snow, and Emma's personal favorite—an exquisite depiction of the cosmos which appeared in *Harry Potter and the Prisoner of Azkaban*. "All the children were sleeping in the Great Hall," Emma recalls, "and above them was a vast solar system. I thought that was brilliant!"

Visual effects were also used to create the floating candles that illuminate every Hogwarts feast. Originally, real lights (candle-shaped holders containing oil and burning wicks) were to be suspended from wires that moved up and down on a special effects rig to give the impression that they were floating. After an incident with a falling candle, however, it was decided that they should be inserted as a digital visual effect for safety reasons.

The Hogwarts feasts—all held in the Great Hall—involve a great deal of preparation. Set decorator Stephenie McMillan recalls how, on the first film, Chris Columbus wanted a very elaborate welcome feast to match Rowling's description in the book. "We

were thinking in terms of piles of sausages and that sort of kids' food," says Stephenie, "but Chris wanted roast beef, ham, turkeys, and all the trimmings. We used all real food, but filming under the hot lights meant that everything began to smell terrible. We had to change the meat every two days and the vegetables twice a day." "But it was impossible to get rid of the stink," says David Heyman.

Things changed on the second film when samples of real food were frozen so that molds could be made of them and copies cast in resin—especially helpful when frozen desserts were needed in a scene. Pierre Bohanna, head of the prop-manufacturing department, reveals how they made some eighty ice cream towers: "They are a combination of resins and powdered glass: tiny little glass beads that create just the right texture and give a wonderful sparkling iridescence."

With such attention to detail, it's no wonder J. K. Rowling has called the visuals in the film series "almost indistinguishable" from the way she wrote them. In an interview with *Dateline*, she particularly called out the Great Hall set, saying that visiting it was like "walking inside" her own head.

Emma Watson as HERMIONE GRANGER

Crookshanks

9 Hermione

When Emma Watson first looked at the set for Hermione Granger's bedroom in *Deathly Hallows – Part 1*, she told Stephenie McMillan emphatically that there should be "more books."

Naturally, Stephenie took this suggestion to heart. After six *Harry Potter* films, Emma understands Hermione and the importance she places on reading and learning. "I know this character inside out!" she laughs. "I've been playing her for so long now, I feel I intuitively know what she'd want."

Emma's familiarity with her character is not surprising: when the series wraps, she will have been playing Hermione for more than half of her lifetime. On being cast at such a young age (nine), Emma says that she is often asked what it's like to grow up on screen. "I've never grown up any other way," she answers honestly, "so I don't know." When she won the role of Hermione Granger, Emma says she was too young to realize the magnitude of the situation. "We stayed in a fancy hotel for the press conference," she recalled in an interview with *MSN News UK*. "I remember sitting on a massive bed jumping around watching myself on the TV evening news. It was mad." She had never acted professionally before and found the experience both exciting and terrifying. Describing stepping onto the huge Great Hall set for the first time, Emma says there was "no acting required" for her to look awestruck.

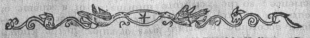

(above right) Hermione's bedroom as seen in Deathly Hallows – Part 1.

(right) Comforting Ron.

Over the years she's been with *Harry Potter*, Emma has worked with several different directors and an ever-changing cast of renowned British actors. Her character has gone from a brainy, "rather bossy" little girl to a confident young woman who experiences the pangs of adolescence in the midst of war. Emma speaks warmly of her character, emphasizing her loyalty. However, she's just as quick to point out scenes in which she feels that Hermione is being stubborn, silly, or completely out of her depth. "It's a minefield being a girl, it really is," she said of the Yule Ball scene in *Goblet of Fire*, "a complete minefield."

Reflecting on the longevity of the series and her role in it, Emma says she hopes the *Harry Potter* films will live on and be discovered by new audiences. "I hope it will be a classic like *The Railway Children*," she says, mentioning a personal favorite. "The books are so unique and wonderful. I hope the films have that [quality] as well."

Having Emma Watson, Daniel Radcliffe, and Rupert Grint stay in their roles through all eight films has helped make the series believable. "People say it's really nice to see us grow up through the films as Hermione, Harry, and Ron," says Emma. **(above right)** Hermione's wand, books, and purse.

Hermione's on-screen look has changed over the years. She has gone from "itchy jumpers" and skirts (Emma's description) to jeans, hoodies, and (occasionally) lavish dresses.

HERMIONE

RACTER:	ACTOR:
DUMBLEDORE	RICHARD HARRIS.

(below) Dumbledore's office.

(left) While filming Half-Blood Prince, *Michael Gambon wore a green glove on one hand. Dumbledore's cursed hand was substituted later with visual effects.*

Thomas
Riddle
1938

Actor: MICHEAL GAMBON
Location: INT. TRIAL PENSIVE
Description:

UNDER ROBE — SILVER/GREY, BUTTON UP
CUFFS, BUTTONS UP

GAMBON

—QUIDDITCH

(above) Costume sketches for Dumbledore. According to chief makeup artist Amanda Knight, the simple act of removing his hat in Half-Blood Prince made Dumbledore appear more vulnerable.

Richard Harris & Michael Gambon as
ALBUS DUMBLEDORE

"**W**e needed a father figure," explains producer David Heyman, recalling the casting of Albus Dumbledore. "We needed someone who was a commanding and authoritative presence and an eccentric with a twinkle in his eye. Richard was perfect."

David had known Richard Harris for many years; his father had been the actor's long-time agent and friend, and Richard was David's godfather. "But," says David, "the deciding factor was Ella, Richard's granddaughter, who loved the *Harry Potter* books. She said that she'd never speak to him again if he didn't play Dumbledore. And so he did!"

Judianna Makovsky, costume designer on the first film, recalls her initial meeting with the actor: "Richard came in, and I showed him this sketch of Dumbledore that I had made for director Chris Columbus. He stared and stared at it and then said, 'Thank you. Thank you so much. Now I know what my character is.'"

When Richard Harris died in October of 2002, the role had to be recast. "We all loved Richard's portrayal," says David Heyman, "and for many he will always be Dumbledore. But Michael Gambon stepped into the role and made the part very much his own. And at the same time, he paid homage to Richard with his Irish accent."

The demands placed on Michael Gambon—assuming the role at such a critical time in the story—were considerable. The character had to have a sense of moral rectitude to be Harry's mentor, while being aware—as J. K. Rowling puts it—that power was his "weakness and temptation."

When asked, Michael Gambon says he has no secrets about how he approached the role. "I just stick on a beard and play me," he says. "It's no great feat. Every part I play is just a variant of my own personality."

41

(above) *The Sorting Hat is voiced in the films by Leslie Phillips.*

THE SORTING HAT

It took considerable ingenuity to produce a talking hat for the *Harry Potter* films. Early attempts by a creature effects company were rejected as looking too much like a puppet and not enough like a hat. Director Chris Columbus then asked Judianna Makovsky, costume designer on *Sorcerer's Stone*, if *she* could make the Sorting Hat. Judianna recalls: "I said, 'I can make a hat, but I can't make it talk!' So Chris told me to go ahead, and I made the hat and took it to set and everyone said it was a beautiful hat. When visual effects supervisor Bob Legato asked how the hat would talk, Chris said, 'She makes the hat, *you* make it talk!'"

The idea, according to Bob, was to make a hat with "some sense of real life and magic to it, but [that] was still comfortable to look at—not a totally unbelievable computer graphics creation."

Hufflepuff

Founder: Helga Hufflepuff

Hufflepuff students are "just," "loyal," and "unafraid of toil," according to the Sorting Hat. In *Harry Potter and the Goblet of Fire*, actor Robert Pattinson portrayed the quintessential Hufflepuff, Cedric Diggory—a hardworking student who believed in fairness and was proud to represent his house and school in the Triwizard Tournament. Cedric is an "all-around nice guy," according to Robert. "He's competitive . . . but he has his priorities right. He's honest."

Other Hufflepuffs during Harry's time at Hogwarts include eventual Dumbledore's Army members Justin Finch-Fletchley (Edward Randell), whom Harry tries to protect from a snake during Dueling Club in the second film, and Zacharias Smith (Nick Shirm).

*Relics of two house founders: **(right)** Hufflepuff's cup. **(far right)** Raven-claw's diadem.*

Ravenclaw

Founder: Rowena Ravenclaw

Many clever witches and wizards are Sorted into Ravenclaw, whose house motto is "Wit beyond measure is man's greatest treasure." The two Ravenclaws Harry gets to know best are Luna Lovegood (Evanna Lynch) and Cho Chang (Katie Leung), both of whom join Dumbledore's Army in *Harry Potter and the Order of the Phoenix*.

"She's a Ravenclaw, and they're known for intelligence," Evanna says of her character, adding that Luna gains something besides just skill during the D.A. meetings—friends. "She wanted to learn the magic, but also to make friends. She's not a loner although she's often alone."

Cho is much more of a social butterfly than Luna, but after the death of her boyfriend, Cedric Diggory, in the fourth film, she is sad and withdrawn. When she signs up for the D.A., "she wants to avenge Cedric's death," says Katie, "and she's determined to be taught all this magic."

Ravenclaw students wear the standard school uniform trimmed in blue and silver—a slight change from the books in which their house colors are blue and bronze.

43

Gryffindor™

Founder: Godric Gryffindor

Gryffindor is, without a doubt, the house that viewers of the *Harry Potter* films and readers of the novels learn the most about. Harry, along with Hermione and Ron, is Sorted into Gryffindor after the Sorting Hat briefly flirts with the idea of making him a Slytherin. Gryffindors, as Harry exemplifies at many points during the series, are courageous—possessing "daring nerve" and "chivalry," according to the hat.

Not only were Harry's parents both in Gryffindor, but he meets many former Gryffindors during the span of the series, such as Sirius Black, Molly and Arthur Weasley, and Minerva McGonagall (the current head of the house).

"The Gryffindor common room is the first home experience Harry has ever had," says Stuart Craig. (Harry's previous dwelling was, after all, the cupboard under the stairs in the Dursley house.) "We wanted it to provide a reassuring feeling of warmth and comfort—a massive fire, a beaten-up old sofa, and a threadbare carpet." The walls are covered with richly embroidered tapestries based on a famous sixteenth-century French wall hanging—showing a medieval scene of a woman and a unicorn—done in the Gryffindor colors of scarlet and gold.

(left) The school uniform has remained the same since Prisoner of Azkaban. *Students wear a badge with their house crest, and house colors are reflected in ties and sweater trim.*
(right) The sword of Hogwarts founder Godric Gryffindor.

Salazar Slytherin's locket.

Slytherin

Founder: Salazar Slytherin

Slytherin is named after Hogwarts founder Salazar Slytherin, who created the Chamber of Secrets to "purge" Hogwarts of Muggle-born students. "There's not a witch or wizard who went bad who wasn't in Slytherin," Ron tells Harry in the first film. That list includes the most famous Slytherin of them all, Tom Marvolo Riddle (Lord Voldemort).

The Sorting Hat looks for Slytherins who are, among other qualities, power-hungry and ambitious. Draco Malfoy—schoolyard bully and later Death Eater—is in Slytherin, as are his cronies Vincent Crabbe and Gregory Goyle.

While Harry would normally never set foot in the Slytherin common room, both he and Ron visit it in *Harry Potter and the Chamber of Secrets*, disguised as Crabbe and Goyle. The cavernous space is located in the dungeon under the black lake. Taking a cue from this location, Stuart Craig decided that it should look as if it had been "carved out of the solid rock." The cool stone space, loaded with touches of Slytherin green, contrasts rather directly with the warm, earthy Gryffindor common room.

45

(below) *Concept art for the Slytherin common room by Andrew Williamson.*

Slytherin Quidditch uniforms.

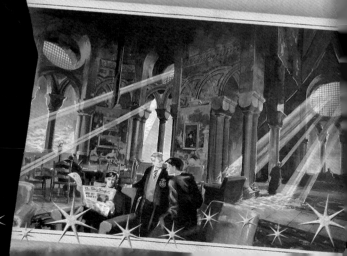

THE HOGWARTS GHOSTS

Although the ghosts of the four Hogwarts houses all appeared in the first *Potter* film—Slytherin's Bloody Baron, Hufflepuff's Fat Friar, Ravenclaw's Grey Lady, and Gryffindor's Nearly Headless Nick—only Nick, or Sir Nicholas de Mimsy-Porpington, to use his full name, has a significant role to play in the second.

Nearly Headless Nick was played by the inimitable John Cleese, and, as visual effects supervisor Bob Legato recalls, "He was a riot! The hard part was that the kids had to act surprised when he comes out of the middle of the table. We had John there on the set, [speaking his lines] off to the side, and he was so dynamic that all the kids tended to stare at him instead of where the character was going to be. So you'd have to do take after take, and it would be like, 'No, no, no, no! He's just *performing* it. You're looking *here*!'"

Bob says the hardest part about working on the ghosts is that "you've seen ghosts a million times before." He endeavored to make them new, exciting, and unique to Hogwarts and the world of *Harry Potter* by using a variety of visual effects techniques that provided additional highlights, ghostly trails, and different levels of transparency.

(top left) Nearly Headless Nick after being Petrified by the Basilisk.
(above) Concept art for ghosts at Nearly Headless Nick's Deathday Party (which did not appear in the film) by Adam Brockbank.
(left) The Fat Friar, the Grey Lady, and the Bloody Baron.

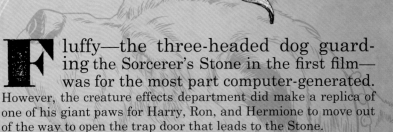

FLUFFY

Fluffy—the three-headed dog guarding the Sorcerer's Stone in the first film— was for the most part computer-generated. However, the creature effects department did make a replica of one of his giant paws for Harry, Ron, and Hermione to move out of the way to open the trap door that leads to the Stone.

For the rest of Fluffy's scenes, Bob Legato says the goal was to make "an unbelievable creature . . . believable." To make Fluffy more "realistic," the animators ensured that each of Fluffy's three heads moved independently and had its own unique personality. "One was more alert," says Bob, "one was smarter, and one was sleepier." While he says the film's audience may not fully appreciate the differences among the heads, this variation at least gave the animators "something to play with" and the actors something to react to.

QUIDDITCH

"**I** wanted Quidditch to feel like a real sport," says Chris Columbus, director of *Harry Potter and the Sorcerer's Stone*. It was an ambition shared by J. K. Rowling, who revealed in a 1999 interview on *The Diane Rehm Show* that visualizing Quidditch was one of the reasons she was excited about the making of the first film. "I've been able to see this game playing in my head for years now," she said. "Being able to watch it—literally *watch* it—would be the most fabulous thing."

For Chris, it was vital not only to satisfy the author and her readers, but also to make Quidditch an accessible game to everyone who would see the film, even if they were unfamiliar with the novels. He confesses that it took him a long time to grasp the rules of the game, and he eventually had to enlist the author's assistance. "J. K. Rowling came up with a chart for me," he recalls, "giving me the rules of Quidditch to incorporate into the film."

The Flying lesson was filmed on location at Alnwick Castle. The actors were attached to rigs, which moved up and down and gave the illusion that they were floating. But when it came to filming the Quidditch match, things got vastly more complicated. The game is dynamic and perilous, and players fly at tremendous speeds. "You don't really get a sense of speed if you have no context and simply have a player moving against a distant background," Chris explains, "so we came up with the idea of towers so Harry and the other Quidditch players could fly around them and they could provide the foreground context to create the illusion of speed."

Having decided how the stadium would look, the filmmakers then had to determine how and where to build it. It needed to be a large, actual-sized structure and had to be situated in the same Scottish Highlands setting as Hogwarts. Both factors presented huge problems. Building such a vast set in a mountain valley in Scotland was impossible, so the production had to turn to computer-generated imagery. As a rule, Chris preferred to do everything practically, so this represented a significant turn. They compromised though, building the base and top of one of the towers as a studio set, and leaving the rest of the stadium to the digital imagination. The end results, however, are an arena and a game that are very real, and that realize Rowling and Columbus's desire virtually to watch Quidditch.

Firebolt concept art by Dermot Power based on sketches by Stuart Craig.

A NEW GAME FOR EVERYONE

Just as Harry had to come to grips with this new game, so the film's art department had to come up with designs for everything connected with the sport—from the players' uniforms and equipment to the programs handed out at the Quidditch World Cup. The prop-making department built a succession of broomsticks used throughout the film series, feeding the players ever faster and better designs, and keeping up with the new models that appear annually in the window of Diagon Alley's Quality Quidditch Supplies. They also designed the three types of Quidditch balls: a Quaffle, Bludgers, and a Golden Snitch with fully operational mechanical wings.

In scenes where digital elements will be added during post-production, actors must use their imagination. As Sean Biggerstaff, who plays Oliver Wood, observes, "It's not that hard to work with things that aren't really there. When you are performing, you are pretty much using your imagination anyway."

The Quidditch stadium in the films has spectators seated in towers. This added detail helps create a more realistic sense of the speed of the game when players fly past them.

EASLEY TWIN
Oliver

82

Madame Hooch

49

UNIFORMS
FOR A DANGEROUS GAME

As is the case in any sport that has a strong tradition, Quidditch uniforms have been refined over the years. In the first two films, the players' robes were quite thick. However, for the match in *Prisoner of Azkaban*, the players wore lighter, sportier robes with their names and numbers on the back. "The idea," says costume designer Jany Temime, "was to create a look that kids who watch football, rugby, or whatever would recognize so that they would instantly see Quidditch as a sport."

In *Harry Potter and the Half-Blood Prince*, the Quidditch players were given modern tracksuit-style clothes for training, but their match gear was a sophisticated blend of the contemporary and the historical. The elbow and knee pads and helmets they don during games are reminiscent of the protective wear worn by early American football players, while the padded leather arm, chest, and shin guards are reminiscent of the kind of body armor worn by sportsmen in Edwardian England.

This sort of padding was needed because, according to director David Yates, Quidditch is a violent sport. For him, the championship game between Gryffindor and Slytherin represents "the terrible violence that Quidditch entails. It always looks really fun, but when you're flying along on a broomstick at sixty miles an hour, whenever you collide or don't get the Quaffle and end up falling about fifty feet, it's very precarious."

New Quidditch robes designed for Harry Potter and the Prisoner of Azkaban *featured names and numbers on the back of the uniforms in the style of various Muggle sports.*

50

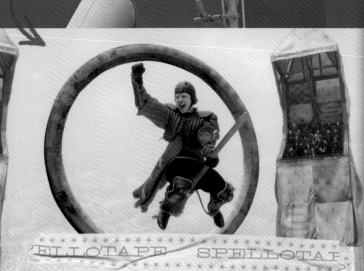

"Because Ron gets hand-me-downs," says costumer Steve Kill, "we made Rupert's chest protector and helmet a couple of sizes too small for him, as well as making [them] look old and worn."

STORY DAY: 8
PT. QUIDDITCH FLYING.

SPELLOTAPE SPELLOTAPE

To make sure the "story" of each Quidditch scene is clear, and that the necessary excitement will be built when all the pieces are assembled, every move in a Quidditch match is carefully plotted in a series of detailed storyboard sketches well before filming begins. The movements between these key shots are then worked out on computers using simple animation known as previsualization, or "pre-viz." This process gives the filmmakers a good sense of how many different elements they will have to combine in the final shot, and creates a preliminary shooting list for each individual player's moves, which are subsequently filmed one by one. It's an incredibly time-consuming process. A shot that features ten players, for instance, might involve a week's filming before the visual effects team can even think about starting work. On screen, that shot might last just two seconds.

Technological advances during the making of the series have made it possible for Quidditch to be filmed in an increasingly exciting way. "Inside a computer, we can do just about anything," says visual effects supervisor Tim Burke. "Players' cloaks can be made to flap and whip around, and moves in the game that would be impossible for an actor to perform can now be made by a digitally animated version of the actor."

THE NEED FOR SPEED

Quidditch is essentially created in the computer. All the actors are filmed separately on their brooms, which are held and moved by a rig. They act and react while a motion-control camera films the performance in front of a blue or green screen. This colored background is later eliminated when the actors are incorporated into the complete CGI (computer-generated imagery) environment by the visual effects department.

• With little to interact with but the blue and green screens, filming Quidditch scenes was "one of the more grueling experiences for the actors," says Chris Columbus, director of the first two *Harry Potter* films. "Riding those brooms was a tremendously difficult thing, but to create a sense of movement, a sense of urgency, and, at the same time, to *feel* as if these were real athletes playing a game, was the biggest challenge."

NIMBUS 2000 BROOM. RIG

CHECKMATE!

Of all the scenes in *Harry Potter and the Sorceror's Stone*, Chris Columbus has said that he was "most excited" to shoot the scene where Harry, Ron, and Hermione encounter a giant version of a wizard chess set and must play their way across the board. According to Chris, great scenes like that make him feel like a "kid in a candy store."

A giant chessboard and enormous, twelve-foot-high chess pieces were constructed. The chessmen were radio-controlled, which was a far-from-simple operation because of their height and weight and the fact that their bases were relatively small.

"Not only did we have to move the pieces," says special effects supervisor John Richardson, "we had to have them battling with one another, blowing up, and crashing to the ground." There were also flames for the burning wreckage of the destroyed chess pieces and, as John puts it, "pretty much a bit of everything that we've ever come across in special effects!"

As Chris reflects: "The combined movement of the camera, along with the pieces mechanically moving across the floor, created a real sense of terror and suspense. While we talked about trying to make the pieces move more quickly, I just love that, in the end, this sequence happened at its own pace."

Though surprisingly little visual effects work was required, there were a couple of moments of digitally created magic—for example, when one of the pawn-soldiers comes alive and draws its swords.

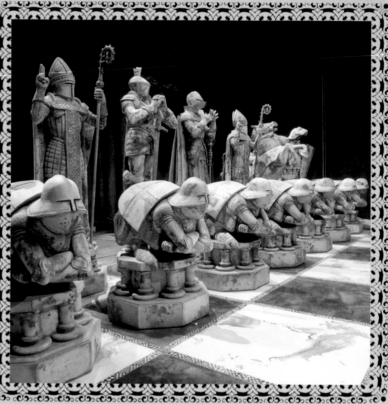

For Chris, the scene was remarkable not just for the effects, but for Rupert Grint's performance as Ron: "That is just an amazing performance by a kid who was starting to feel very comfortable with his character. And when he sees the power of these things and realizes he [must] sacrifice himself for his friends, I sensed a real moment of fear, but also courage from Rupert."

The scene was also a highlight from Rupert's perspective. "It was really exciting," he later recalled. "I got to sit on the horse, and I remember really enjoying that. The set was huge, and it was incredible when the pieces got smashed. I've actually still got a broken piece of the horse! That was so cool!"

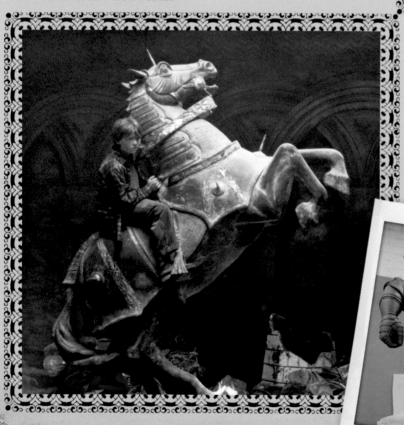

Bryn Court sculpting giant chess pieces.

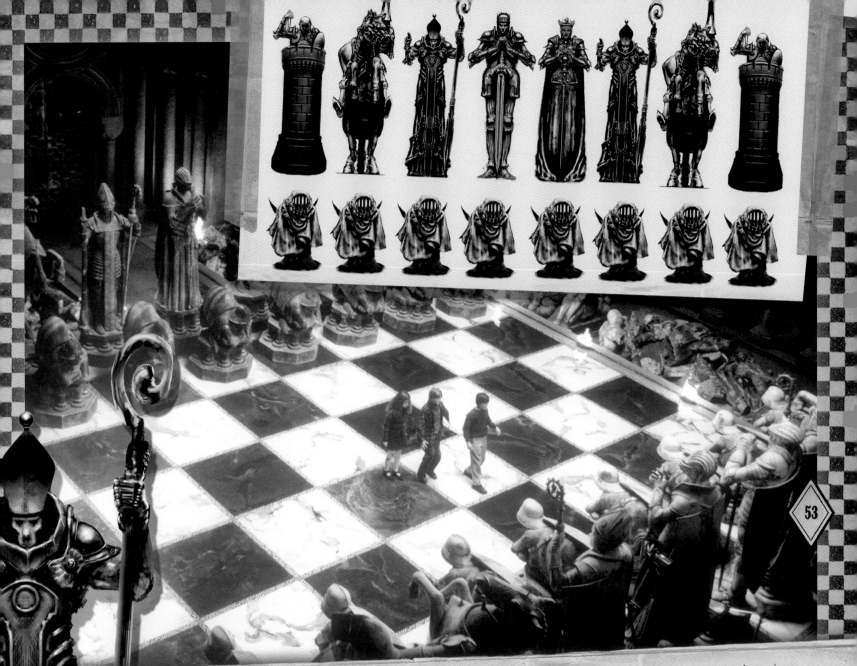

53

(top) Original concept art by Cyrille Nomberg for the giant chess pieces.
(left) One of the giant pawns built for the scene. (below) A pawn is brought
to life during the game.

Harry Potter and the Chamber of Secrets

Harry Potter and the Sorcerer's Stone opened on a Friday night in November 2001, and on the following Monday morning everyone was back at work filming *Harry Potter and the Chamber of Secrets*.

Preproduction on the second film had already begun while the first was being edited. "We didn't want to wait another year," explains Chris Columbus, "because kids age so quickly that they would be too old for their roles."

After a 150-day shoot, the cast and crew had already bonded as a family, and everyone now had answers to many of the questions that they had been asking before work began on *Sorcerer's Stone*. But there were still things that screenwriter Steve Kloves wanted to know. "The hardest part for me," he confessed, "is writing a story to which I do not know the end. It's important that I talk to Jo along the way and ask her, 'Am I on the right path?' And Jo's maddening in the sense that she will not tell me what's going to happen, but she will tell me if I'm going down the wrong path."

The author considered her second book "easier to translate to the screen." For Chris, because everyone was now familiar with Harry's life and the wizarding world, the second film didn't require as much screen time to set up the story.

There was also a change in mood away from what Chris describes as the "wonderful, rich, storybook version of Hogwarts" that had been created for the first film to one that was somewhat darker and more menacing. Similarly, there

was a change in the way the central characters viewed Hogwarts and the craft of magic, as Steve Kloves explains: "In *Chamber*, the magic is becoming a bit second nature to them—at least 'simple' magic is—and it's a case of a little bit of knowledge will get you into a lot of trouble! In the second film, they're getting more mature, but it's a dangerous kind of knowledge."

The addition of new characters with each episode would become one of the many pleasures of the series. *Chamber of Secrets* allowed us to meet, for the first time, two Hogwarts staff members.

Professor Sprout, head of Hufflepuff house, is introduced as the Herbology teacher. Played by Miriam Margolyes, Sprout's role in the story was crucial since it is her "healthy growth of Mandrake" that provides the antidote to the Petrifying gaze of the Basilisk. The staff was also joined by a new Defense Against the Dark Arts teacher—flamboyant Gilderoy Lockhart, played by Kenneth Branagh, who says of his character: "He's the kind of guy that, if you've been to the moon, he's been there—*twice!*"

As J. K. Rowling revealed, Lockhart was the only character in the *Potter* books that she had deliberately based on a real person. "I have to say that the living model was worse," the author told an audience at the Edinburgh International Book Festival in 2004. "The lies that he told about adventures that he'd had, things he'd done, and impressive acts that he had committed . . . he was a shocking man. I can say this quite freely, because he will never in a million years dream that he is Gilderoy Lockhart."

The scene where Lockhart is signing copies of his autobiography, *Magical Me*, in Flourish and Blotts bookshop in Diagon Alley was an opportunity to introduce another character that would have an important role to play in future episodes—Draco Malfoy's father, Lucius, played by Jason Isaacs. Producer David Heyman says of Jason's casting: "We wanted someone who could play superior and disdainful, and Jason has a wonderful ability to be slightly theatrical, but with a real truth—and a darkness."

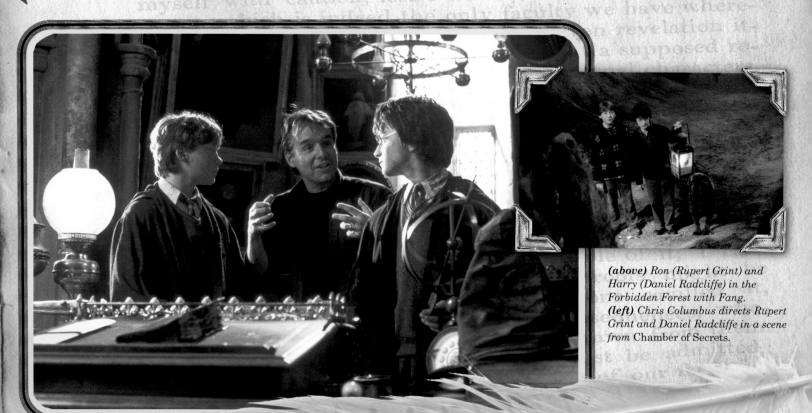

(above) Ron (Rupert Grint) and Harry (Daniel Radcliffe) in the Forbidden Forest with Fang.
(left) Chris Columbus directs Rupert Grint and Daniel Radcliffe in a scene from Chamber of Secrets.

For Chris, one of the pleasures of working on *Chamber of Secrets* was that members of the young cast were beginning to grow as performers: "The problem all the kids had on *Sorcerer's Stone* was that they were so unfamiliar with being on a movie set that they could never stop smiling, even if it was a serious scene. Those early days were part filming and part acting lessons! But, by the time we got to *Chamber of Secrets*, they felt more comfortable in their roles and they were getting better and better."

The story also offered plenty of new opportunities to test the production team's creativity and ingenuity—among them the flying Ford Anglia, the Whomping Willow, the Basilisk, and Aragog the Acromantula.

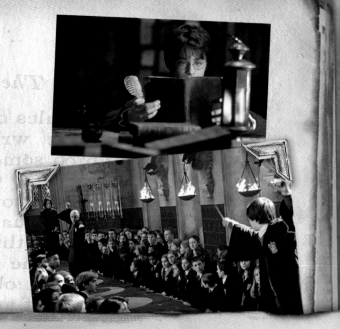

There were, initially, some concerns about the spiders in the Forbidden Forest—an episode from the novel that had been written into a script, but which could all too easily have seemed ludicrous when filmed. Screenwriter Steve Kloves recalls his apprehension about the sequence: "You have Aragog saying, 'Who goes there?' and,

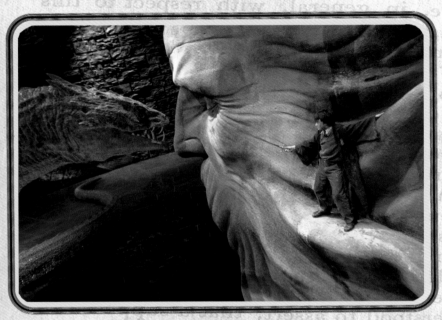

Harry (Daniel Radcliffe) faces the Basilisk on the carving of Salazar Slytherin.

as I was writing, I was thinking, 'How are we going to do this?'" Rowling shared Steve's anxiety: "You see these old sci-fi movies," she says, "where they have spiders and they're always hysterically funny; they're never, never scary. But in fact it was extremely frightening."

The hordes of scuttling, scurrying spiders were created using computer-generated imagery, but their leader was a giant animatronic figure created by Nick Dudman's creature effects workshop. "Aragog was a piece of pure theater," says Nick. "I was standing on the set thinking, 'That's an eighteen-foot-leg-span, giant spider, and I've just seen it walk out of a hole and deliver dialogue, for real, in front of me! And it's not a camera trick!'"

For Stuart Craig and his art department team, the film provided an opportunity to visualize and build new settings such as the Weasley home (The Burrow), the Slytherin common room, the girls' lavatory (home of resident ghost Moaning Myrtle), and, in particular, the Chamber of Secrets itself. "The size of it was staggering," recalls Chris Columbus. "I'd seen drawings and models, but when I first stepped into the Chamber of Secrets, it was amazing. This was not a computerized environment. This was real! Building the Chamber of Secrets set not only preserved the reality of being in that world, but it was great for the kids to feel that world around them."

EMMA WATSON
LOOKS BACK

Emma Watson was eleven years old during the filming of *Harry Potter and the Chamber of Secrets* and often brought her pet hamster, Millie, to the set. She remembers sitting for hair and makeup while Millie squirmed around in her lap—noting that the hair and makeup artists were "very patient" with her. Sadly, Millie passed away soon after production began, and Emma was understandably devastated.

News of the tragedy spread quickly through the crew, and Emma remembers fondly that the set department created a special hamster-sized coffin for her pet. The coffin had "a velvet lining and *Millie* engraved on the top," she recalls. "I don't think a hamster has ever had a better send-off."

DEFENSE AGAINST THE DARK ARTS CLASSROOM

PRODUCTION DESIGNER'S NOTEBOOK

Name: *Stuart Craig*

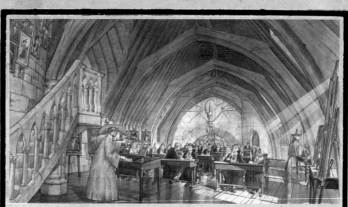

Concept art for Gilderoy Lockhart's Defense Against the Dark Arts classroom by Andrew Williamson.

For *Harry Potter and the Sorcerer's Stone*, Professor Quirrell's Defense Against the Dark Arts classroom was filmed on location at Lacock Abbey in Wiltshire, a building that dates back to the thirteenth century. We filmed in what is known as the "Warming Room," which is the only room in the Abbey where the nuns were allowed a fire.

It is always easier to film on a studio set than to take your cast and crew on location, so for *Chamber of Secrets*, we designed and built the Defense Against the Dark Arts

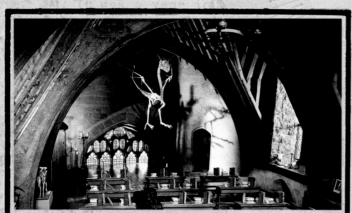

The studio set for the Defense Against the Dark Arts classroom in Chamber of Secrets, *featuring a hanging dragon skeleton.*

classroom used by Gilderoy Lockhart and all the D.A.D.A. teachers who followed (with the exception of Severus Snape).

I started, as I often do, by thinking of the room as though it was a piece of sculpture: a shape with which I could do something interesting. Because the Defense Against the Dark Arts classroom is an attic room with a curved wall that sits at the top of one of the towers, it could only have windows along one side.

At the far end we put a staircase that leads up to the teacher's office, taking our inspiration from a Gothic church pulpit. This design helped create a theatrical, stage-like setting ideal for Gilderoy Lockhart's dramatic entrances and exits.

The contents of the room have changed with each teacher. In *Harry Potter and the Prisoner of Azkaban*, for instance, when Remus Lupin becomes the Defense Against the Dark Arts teacher, the big wardrobe containing the Boggart takes center stage. When Mad-Eye Moody takes the post in *Goblet of Fire*, the room is filled with lenses and optical gadgets. In *Order of the Phoenix*, the room is empty apart from the desks and chairs because Dolores Umbridge doesn't actually teach the students anything about the Dark Arts. Thus, like the rest of Hogwarts, the classroom has evolved to serve its purpose in each film.

Neville Longbottom faces a Boggart in the form of Professor Snape during one of Remus Lupin's Defense Against the Dark Arts lessons in Prisoner of Azkaban.

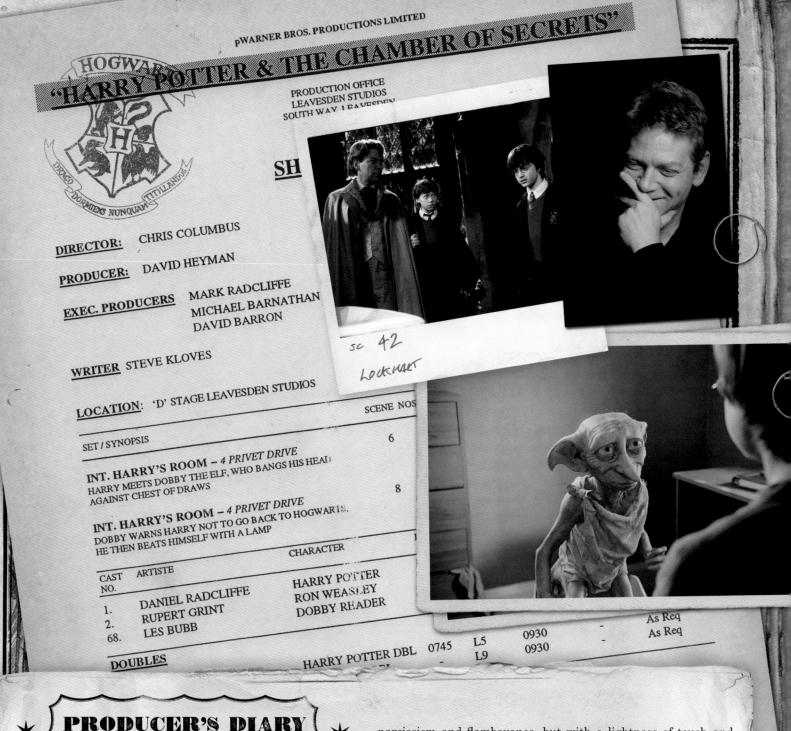

"HARRY POTTER & THE CHAMBER OF SECRETS"

HOGWAR

PRODUCTION OFFICE
LEAVESDEN STUDIOS
SOUTH WAY LEAVESDEN

SH

DIRECTOR: CHRIS COLUMBUS

PRODUCER: DAVID HEYMAN

EXEC. PRODUCERS MARK RADCLIFFE
MICHAEL BARNATHAN
DAVID BARRON

WRITER STEVE KLOVES

LOCATION: 'D' STAGE LEAVESDEN STUDIOS

SET / SYNOPSIS	SCENE NOS
INT. HARRY'S ROOM – 4 PRIVET DRIVE HARRY MEETS DOBBY THE ELF, WHO BANGS HIS HEAD AGAINST CHEST OF DRAWS	6
INT. HARRY'S ROOM – 4 PRIVET DRIVE DOBBY WARNS HARRY NOT TO GO BACK TO HOGWARTS. HE THEN BEATS HIMSELF WITH A LAMP	8

sc 42
LOCKHART

CAST NO.	ARTISTE	CHARACTER					
1.	DANIEL RADCLIFFE	HARRY POTTER					
2.	RUPERT GRINT	RON WEASLEY					
68.	LES BUBB	DOBBY READER					
							As Req
							As Req
DOUBLES		HARRY POTTER DBL	0745	L5	0930	–	
				L9	0930		

★ PRODUCER'S DIARY ★
by David Heyman

Chamber of Secrets was to be re-
leased one year after the first film, and
so preproduction was very compressed.
We were working on the script, building sets, casting, etc.,
while we were editing, and we began filming while we were
still mixing *Sorcerer's Stone*. It was a very intense period, and
yet Chris Columbus never lost his good cheer. I cannot imagine
any other director being so unflappable, enthusiastic, and
relentlessly energetic.

One of the most important decisions we had to make for
Chamber of Secrets was casting the role of Gilderoy Lockhart.
We interviewed a number of amazing, talented actors, but then
we met Kenneth Branagh. He immediately captured Lockhart's
narcissism and flamboyance, but with a lightness of touch and
a willingness to make a complete ass of himself! It's amazing
how unlike Lockhart Ken himself really is—he is one of the most
generous and self-effacing people I have met.

By the time the first film came out, the fourth book in Jo's *Harry
Potter* series had been published, and it was becoming increasingly
clear that these were not seven independent stories but a single
saga. One of the many great pleasures in reading the later
volumes was recognizing just how much significant information
Jo had seeded in the earlier ones—and how beautifully she had
plotted the entire story from the very beginning. For example, in
Chamber of Secrets, we first see the sword of Godric Gryffindor,
hear of Azkaban prison, and take a quick visit to Borgin and
Burkes. And whilst none of us knew it at the time, Tom Riddle's
diary was our first introduction to the concept of the Horcrux—
something not fully explained until *Harry Potter and the Half-
Blood Prince*, which turns out to be nothing less than the key to
defeating Voldemort himself!

The first time Harry visits The Burrow in the books by J. K. Rowling, he says to Ron, "This is the best house I've ever been in." It was that unique atmosphere that the filmmakers set out to create as they built a set for the Weasley home.

"Although The Burrow is whimsical, quirky, and filled with magical things," says director Chris Columbus, "I also wanted it to feel like a warm family home: a place where Harry could feel very comfortable."

Rowling describes the building as looking as if it had once been a large stone pigsty, and that became the starting point for production designer Stuart Craig: "We decided that maybe there had once been a little Tudor building with a pigsty on the side," he says, "and that Arthur had accommodated his growing family by building upward with lots of add-on bits of architectural salvage, picked up wherever he could find it and none of it matching."

The ramshackle look of the exterior determined how things would look inside. "The Burrow has a crooked quality," says Chris Columbus, "the floors, the ceilings, the staircase; everything is a little slanted, nothing is really perfect."

The windows are a patchwork of bits of glass from other buildings, the flagstone floors are worn, and every few steps on the staircase have different pieces of carpeting. As Stephenie McMillan explains, "We wanted everything—from the furniture through to the crockery on the kitchen table—to look as if it had been bought in second-hand shops, picked up at swap meets, or rescued from curbs." And that is how quite a few of the things used in The Burrow were bought and found—including an antique kitchen range rescued from the home of a pop star. The only real sense of uniformity in The Burrow comes from the furnishings and decorations—most of which keep to orange and red colors inspired by the flame-haired Weasley family.

58

While Mr. Weasley's workroom is filled with Muggle inventions he is studying, the house itself contains various magical objects like self-cleaning frying pans and "automatic" knitting needles created by the special effects department. The prop-makers had to produce several out-of-the-ordinary additions to The Burrow's décor, such as the fanciful clock that shows where all the members of the family are at any given time. Mark Williams, who plays Arthur Weasley, notes, "That kind of stuff is great. Even the grown-up actors had to be told: 'Don't touch the props! Stop poking around! Leave them alone!'"

Among the many things specially created for the sets was Ron's knitted bedspread in the colors of his favorite Quidditch team, the Chudley Cannons, and the children's drawings of witches, wizards, and mythical creatures pinned up in the kitchen that were actually made by family members of the art department staff.

The location chosen as a setting for The Burrow was an area of marshland near the Dorset village of Abbotsbury. "It's a beautiful place," says Stuart, "the noise that the reeds make, the reflection from the water. What a great image: this mad vertical tower in this otherwise entirely horizontal landscape."

When it came to having The Burrow burned down by Death Eaters in the sixth film, a one-third-scale model was made and ignited on the studio back lot. "We had to build the model to that scale," says assistant art director Gary Tomkins, "because you can't scale down fire, and if the model was too small, it would give the game away." Everything on and around the house was painstakingly recreated and constructed so that it would burn and collapse as the real building would.

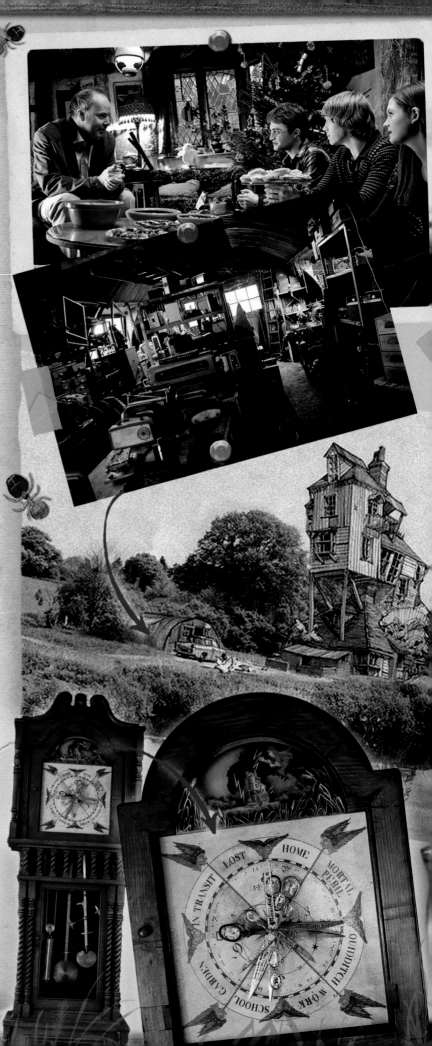

The BURROW

With only one opportunity to capture the burning, it was filmed with five cameras. "It was quite dramatic," recalls Gary. "It took six months to build and six minutes to burn down!"

Visual effects supervisor Tim Burke explains how his department contributed to the sequence: "David Yates wanted the fire to embody some serpent-like characters, so we developed some animation based on studies of snakes to give more threat to the house and a little magical property to the fire itself."

After the fire, the set was recreated in *Deathly Hallows* to look as if the building had been rebuilt and renovated by Arthur Weasley, but with the original orange paintwork and wooden beams painted over with whitewash—which is how it appears for the wedding of Bill Weasley and Fleur Delacour.

Certain things never change about The Burrow, as Julie Walters, who plays Molly Weasley remarks: "It is gorgeous and homey. It's not about appearances or ambition or anything like that; it's about love and protection and care, and that's why the Weasleys are so special. I want to live there myself. It's just divine!"

(clockwise from top left)
David Yates directs a scene in the Weasleys' home for Half-Blood Prince; a view of the Weasleys' kitchen table; The Burrow decorated for Bill and Fleur's wedding; concept art for The Burrow by Andrew Williamson.

(left) The famous Weasley clock.

(below) The burning of The Burrow.

The WEASLEYS

HOME MADE YUMMY HONEY
Weasleys

STRAWBERRY JAM

MAGNIFICENT MARMALADE

The Daily Prophet

Grand Prize Winner Visits Egypt!

The Daily Prophet Grand Prize Galleon Draw winner - The Weasley Family

(clockwise from top left)
Labels for Molly Weasley's home-made goods; director David Yates (left) conducts a Weasley Christmas at Grimmauld Place in Order of the Phoenix; *continuity photographs of Mark Williams as Arthur Weasley; two pictures of Williams with his onscreen wife Julie Walters (Molly Weasley); a clipping from the* Daily Prophet *about the Weasley family's trip to Egypt.*

HARRY POTTER
And the Chamber of Secrets

CHARACTER: MR WEASLEY

ACTOR: MARK WILLIAMS

DAY: SCENE

"It's really quite surreal," says Oliver Phelps, who plays George Weasley. "When we're on set, we all just talk to each other how you would do in a normal family. Except that when we're in character we talk down to Rupert and Bonnie, but talk up to mum and dad!"

Though Rupert Grint is the eldest of five children in real life—not the second youngest of seven—he says he "felt quite a connection to Ron because we have things in common like both having quite large families. I always thought my family was quite similar to the Weasleys, really."

The Weasley family scenes are among Rupert's favorite film moments, as they are for Bonnie Wright, who plays Ginny Weasley: "I really love the Weasley house we have shared as the family. It's always . . . energetic when all of us are

together—and Julie Walters and Mark Williams as our parents are so warm and bubbly."

Describing Arthur's character and his relationship with his family, Mark says, "He is a clean, simple sort of person. I knew where his heart was, and that was dead easy for me to play because he loves his wife, he loves his family, and he loves the truth."

Arthur Weasley also loves Muggle artifacts, and Mark relished the chance to have his character take an ongoing interest in the gadgets and gizmos of the non-wizarding world—from the flying car to the bicycle basket on the back of his broomstick.

Mark also considers Arthur to be the only father figure in the stories who is a *genuine* father. "The others," he says, "tend to be surrogate fathers—Sirius, Lupin, Dumbledore—but Arthur Weasley is the real deal! He's a proper dad!"

Julie Walters considers the character of Molly Weasley not just in relation to her screen husband and children, but also in terms of what the family represents to Harry: "Harry is like another son to her, and the Weasleys are really the only family Harry's got in terms of love and friendship. They provide a haven for him, a place of safety and warmth where he feels protected."

Part of that warmth comes from the make-do-and-mend philosophy of the Weasleys that is seen both in their home and in the clothes they wear. "I think Mrs. Weasley recycles a lot of things," says costume designer Jany Temime. "She has to, because she has no money. But she has an amazing imagination and could make a new coat out of an old bedspread."

Under Molly Weasley's costume, Julie Walters wears a padded suit to give her a more substantial, motherly shape. "What you see on screen is not all me!" says Julie. "When we were

making one of the films, I was scratching and complaining to Dan [Radcliffe] about my padding. 'Oh,' he said, 'is it padding?' '*Yes*,' I told him, 'it *is*!' Still, it's not as bad as the first couple of films where they put birdseed in my bosoms. That was very worrying with all those pigeons at King's Cross station, not to mention the owls!"

The Weasleys are a large clan, and the family's eldest son, Bill, finally joins the cast in *Harry Potter and the Deathly Hallows – Part 1*. Julie Walters couldn't be happier about the newest on-screen member of the family: "Another boy!" she laughs. "He's very handsome and romantic. Absolutely fits in. A gorgeous, lovely lad, and easygoing, just like his dad!"

"It was very cool meeting Julie and Mark," says Domhnall Gleeson, who plays Bill, "but it was kind of funny coming into the *Potter* world after seven movies. In one way it was all very familiar, because I've read all the books and seen all the movies. So it felt strangely normal seeing Bonnie, Rupert, and the twins and thinking they're my sister and brothers. But in another way it was completely bizarre because, of course, I'd never met any of those people before in my life!"

However, it didn't take long for Domhnall (son of Brendan Gleeson, who plays Mad-Eye Moody) to settle into what was—on and off screen—the family atmosphere of the Weasleys. "It's another fun day at the office," is how James Phelps, who plays Fred, sums up the on-set mood whenever the movie family is together. "If we're shooting a Weasley scene," he says, "there's always guaranteed to be a laugh at one point or another!"

(clockwise from right) Harry (Daniel Radcliffe and Ron (Rupert Grint) in Prisoner of Azkaban; *continuity snapshots of James Phelps as Fred Weasley, Oliver Phelps as George Weasley, and Bonnie Wright as Ginny Weasley; a group photo of three Weasley brothers with their younger sister; Percy Weasley (Chris Rankin); Bill Weasley (Domhnall Gleeson) stands with his father at his wedding to Fleur Delacour (Clémence Poésy).*

SC. 106 PERCY RELEASES SNITCH

The Flying
FORD ANGLIA

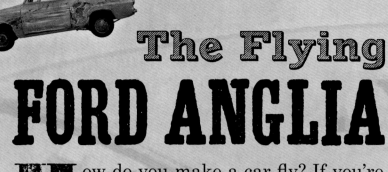

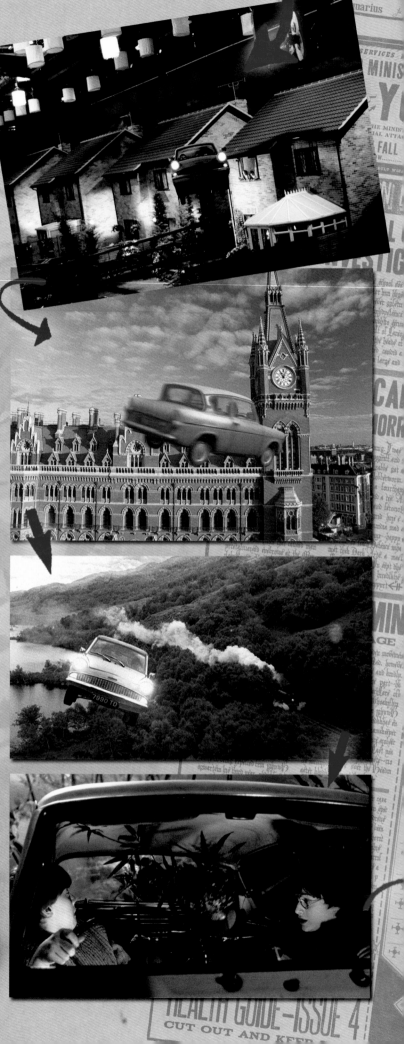

How do you make a car fly? If you're Arthur Weasley, you enchant a Muggle vehicle. Alas, the filmmakers behind *Harry Potter and the Chamber of Secrets* had to find another way.

The light blue car (license number 7990 TD) that appears in the second film was an authentic 1962 Ford Anglia 105E, built in Ford's factory in the United Kingdom. Special effects supervisor John Richardson took out the engine and gutted the vehicle to make it lighter, and then fitted it onto a rotating crane with a special joint called a "gimbal head." The gimbal head let the filmmakers rotate, pitch, and roll the car backward and forward. They then fit the gimbal head onto the back of an American pickup truck (with specially adapted suspension and outriggers) so that they could create all kinds of flying effects while on the move.

The Ford Anglia made the Muggle news when, in 2005, the British press reported that the car had been stolen from a film studio and found in a ruined castle in Cornwall. In fact, the car reported stolen was just one of many prop cars used in the making of the film. "We had sixteen different Anglias," reveals John, "all of which were differently adapted." Some of the Anglias were cut in half to allow for filming inside, others had racing engines for high-speed driving, and others were in various stages of being smashed for the scene where the car crashes in the Whomping Willow. According to John, the special effects team also built "wild" cars that had been "running around in the Forbidden Forest for a year."

(right) The flying car's incredible journey from Privet Drive to Hogwarts (and, more specifically, the Whomping Willow).

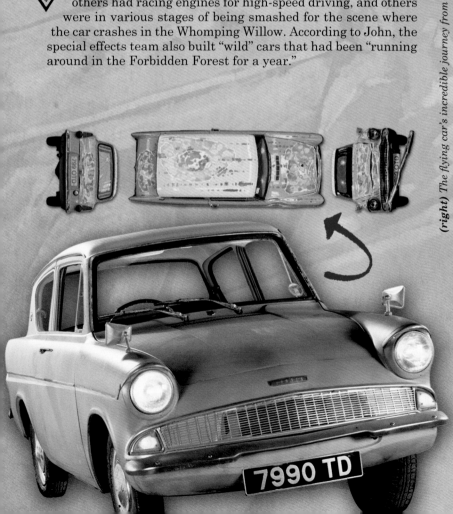

7990 TD

National Weather
south – sunny period 11c
north – cloudy & rain 9c
central – sunny period 10c
London – cloudy & rain 14c

Zodiac ✳ Aspects
ta – ♍ virgo ☾ ☍ luna opp–
in– ♈ aries – com ○ ● e
☊ sizio–♒ ne pi ✳ sces □

FIRST–SECOND EDITION
№ 10003461 London – UK
TODAY ☺ in Scorpio
Letters or vibes to the Editor should
be sent only "by owl post" and with a
clear mind to The Daily Prophet – UK

100,000 GALLEONS **ON BELLATRIX LESTRANGE'S HEAD** — SEE INSIDE FOR FULL DETAILS PG.3

THE MAGICAL WHOMPING WILLOW

➥ **EXCLUSIVE**

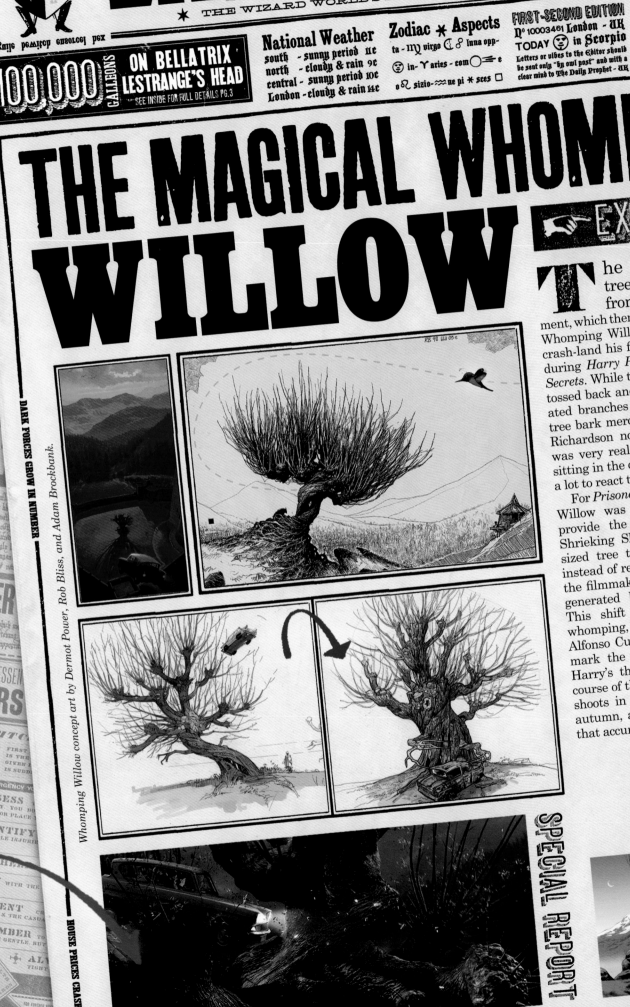

Whomping Willow concept art by Dermot Power, Rob Bliss, and Adam Brockbank.

The temperamental tree began as a sketch from the art department, which then had to be made into a real Whomping Willow into which Ron could crash-land his father's flying Ford Anglia during *Harry Potter and the Chamber of Secrets*. While the Anglia was pitched and tossed back and forth, mechanically operated branches covered in molded-rubber tree bark mercilessly "whomped" it. John Richardson notes that "the whole thing was very real. As Rupert and Dan were sitting in the car at the time, it gave them a lot to react to!"

For *Prisoner of Azkaban*, the Whomping Willow was relocated so that it could provide the secret passageway to the Shrieking Shack in Hogsmeade. A full-sized tree trunk was built on set, but instead of reprising the mechanical arms, the filmmakers decided to add computer-generated branches in post-production. This shift allowed for more dramatic whomping, and let *Azkaban* director Alfonso Cuarón use the tree as a way to mark the changing seasons throughout Harry's third year at Hogwarts. In the course of the film, the Willow sprouts new shoots in spring, sheds all its leaves in autumn, and throws off the winter snow that accumulates on its branches.

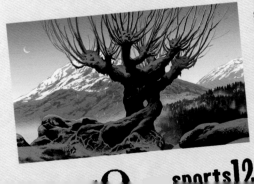

FACTS ABOUT THE FACULTY

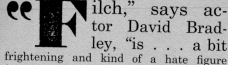

With her spiky hair and yellow, hawk-like eyes (created with special contact lenses, Flying instructor and Quidditch referee Madam Hooch was played in *Harry Potter and the Sorcerer's Stone* by Zoë Wanamaker.

Matthew Lewis (Neville Longbottom) recalls meeting Zoë on his first day, on location at Alnwick Castle—home of the Dukes of Northumberland in the north of England. "We came into work, and it was the broomstick lesson with Madam Hooch," Matthew recalls. "I had no idea what to expect . . . but Zoë Wanamaker was lovely. She made us all feel very, very comfortable and calm."

Zoë channeled Madam Hooch's no-nonsense persona when she was asked

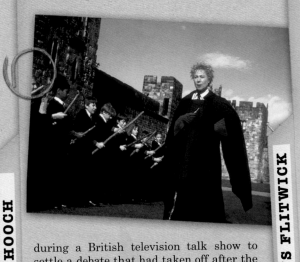

during a British television talk show to settle a debate that had taken off after the release of the first film about whether a broomstick should be flown with the brush forward or backward: "Brush backwards, of course—otherwise, *you'll* go backwards!"

"Filch," says actor David Bradley, "is . . . a bit frightening and kind of a hate figure for children everywhere, [so] it has surprised and rather delighted me that they also find him funny. I think the source of the humor in the character is in the fact that he's hanging on to the last vestige of authority that his job title gives him—and we all know people like that!"

Laughs David, "I get kids coming up to me and they say, 'You're just like the caretaker at our school,' and I think, oh my God, where *are* you educated?"

Despite disliking what David calls Filch's "narrow-mindedness and meanness of spirit," he is pleased that the character is human and believable. "It would be okay if he was just an ogre, prowling the corridors with his cat, getting kids into trouble—but it would be a very one-dimensional character. But his self-importance and vulnerability make him funny, and he's the last person in the world to realize he's *being* funny. He is funny because he takes himself and his job so seriously."

DAVID BRADLEY AS **ARGUS FILCH**

ZOË WANAMAKER AS **MADAM HOOCH**

"Professor Flitwick," says Warwick Davis, "is an understanding teacher. He likes to have fun in the class, but he's not the kind of teacher that the pupils would make fun of."

The actor took his inspiration for Filius Flitwick from a home video he shot when he was thirteen years old: "I created a kind of laboratory in my bedroom and filmed myself as this eccentric, mad professor creating experiments. And that really is Professor Flitwick."

Professor Flitwick is the kind of teacher Warwick wishes he'd had at school. "I imagine he's a guy that you could go to if you hadn't done your homework, and he'd say, 'Listen, don't worry about it. Complete it today and bring it tomorrow.'"

And as for the dramatic alteration in Flitwick's appearance between films two and three? Warwick was actually meant to be playing a different character in *Prisoner of Azkaban* (a choir director), but *Goblet of Fire* director Mike Newell liked the look of the choir director so much that he adopted it for Flitwick—and the character of Flitwick in the films then took on the additional duties of the Hogwarts choir director.

WARWICK DAVIS AS **PROFESSOR FILIUS FLITWICK**

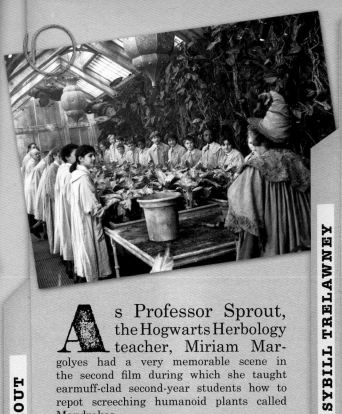

As Professor Sprout, the Hogwarts Herbology teacher, Miriam Margolyes had a very memorable scene in the second film during which she taught earmuff-clad second-year students how to repot screeching humanoid plants called Mandrakes.

During an interview on Andrew Denton's show *Enough Rope* in 2007, Miriam was asked whether, despite all her award-winning film work, she would ultimately be remembered for her role in the *Harry Potter* films. "I probably will," she replied. "It's rather odd actually, when you think about it, but more people have seen me do that. And kids everywhere recognize me and come up to me." (Subsequently cast as another witch, Madame Morrible, in the Broadway stage musical *Wicked*, Miriam wondered why everyone is "so nuts about witches!")

"I thought she was terribly funny," says Emma Thompson of her role as Hogwarts Divination teacher, Professor Sybill Trelawney. "I immediately saw her as this kind of wild-haired person who hasn't looked in a mirror for a long time and who really just couldn't see anything at all!"

Emma sent Alfonso Cuarón, director of *Harry Potter and the Prisoner of Azkaban*, some sketches of how she thought Trelawney might look. These helped inspire Jany Temime's costume designs. "Jany came up with something much prettier than any of my ideas and a fantastic material covered with little mirrors," says Emma. "So it's as if I had eyes all over my costume."

As for her large spectacles, Emma explains that "they are magnifying lenses to make my eyes look enormous. Professor Trelawney sees into the future, so my notion was that if she can see into the future all the time, she can't see anything at all in the present." As a result, the professor takes little interest in her appearance. Emma describes Trelawney's hair as having "exploded on the top of her head and not been brushed for a long time," while her clothes probably come from charity stores and are always done up in "a kind of slightly wrong way."

The actress has developed her own theory about why Professor Trelawney and Hermione Granger don't get along with one another. "I think," says Emma, "she sees in Hermione something of the person she was when she was a little girl—completely devoted to books and, therefore, a bit chilly and heartless at times. And Hermione looks at Trelawney and sees the person that she might become if she's not careful—a sort of dried-up, unfulfilled creature surrounded by cats and the demons of the past and the future whilst not being able to see what's happening in the present."

Emma enjoys the contradictions in Sybill Trelawney's character: "There's something kind of faintly helpless about her," she says, "but underneath the helplessness is *steel*!"

65

Jason Isaacs as
LUCIUS MALFOY

Jason Isaacs describes his character Lucius Malfoy as "a very proud man—incredibly vain and pompous, a peacock of a man." Jason first portrayed Lucius in *Harry Potter and the Chamber of Secrets,* and has reprised the role in four subsequent films. "To come back and to slip into this beautiful wig and to get this particularly sinister costume and to get to be murderous is nice," reflects the actor. "After doing lots of little independent films and trying to be complex and 3-D and human, just to come in and be satanic is a great relief."

Jason credits the wig of long, blond hair as a great aid in his performance. "I thought: 'How can I possibly be threatening in any way?' So I went for everything I could and asked for a wig, which wasn't originally in the conception. Every time I put it on, in order to keep it straight, I have to tilt my head back, and suddenly I'm looking down my nose at everybody."

He also relishes Lucius's aristocratic costumes, in particular the ermine-trimmed velvet coat and, in the later films, the leather armor that Jason says makes him feel "like a wizard ninja." Jany Temime describes the costumes she designed for Jason in *Harry Potter and the Deathly Hallows – Part 1* as a further evolution of the character: "As the Death Eaters develop from being a secret society to becoming more and more official, their costumes become battle uniforms with cloaks that have hoods that, unlike most hoods that are just ugly, hang down the back in snake-like folds."

Then there is Lucius's silver, snake-headed wand, which he secretes in his cane like a sword. Recounts Jason: "When we were first putting together the look for Lucius, I asked Chris Columbus, 'Can I have a cane?' He said, 'Why, is there something wrong with your leg?' And I said, 'No, I just think it would be kind of good for pointing and gesturing and I could pull the wand out of it.' And he said, 'I think that'd be cool.' And, as old as I am, I *still* think that's cool. I'm hoping I walk off with it at the end!"

66

(left) *Lucius Malfoy's Death Eater mask and snake-headed cane containing his wand.*
(right) *Lucius as a prisoner in Azkaban at the end of* Order of the Phoenix.

DOBBY

67

Dobby the house-elf is one of the most beloved characters in the *Harry Potter* series. While he plays a larger role in the novels than in the films, he has nonetheless been memorably represented by voice actor Toby Jones and a crew of talented animators.

The animation of Dobby begins with a video of Toby giving his performance. "We film his performance," says visual effects supervisor Tim Burke, "in order to relate that back to Dobby—the little computer graphic character—and put all of the emotion and performance into him. I like to think that we can create a character that can then be directed by the director as an actor would. All of these creatures that we create in the computer have to be believable. You have to believe they have a soul."

For Jason Isaacs, who plays Lucius Malfoy, acting alongside Dobby required an extra bit of imagination. "The first time I worked with Dobby," he says, "I asked, 'So where is Dobby going to be in the room? Where should I look?' And they went, 'Well, wherever you look, that's where we'll put him!'"

To help the process, Nick Dudman's creature shop created a full-sized, articulated model of the character: "We produced that in silicon with a complete functioning skeleton inside," he says. "We painted it so as to reproduce the entire color scheme—down to the last detail like the veins in the eyes. Everything needed to give the lighting cameraman a point of reference for whatever scene is being filmed."

Reflecting on his on-screen relationship with the former Malfoy family house-elf, Jason Isaacs says, "If I had realized he was going to be such an upstager, I might have gone a bit bigger!" After a moment, he adds: "Dobby never returns my calls now. I think he's gone Hollywood. I hear he's got a very big agent and doesn't get out of bed for less than a million dollars a day."

The house-elf gains his freedom from the Malfoys with one of Harry's socks.

GILDEROY LOCKHART

"He's a show-off and he's boastful and he's arrogant and I think he's deeply, deeply, deeply in love—but with himself!" That's how Ken Branagh describes his role as Professor Gilderoy Lockhart, Defense Against the Dark Arts teacher in *Harry Potter and the Chamber of Secrets.*

Ken's characterization began with what he found in the book: "He's wonderfully well-described and created by J. K. Rowling. I wish I could tell you that it's because he's very insecure. In fact, he's not. He's just a narcissist, and he loves himself. This is the abiding love affair of his life. He's also wonderfully cowardly and unreliable, totally out for number one, ruthlessly ambitious, would do anything

(above) Gilderoy Lockheart's insignia—designed by the graphic arts department.

sc 130
N 20
LOCKHART

D7

(right) The graphic arts and prop departments joined forces to create the complete works of Gilderoy Lockhart.

GILDEROY LOCKHART

GILDEROY LOCKHART

GILDEROY LOCKHART

GILDEROY LOCKHART

MAGICAL ME

Travels with TROLLS

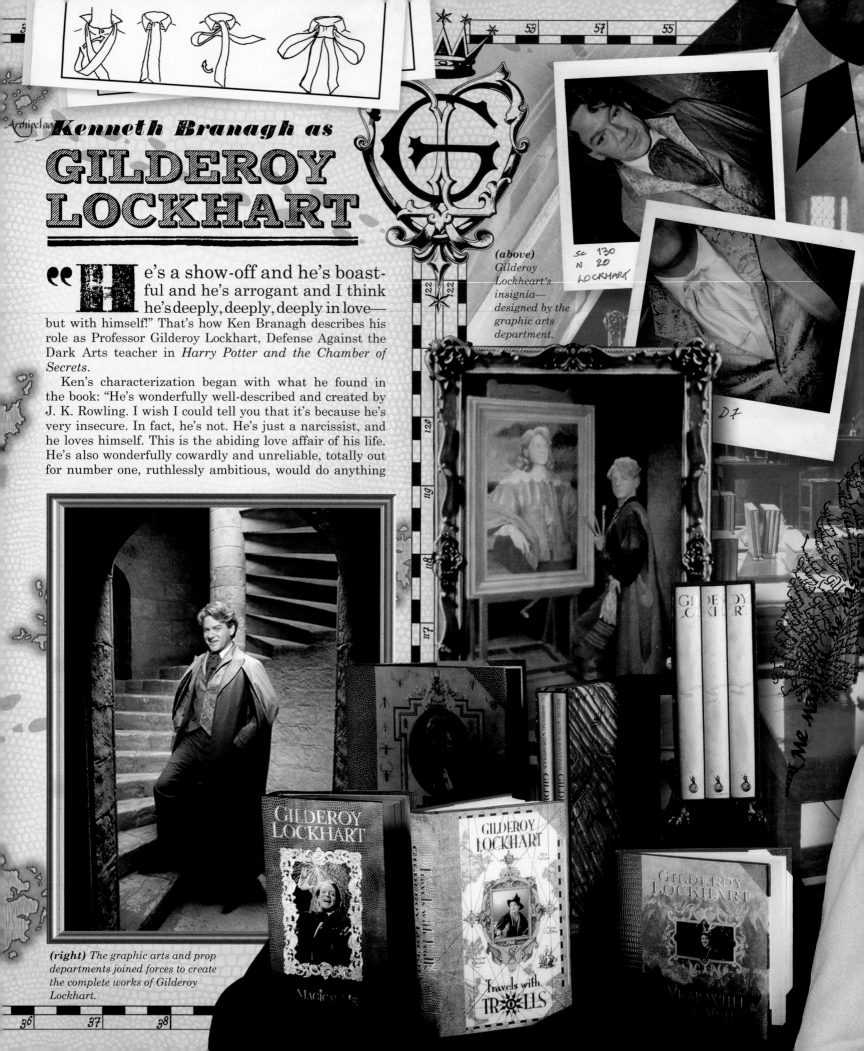

Cornish Pixies.

Maris Profondus

GILDEROY LOCKHART

Gadding with Ghouls
Break with a Banshee

to further his career, his aims . . . desperate to be loved. Those are all qualities that it was good fun to play."

The production team took great pains in helping create Lockhart's super-vain image, attending to every little detail from his elegant but dandified costumes to his makeup, which featured a set of perfect, gleaming false teeth. Lockhart also wore wigs that were intentionally created to *look* like wigs because, of course, they are—as we find out in the scene where Harry and Ron catch Lockhart stuffing a hairpiece into his 1950s Louis Vuitton luggage!

Set decorator Stephenie McMillan and her colleagues created a self-aggrandizing atmosphere in Lockhart's classroom with moving photographs of him as a champion Quidditch player and an intrepid world explorer, and a portrait of Lockhart as an accomplished painter who is painting, of course, his own likeness. "It's a wonderful image," says Ken, "Lockhart looking at a portrait of himself—painting himself! There just aren't enough images of Gilderoy Lockhart in his life."

The actor further describes his on-screen character as "a great showman. He has one eye on the audience and one eye on the mirror. It's not possible for him to be in a room and be in second place. He is totally aware and conscious of trying to manipulate public perception of himself by permanently presenting himself as a hero, and, in that sense, he is a wonderfully upfront, see-through, vainglorious, beautiful kind of idiot!"

69

ACTOR:
KENNETH BRANAGH

PETRIFIED!

(above) Concept art by Adam Brockbank of Colin Creevey and Hermione Granger after being Petrified. (right) Concept art of the Basilisk by Rob Bliss.

When the Chamber of Secrets is reopened, the Basilisk begins a reign of terror at Hogwarts, claiming a series of victims—Mrs. Norris, Colin Creevey, Justin Finch-Fletchley, Nearly Headless Nick, and Hermione Granger. The Petrified humans (and ghost) we see on screen are not the actors lying still, but amazingly lifelike dummies. Each dummy has color-matched eyes and hair, with every strand and eyelash hand-punched into its artificial skin.

These replica cast members began their still lives in the prosthetic makeup workshop through a process known as "lifecasting." According to creature effects supervisor Nick Dudman, lifecasts of actors are used to make dummies like the ones needed for the Petrified characters in *Harry Potter and the Chamber of Secrets*, as well as to create CGI doubles for visual effects.

The lifecast process begins with an actor putting on a plastic cap that protects his or her hair before being covered with a substance called dental alginate (which, as its name suggests, is what dentists use to make casts of patients' teeth). Dental alginate is applied to the head and shoulders—or, if necessary, the whole body—and, within a few minutes, becomes rubbery.

Plaster bandages are then applied to the exterior of the rubbery substance to keep everything in shape. When the plaster bandage cast dries, it is cut apart, taken off the actor, and then reassembled to form a mold into which more plaster can be poured to make a perfect lifecast of the actor. The lifecast can then be used to model prosthetic makeup, make masks for stunt doubles, or provide a reference for digital animators, who scan it with a laser to generate an initial 3-D image.

"It's a very old-fashioned method," says Nick, "but it's still the best because it gives you a complete picture of the skin texture—every single freckle, pore, and line."

(right) Lifecast of the head of Edward Randell, who plays Justin Finch-Fletchley. (above) The life-sized model of the Petrified Justin as he is discovered in the corridor at Hogwarts.

FAWKES

Fawkes the phoenix began life as a bunch of flame-colored feathers chosen by key animatronic model designer Val Jones. This combination of natural feathers—taken from pheasants and other game birds—with feathers specially dyed by Val provided the art department with initial reference material to use when they set about devising a look for Professor Dumbledore's magical bird.

Concept artist Adam Brockbank worked on the three stages of Fawkes's appearance in *Harry Potter and the Chamber of Secrets*: the old, decrepit bird who eventually bursts into flames; the phoenix chick reborn from the ashes; and the magnificent, fiery creature that aids Harry during his battle with the Basilisk.

Adam drew his inspiration from depictions in classical mythology, together with observations of real birds. For the glorious, triumphant Fawkes at the end of the film, he referenced the sea eagle—a magnificent bird of prey that is thought to be the world's oldest surviving species of bird. The version of Fawkes Harry first encounters, though, is at the end of its perennial life cycle and, as Adam explains, is more vulture-like in appearance: "His neck is extended, a lot of the feathers have fallen out, and he has the coloring of a burnt-out match, but there are still the last embers of brightness about the eye."

Adam's designs were used by the visual effects department when depicting the phoenix in flight, and by the creature shop when building a complex, animatronic Fawkes. The audio-animatronic bird, which first appears on the perch in Dumbledore's office, was a highly intricate mechanism with some ten controllers. Creature effects designer Nick Dudman describes the incredible degree of control the special effects department had over the phoenix model: "He could move his weight about the way birds do when they walk. He could open his wings and raise his crest. He could blink and had all sorts of little facial expressions. When he cries healing tears for Harry inside the Chamber of Secrets, those are 'real' tears welling up and running from his eyes." Fawkes was so lifelike, in fact, that at one point actor Jason Isaacs thought he was a real bird!

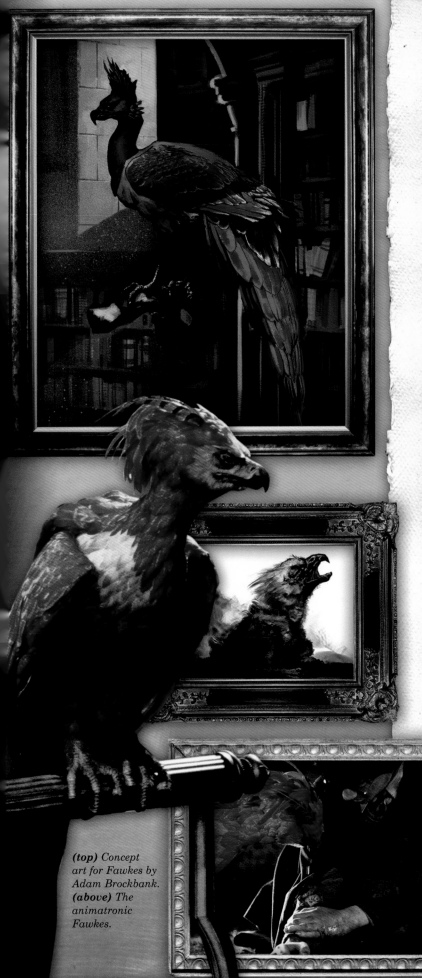

(top) Concept art for Fawkes by Adam Brockbank. (above) The animatronic Fawkes.

THE CHAMBER OF SECRETS

T he Basilisk's use of water pipes to move around Hogwarts castle inspired Stuart Craig to make the entrances and exits to the Chamber a series of tunnels. To get some inspiration, the team clambered down into a manhole in the heart of London and took a tour of the city's Victorian sewer system.

"The Chamber is a highly secret place within Hogwarts," says Stuart, "and it is very much Slytherin territory, so we decided that, like their common room, it was deep down—beneath the black lake." Because Hogwarts in the films is located amongst the hills and lakes of Scotland, the rock surfaces around the entrance to the Chamber were all made from molds taken from Scottish rock faces.

The labyrinth of tunnels provided a suspenseful setting for Harry's dangerous game of hide-and-seek with the Basilisk. Stuart Craig describes the main set, with its monumental carved head of Salazar Slytherin, sculpted by Andrew Holder, and the avenue of open-jawed serpents as being "almost a Slytherin temple."

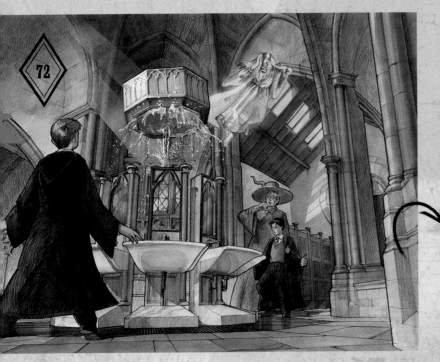

"It was awe-inspiring!" says producer David Heyman of the completed set. "It contributed greatly to the suspense of the scene and it was great for Dan because it gave him something to play against. It had to be intimidating and scary for Harry and yet, at the same time, it had to be a place that would inspire reverence on the part of some."

The Basilisk lurking within the Chamber was created using both digital animation and an animatronic model of the head and part of the neck for those shots where Harry fights the monster and finally stabs it through the jaw with the sword of Gryffindor.

The creature effects department built a twenty-five-foot-long, one-and-a-half-ton section of the Basilisk's body, with a foam

(above left) Concept art by Andrew Williamson. The design of the entrance to the Chamber of Secrets from the girls' bathroom required a moving set in which the washbasins could part "like the petals of a flower."

rubber skin and an interior made out of aluminum stepladders! Creature effects designer Nick Dudman explains: "The structures inside the neck were hexagonal and had to be braced with lengths of aluminum. Since we were going to be hurling it at our leading man, we needed to make it as light as possible. To do this we were going to have to drill a lot of holes in the aluminum. It was at that point that someone said, 'That's going to take a long time; why don't we just buy some stepladders?' So we did, cut them up, and used the side pieces that already had holes where the rungs had been attached!"

The circular door to the Chamber, with its complex arrangement of moving snake-shaped locking devices, is a triumph of both design and the ability to transform extraordinary visual concepts into working reality. The original designs for the door were given to special effects supervisor John Richardson, who then devised a method for building and operating it. Finally, the door was constructed by special effects supervising engineer Mark Bullimore. The final door and its mechanics are examples of a filmmaking craft that in this day and age is often replaced by computer-generated visual effects.

(above) Sculptors Bryn Court, Andrew Holder, and Roy Rodgers stand in front of the statue of Salazar Slytherin. (below) The Basilisk head.

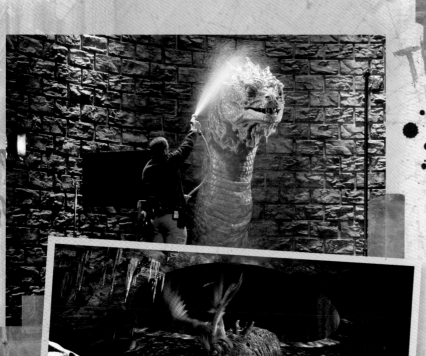

Neither the movie audience nor the filmmakers knew the significance of Harry stabbing Tom Riddle's diary with the Basilisk fang, because, at the time, J. K. Rowling had not yet explained the nature of Horcruxes.

Harry Potter and the Prisoner of Azkaban

"**H**arry Potter and the Prisoner of Azkaban," says producer David Heyman, "represented a seismic change in the film series."

It did indeed: a new director, a new Dumbledore, a mass of new characters, a new costume designer—and an adaptation for the screen of a densely packed novel that included a great deal of character history.

Although he intended to stay with the *Harry Potter* series until the end, director Chris Columbus felt unable to continue with *Azkaban*. "The schedules," he says, "were exhausting. There was no way I could get through a third picture without taking some time off and there *was* no time to be taken off, so that was really the end of it for me."

While Chris remained on the project as a producer, Academy Award-nominated Mexican filmmaker Alfonso Cuarón took over as director. "When I was approached," says Alfonso, "I was very ignorant about *Harry Potter*—I hadn't seen the films, I hadn't read the books, and I dismissed the whole thing." What changed his mind was a telephone conversation with his friend and fellow director, Guillermo del Toro. When Alfonso revealed that he had been sent the *Harry Potter* books but was unsure whether or not to get involved, his friend, frankly, questioned his sanity and told him to read the books "immediately!" Alfonso says he then "read the three books in one week and [instantly] fell in love with the whole universe."

With the third film, Alfonso continued the transformation process begun by his predecessor. "By the time we hit *Prisoner of Azkaban*," notes Chris, "the color was seeping out of the world a little bit and things were getting darker and drearier."

The film was not all dark, however—despite the threat posed by Azkaban-escapee Sirius Black and the menacing presence of the Dementors at Hogwarts. From the violently purple Knight Bus with its talking shrunken head to the roller-skating spider/Boggart in Defense Against the Dark Arts to the vividly hued inventory and décor in Honeydukes—the third film contained plenty of humor and color.

The third film also incorporated certain architectural changes to Hogwarts castle, and Hagrid's hut acquired an additional space for his bedroom and moved to a new location reached by a covered bridge linking the castle to the grounds.

In what would prove a significant decision for the series, Alfonso brought award-winning costume designer Jany Temime onto the project to create a new, more mature look for the young actors and to give added richness to the film's texture. Describing her philosophy of design, Jany says: "It is always two worlds: the world outside the walls, which is hard, tough, and grey; and the world inside the walls, which is full of mystery, romance, and magic."

Alfonso has also been credited with resolving the dilemma of adapting such a large and complex book. "The solution to our struggles," recalls David Heyman, "was for us to focus on Harry's central narrative." David admits that it "killed" him every time they had to exclude any element of Jo's books, but that the decision to focus on Harry's story "helped define a more cinematic structure."

There was, nevertheless, a lot of material to accommodate, much of it surrounding the introductions of Sirius Black, Remus Lupin, and Peter Pettigrew, and a need for audiences to understand how they were connected with Harry's parents and Voldemort's attack on the Potter family.

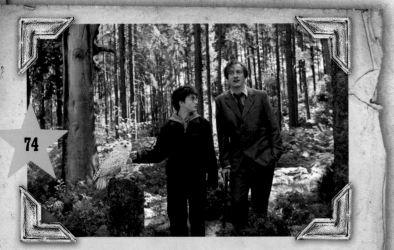

Harry (Daniel Radcliffe) and Professor Lupin (David Thewlis) discuss Harry's past.

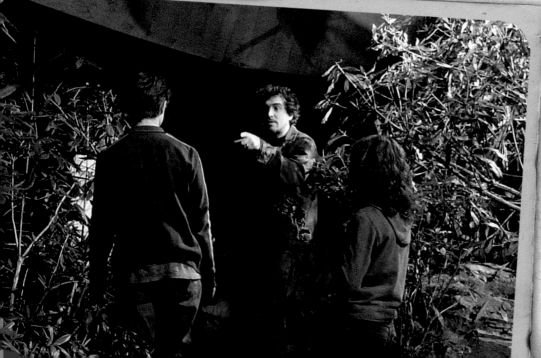

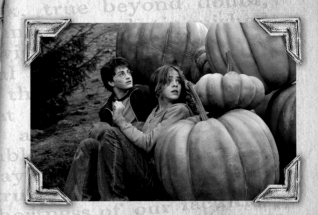

(left) Alfonso Cuarón directs Daniel Radcliffe and Emma Watson. (above) After going back in time, Harry (Daniel Radcliffe) and Hermione (Emma Watson) hide outside Hagrid's hut.

Looking back on the casting of Sirius, Alfonso says: "Throughout the whole first part of the film the villain is Sirius Black. And then there's a twist when you realize that actually Sirius Black has been a good guy all along. Not only that, but he's going to become the new father figure for Harry. So, we needed an actor who could play danger and who could then embrace the tenderness and affection of this character toward Harry. It was an immediate decision to go with Gary Oldman."

Joining Gary for the scene in the Shrieking Shack (a set that was designed and built to quiver and quake) were Timothy Spall as Pettigrew (or to use his nickname, Wormtail), and David Thewlis as Lupin, the new Defense Against the Dark Arts teacher, who is trying to conceal the fact that he is a werewolf.

Describing the relationship in the film between Harry and Lupin, Alfonso says: "We would always find a reference in the universe that we know, so it was never about a kid hanging out with a werewolf; it was this kid who hangs with his favorite uncle who just happens to have this terrible disease."

Among other cast members making their debut were Pam Ferris as the monstrous Aunt Marge, Emma Thompson as Hogwarts' distracted Divination teacher, Sybill Trelawney, and Julie Christie as Madam Rosmerta of the pub, the Three Broomsticks.

There was also an unexpected cast change necessitated by the death of Richard Harris. "It was a big blow for the whole production," recalls Alfonso, "and there was a long process of mourning." Eventually, however, Hogwarts' headmaster had to be recast, and Sir Michael Gambon took over the role.

When J. K. Rowling was asked at Scotland's Edinburgh International Book Festival in 2004 which of the films released to date was her favorite, she replied: "Of the three, *Azkaban* is my favorite. I thought it was really good for a lot of different reasons. I thought that Alfonso Cuarón . . . did a fantastic job and Dan, Emma, and Rupert . . . were really wonderful in the film."

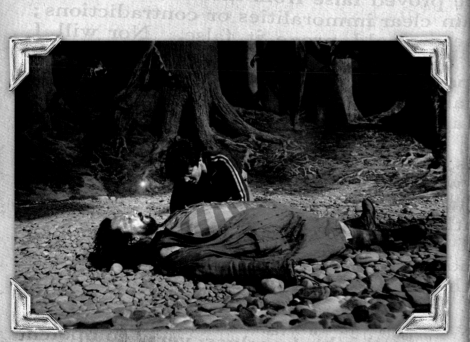

Harry (Daniel Radcliffe) watches in vain as Sirius Black (Gary Oldman) is attacked by Dementors.

TOM FELTON
LOOKS BACK

In *Harry Potter and the Prisoner of Azkaban*, Tom Felton's character, Draco Malfoy, gets hurt when he insults a Hippogriff and has to be carried to the hospital wing by Hagrid (Robbie Coltrane). "Hagrid has to pick me up," Tom explains, "and for that to work size-wise they had to build a miniature model of me that was 30 percent smaller than myself." The model of a smaller Draco successfully gave the illusion of a larger Hagrid, but not without some unforeseen consequences.

"My mum was there that day," says Tom, "and I was like, 'Wow, look at me! It's me lying dead on the floor!' My mum was just horrified. She nearly went faint. I was asking whether we could take it home," he laughs. "I thought it was a brilliant thing to put in your bed. You know, pretend you're sleeping and make a run or something like that. But she was not impressed at all, she was horrified—which is a credit to the people who made it. Obviously it did look just like me if it managed to scare my mum!"

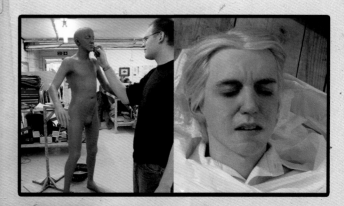

THE GRAND STAIRCASE

PRODUCTION DESIGNER'S NOTEBOOK

Name: *Stuart Craig*

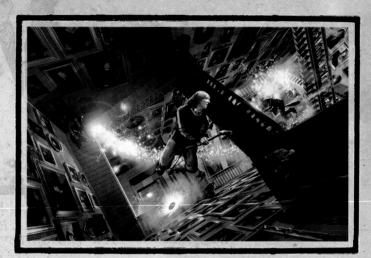

Conceptual art by Andrew Williamson of Fred and George Weasley flying through the stairs and landings of Hogwarts: a scene which emphasizes the fantastic height and depth of the grand staircase.

In bringing the *Harry Potter* books to the screen, we have had to visualize and make real all kinds of highly unusual things—such as the moving staircases in Hogwarts. To have a staircase swing through ninety degrees from one wall to another wall on another level was quite a complicated piece of geometry! To bring this idea to life, we created a vast stairwell made up of staircases that formed the four sides of a square. Those staircases then led to four sides of another square above or below. It's easier to draw than to describe—and it wasn't easy to draw!

I always try to find a single strong idea around which to base the design for a set. With the grand staircase, that idea was to use Jo Rowling's concept of magical portraits. I realized that if we lined the stairwell with portraits in huge numbers, they would make an enormous impact. As production designer, I've been in charge of manufacturing all those props that are unique to the world of *Harry Potter*. A vital part of that job has been overseeing the creation of these paintings. There have been six artists painting these portraits, using various techniques to produce a host of pictures that range in style from medieval art to nineteenth-century Victorian. Their subjects range from classical themes to specific members of the *Harry Potter* cast.

These still portraits are used as reference by the visual effects department to create the animated portrait sequences you see in the films. There's a particularly effective scene in *Harry Potter and the Prisoner of Azkaban* when the Fat Lady who guards the door to the Gryffindor common room goes missing, causing a commotion not just among the staff and pupils, but also among the inhabitants of the other portraits. During this sequence, we see characters moving from one painting to another. At one point, we glimpse a giraffe with its head in one portrait, and a few seconds later, the giraffe's feet appear in another painting farther down the wall! We began with a concept, then created environments through which the giraffe could move.

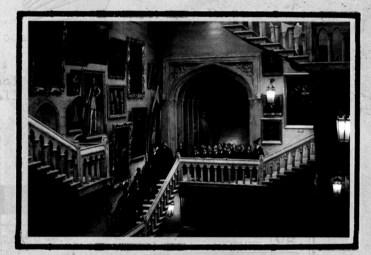

The grand staircase is one of the most magical aspects of Hogwarts castle. Not only do the stairways move, but the subjects in the paintings that line the walls move as well.

Classic paintings in the Muggle world inspired many of the Hogwarts portraits, and some of them feature likenesses of people working on the film. Detailed charts were kept to ensure that portraits were always correctly hung in relation to other pictures and to the stairways that pass them.

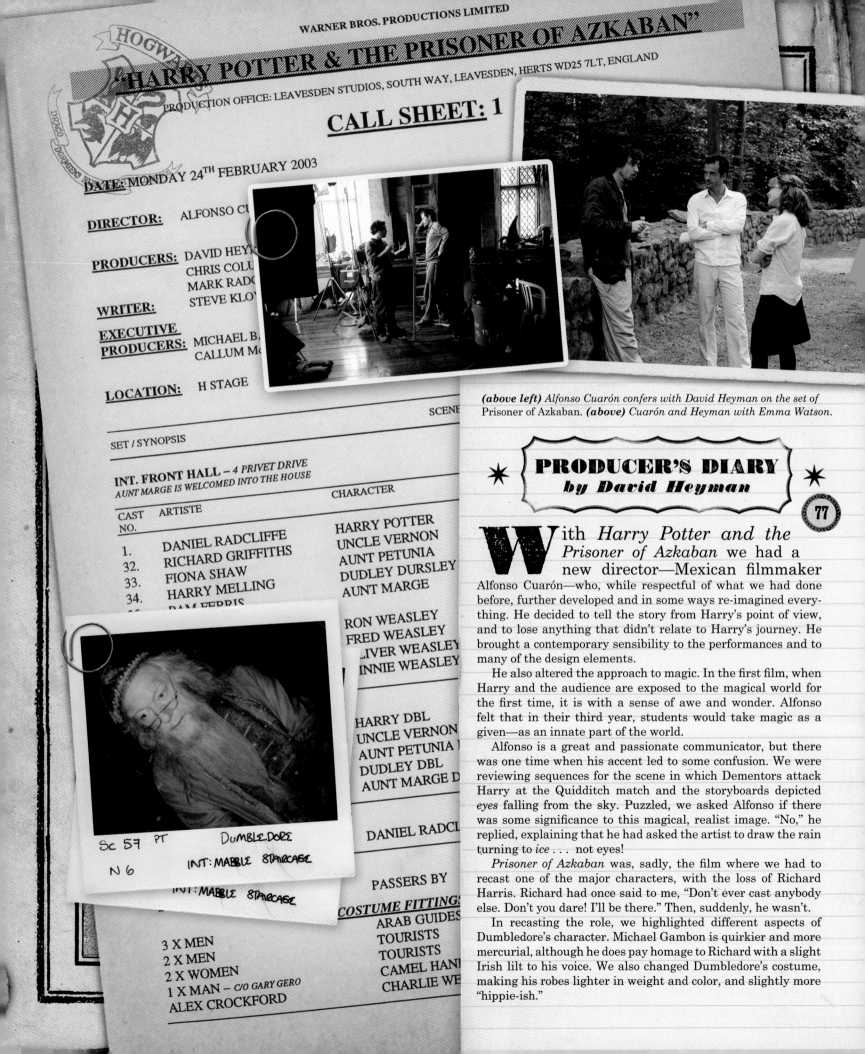

WARNER BROS. PRODUCTIONS LIMITED

"HARRY POTTER & THE PRISONER OF AZKABAN"

PRODUCTION OFFICE: LEAVESDEN STUDIOS, SOUTH WAY, LEAVESDEN, HERTS WD25 7LT, ENGLAND

CALL SHEET: 1

DATE: MONDAY 24TH FEBRUARY 2003

DIRECTOR: ALFONSO CU...

PRODUCERS: DAVID HEY...
CHRIS COLU...
MARK RAD...

WRITER: STEVE KLO...

EXECUTIVE PRODUCERS: MICHAEL B...
CALLUM Mc...

LOCATION: H STAGE

SCENE...

SET / SYNOPSIS

INT. FRONT HALL – 4 PRIVET DRIVE
AUNT MARGE IS WELCOMED INTO THE HOUSE

CHARACTER

CAST NO.	ARTISTE	
1.	DANIEL RADCLIFFE	HARRY POTTER
32.	RICHARD GRIFFITHS	UNCLE VERNON
33.	FIONA SHAW	AUNT PETUNIA
34.	HARRY MELLING	DUDLEY DURSLEY
	PAM FERRIS	AUNT MARGE
		RON WEASLEY
		FRED WEASLEY
		...LIVER WEASLEY
		...INNIE WEASLEY
		HARRY DBL
		UNCLE VERNON
		AUNT PETUNIA ...
		DUDLEY DBL
		AUNT MARGE D...
	DANIEL RADCL...	

PASSERS BY

COSTUME FITTINGS
ARAB GUIDES
TOURISTS
TOURISTS
CAMEL HAN...
CHARLIE WE...

3 X MEN
2 X MEN
2 X WOMEN
1 X MAN – *C/O GARY GERO*
ALEX CROCKFORD

Sc 57 PT DUMBLEDORE
N 6 INT: MABBLE STAIRCASE
INT: MABBLE STAIRCASE

(above left) *Alfonso Cuarón confers with David Heyman on the set of* Prisoner of Azkaban. (above) *Cuarón and Heyman with Emma Watson.*

✳ PRODUCER'S DIARY ✳
by David Heyman

With *Harry Potter and the Prisoner of Azkaban* we had a new director—Mexican filmmaker Alfonso Cuarón—who, while respectful of what we had done before, further developed and in some ways re-imagined everything. He decided to tell the story from Harry's point of view, and to lose anything that didn't relate to Harry's journey. He brought a contemporary sensibility to the performances and to many of the design elements.

He also altered the approach to magic. In the first film, when Harry and the audience are exposed to the magical world for the first time, it is with a sense of awe and wonder. Alfonso felt that in their third year, students would take magic as a given—as an innate part of the world.

Alfonso is a great and passionate communicator, but there was one time when his accent led to some confusion. We were reviewing sequences for the scene in which Dementors attack Harry at the Quidditch match and the storyboards depicted *eyes* falling from the sky. Puzzled, we asked Alfonso if there was some significance to this magical, realist image. "No," he replied, explaining that he had asked the artist to draw the rain turning to *ice* . . . not eyes!

Prisoner of Azkaban was, sadly, the film where we had to recast one of the major characters, with the loss of Richard Harris. Richard had once said to me, "Don't ever cast anybody else. Don't you dare! I'll be there." Then, suddenly, he wasn't.

In recasting the role, we highlighted different aspects of Dumbledore's character. Michael Gambon is quirkier and more mercurial, although he does pay homage to Richard with a slight Irish lilt to his voice. We also changed Dumbledore's costume, making his robes lighter in weight and color, and slightly more "hippie-ish."

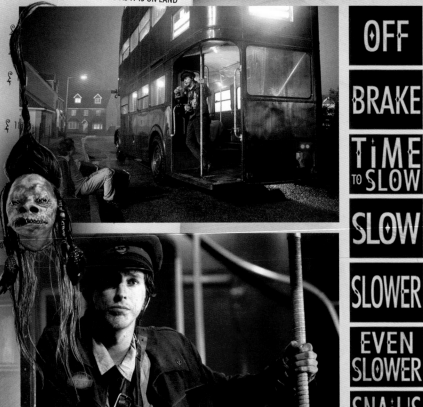

OFF

BRAKE

TIME TO SLOW

SLOW

SLOWER

EVEN SLOWER

SNAIL'S PACE

THE KNIGHT BUS

In London, the night bus service continues to run after the Underground rail network has closed—effectively keeping Muggles from getting stranded. As we learn in the third book and film, witches and wizards stranded in the London area have their own designated *Knight* Bus service.

The bus featured in the film was specially built using components from a genuine London Transport Routemaster bus—a red, double-decker model first introduced in 1956 that remained in service for almost fifty years. As the Knight Bus is a triple-decker, John Richardson's special effects department cut the top off the Routemaster, added an additional level, put the top deck back on, and had it repainted purple. A second Knight Bus was constructed for stunt work using another rebuilt Routemaster. This double was fitted onto the chassis of a commercial coach that had an engine powerful enough to pull two tons of added lead weight—necessary to counterbalance the extra height so that it didn't tip over when going around corners.

One of the logistical problems encountered when filming with the Knight Bus was getting it to and from the various locations in London. "We had a team with a crane permanently on call," John explains. "We'd have to take the top off, transport the bus, the top, and the crane, and then put it all back together again before we could start filming!"

A studio set for the interior of the bus was built on a moving gimbal so that it could be rotated and tilted to mimic the Knight Bus's erratic movement. The interior was fitted with sliding bedsteads, a swinging chandelier, and the now-iconic talking shrunken head—an addition to the films that J. K. Rowling approved of heartily, saying, "I wish I'd thought of that."

KNIGHT BUS

XT: PLAY GROUND

RIUS BLACK
MAN HUNT

Gary Oldman as
SIRIUS BLACK

A ctor Gary Oldman describes his cha-racter, Sirius Black, as "a man very much haunted, living in the past and emotionally rooted in the old days. Harry is so like James, who was my friend—whom I adored—so I am living a friendship through him and wanting him to be like James."

The special relationship between Sirius and his godson is one that, for Gary, requires very little acting: "There is obviously some special relationship there but it isn't hard to play because, you see, I love Dan. So, I just use what's already there. We're just appreciating a relationship that we have off-screen."

The feeling is evidently mutual. In a 2004 interview, Daniel Radcliffe said "I watched 90 percent of Gary Oldman's films and I just have so much respect for him as an actor. He's one of the greatest of his generation. It was a complete inspiration to work with him. He's actually the nicest guy as well."

Gary first portrayed Sirius Black in *Harry Potter and the Prisoner of Azkaban* as a wanted man who has just escaped from Azkaban prison. "I've been there for twelve years," he says, "and by the look of me, one can only imagine what life is like in Azkaban. I'm a disheveled, undernourished wreck—a guy in need of some dental work, a shave, and some decent clothes."

By his third appearance in the series in *Order of the Phoenix,* Sirius still has long hair, but it is now clean and he has a carefully manicured beard. An elegant velvet suit has replaced the prison uniform and borrowed coat. But, while his outer appearance is transformed, his inner emotions and his renegade personality remain unchanged.

"There's a kind of rock 'n' roll quality about Gary," says *Phoenix* director David Yates. "That's how he's interpreted the role and you can almost imagine him growing up in the sixties. He's not that old, but he kind of feels like he's been there forever!"

(below) The "WANTED" poster of Sirius Black was widely featured in advertising campaigns for Prisoner of Azkaban.

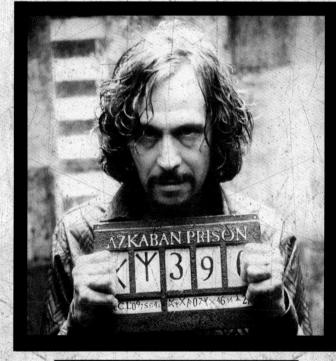

HAVE YOU SEEN THIS WIZARD?

APPROACH WITH EXTREME CAUTION!
★ **DO NOT ATTEMPT TO USE MAGIC AGAINST THIS MAN!** ★

Any information leading to the arrest of this man shall be duly rewarded

Notify immediately by owl the Ministry of Magic - WitchWatchers Dept.

28A HARRY IS SLAMMED INTO UNDERPASS WALL.

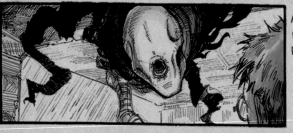

29A ANGLE OVER HARRY ONTO DEMENTOR.

30A. OVER DEMENTOR ONTO HARRY.

AS DEMENTOR STARTS FEEDING

HARRY LOOKS OFF RIGHT.

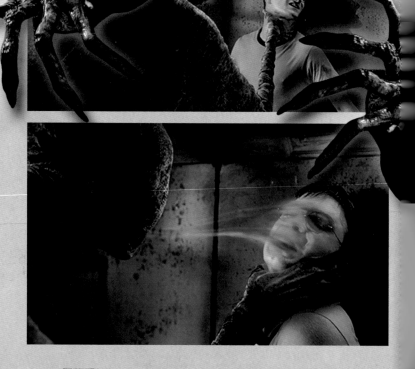

DEMENTORS

"**D**ementors are among the foulest creatures that walk this earth," Remus Lupin tells Harry in J. K. Rowling's book *Harry Potter and the Prisoner of Azkaban*. "They infest the darkest, filthiest places, they glory in decay and despair. . . ."

For the third film in the series, the terrifying nature of the creatures described in the book had to be visually conveyed on-screen. "The Dementors," says executive producer Mark Radcliffe, "were probably the scariest element that we had to deal with. You're talking about something sucking out your soul and leaving you lifeless."

The look of the Dementors began with director Alfonso Cuarón's initial vision for shrouded, spectral creatures—with arms, but no legs—hovering in the air. Concept artist Rob Bliss created a series of images in which the Dementors' robes became more of a veil, or a semi-translucent skin, revealing the shape of their skulls and skeletal torsos. Experimental models were also made with various materials used for the shrouds. Searching for ways to give the Dementors a unique floating movement, the filmmakers turned to the talent of American puppeteer Basil Twist, who had created underwater puppet performances.

Creature workshop supervisor Nick Dudman recalls: "We did various underwater tests with puppets at different scales, filming forwards and backwards and at different speeds. But it became very difficult to replicate movements. We'd get a really nice move and a weird look and then realize that we couldn't do it again."

As a result of these experiments, the filmmakers decided to create the Dementors using computer-generated imagery. However, as Alfonso explains, the research was not wasted: "Although we had proved that it was going to be pretty much impossible to do what we wanted to do with puppeteers, the amazing thing was that we had the look we wanted. So we used all the puppeteers' reference so the visual effects artists would have a perfect sense of what kind of movement and textures we wanted to achieve."

As they eventually appear on-screen, the Dementors—whether invading the Hogwarts Express or hanging in the night sky around the castle—perfectly convey the fearsome creatures that, in Professor Lupin's words, "drain peace, hope, and happiness out of the air around them."

BUCKBEAK

"One of the finest effects was Buckbeak flying," says actor Robert Hardy, who plays Minister for Magic Cornelius Fudge. "I thought that was pure magic!" That magic, however, took some time to master for the third film.

The process began with designs by concept artist Dermot Power. After Dermot's designs were approved, the challenges became technical—and *anatomical*. As executive producer Mark Radcliffe explains: "One of the first things we did was go to the computer and ask, 'Okay, if it's a horse back-end with bird front legs, how does it move, how does it run, and how does it fly? Just how wide do the wings have to be to carry a creature the size of a horse?'"

The sculptors in Nick Dudman's creature shop built a series of maquettes, or scale models, for director Alfonso Cuarón, and then a life-sized animatronic Buckbeak, complete with a full set of feathers and simulated horsehair. This figure was then cyber-scanned for the computer graphics animators who would be responsible for bringing the Hippogriff to life in post-production.

"It was very challenging," says Alfonso, "because the interaction with the characters was a little tricky. They not only had to touch Buckbeak, but Sirius Black and Hermione and Harry had to ride him. A lot of attention went into how we could give the Hippogriff a sense of weight. And once we got the main elements, it became more about animating the character and making it something that would be realistic. I mean, it's so realistic that if people watch carefully in

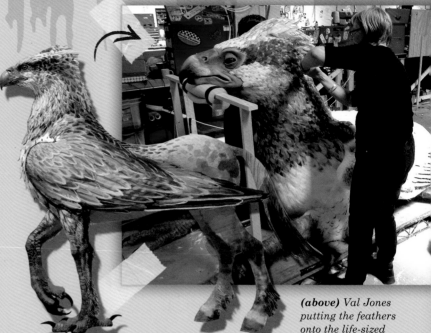

(above) Val Jones putting the feathers onto the life-sized Hippogriff.

(above) Concept art by Dermot Power.

the paddock scene, Buckbeak poos! It's not a big deal; it's just a matter-of-fact thing that he does."

It is this effort to be completely authentic that Mark finds so impressive: "When you see Buckbeak in the movie and he's placed in the live-action scene, matching the light of the set with how the light falls onto the Hippogriff, and the shadow movement in relation to the other actors, it is seamless."

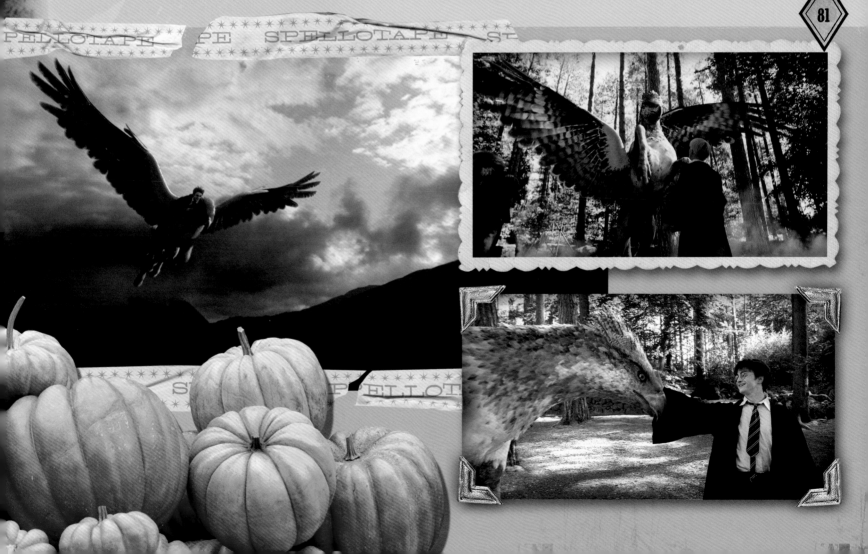

THE VILLAGE OF
HOGSMEADE

"**H**ogsmeade," wrote J. K. Rowling in *Harry Potter and the Prisoner of Azkaban*, "looked like a Christmas card." And that is how it has appeared in all the *Harry Potter* movies.

"We made the decision that Hogsmeade is permanently above the snow line, so we always see it in snow," says Stuart Craig. "It has a feeling of Christmas . . . It's cold and rugged on the outside, but all the shop windows—Honeydukes, Dervish and Banges, Zonko's, and the others—are warm and inviting and full of magical things."

The Hogsmeade that appears in the *Harry Potter* films is sometimes a series of full-sized sets with practical or digital models used for the wider establishing shots. Parts of the High Street, the shops and inns, even areas of the neighboring landscape such as the fenced-off fields leading to the Shrieking Shack, were built to scale. Everything was then smothered in a blizzard of artificial snow.

82

Micro-window displays for village shops with a British £1 coin for size comparison.

Concept art for Hogsmeade by Andrew Williamson.

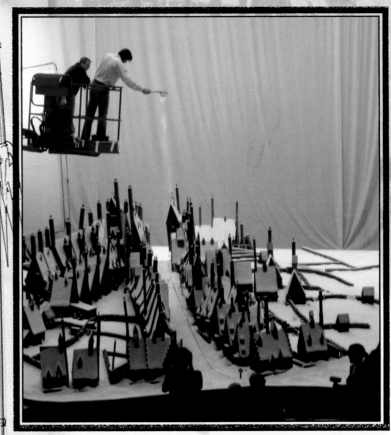

Adding snow to the Hogsmeade village miniature with a kitchen sieve!

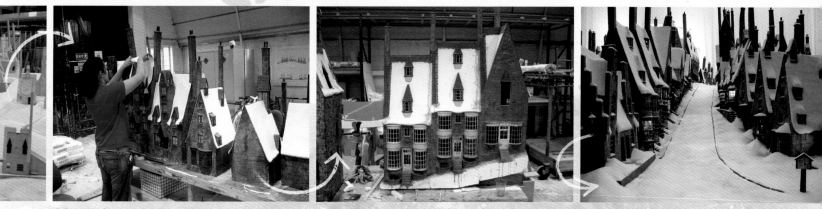

(above left to right) The miniature model of Hogsmeade from beginning of construction to completion. **(below)** The full-sized Hogsmeade set.

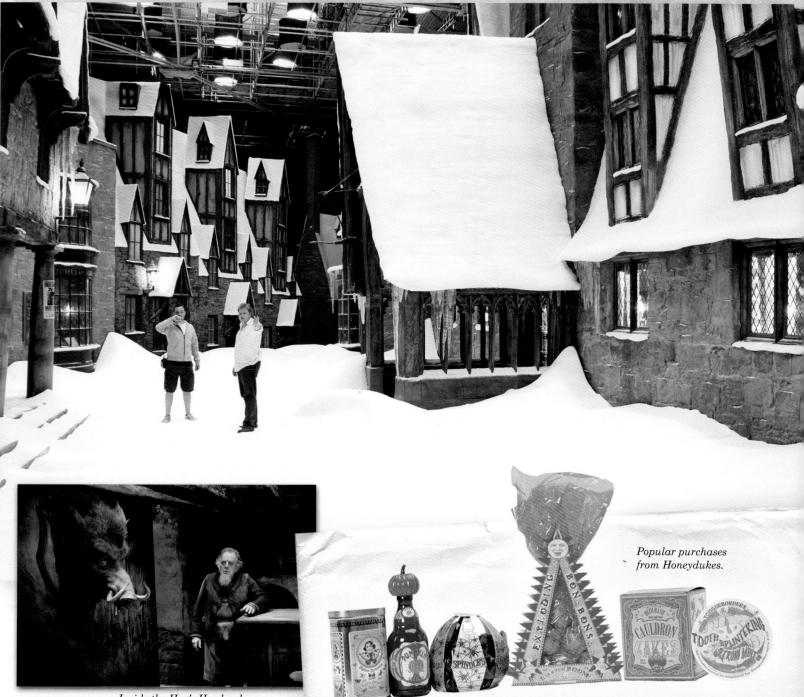

Inside the Hog's Head pub.

Popular purchases from Honeydukes.

HOGSMEADE

CONTINUED...

The Hogsmeade buildings were constructed using seventeenth-century Scottish architecture as a main point of departure. The town is essentially a series of granite houses, several stories high, with tiny dormer windows and steeply pitched roofs that are adorned with towering chimney stacks and what are called "crow-step gables."

It was decided early on that all the buildings in Hogsmeade would lean, and that there would be no right angles. "There wasn't a vertical wall in sight," says assistant art director Gary Tomkins. "Every building was twisted, skewed, or bent with every one of them leaning in a different way to the building next door! We had endless discussions about how a doorframe would shift or a window would tilt."

These characteristics were all adapted to a miniature model (as well as a digital model) of Hogsmeade, which was needed for the establishing shots of the village. All the buildings, lit by tiny bulbs, were replicated complete with tiny goods in the shop windows. The snow on the model was created using a product called dendritic salt. Unlike ordinary table salt, which has cube-shaped grains, dendritic salt is made up of star-shaped crystals that allow it to fall and lie like snow. It's so convincing, it even squeaks like freshly fallen snow if you step on a new layer of it.

The model may be seen on-screen for only a few seconds, but the model makers went to great lengths to make it as authentic as possible. "We made up two sticks with little feet to scale and then 'walked' footprints through the snow coming out of some of the doors and going up the street," says Gary. "We even made up some dog footprints so that someone could walk a dog through the village!"

84

DARK BROWN BLINDS

DERVISH & BANGES

DARK GREEN SLUDGEY

(above) Scale drawing of Dervish and Banges by art director Al Bullock. (below) Concept art of Cornelius Fudge arriving at the Three Broomsticks by Andrew Williamson.

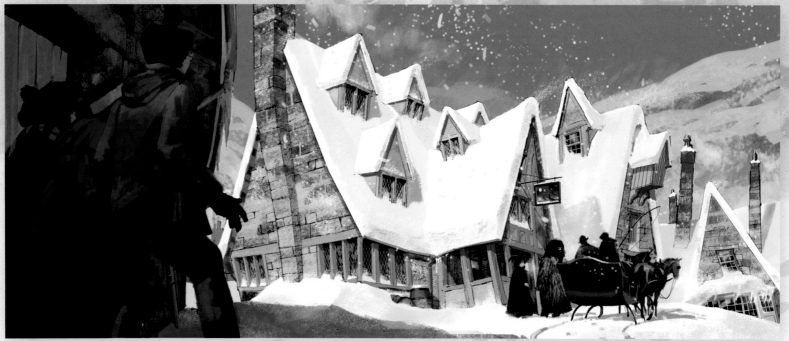

Bonnie Wright as *Ginny Weasley*

Before reading *Harry Potter and the Half-Blood Prince*, Bonnie Wright would have never guessed how the friendship between Ginny Weasley and Harry Potter was going to develop. "That was quite a shock!" she says. "People who read more speedily than I do were saying, 'Oh, my goodness! Have you got to page blah-blah-blah?' And I was saying, 'No! Don't tell me! Please, please, don't tell me!'"

Looking back to 2000, Bonnie remembers how she came to be cast as the only girl in the Weasley family. "My brother, Lewis, had read the books and really enjoyed them, and he saw in the papers that they were holding auditions for *Harry Potter and the Sorcerer's Stone*. He said that I really reminded him of the character of Ginny Weasley, so I asked my mum, 'Can I get an audition?'" Two auditions later, Bonnie had the role.

Describing her on-screen character, Bonnie says, "Because she's had to grow up with all of those older boys, I think she's not a really 'girly' girl." And looking at how the character has changed through the series, she adds: "Her confidence grows. In the first films, she's very shy and runs away from everything, but as she becomes more confident she has this sense of fearlessness—and she'll fight."

Bonnie went from a bit part in the first film to a major part of the plot in the second, and says she learned a lot about acting in a short amount of time. Becoming romantically linked to Harry in *Half-Blood Prince* was another milestone for the character and an interesting experience for Bonnie. "[Dan and I] have known each other for so long, that was weird," she told *Seventeen* magazine about filming their kiss in the Room of Requirement. "On the actual day it all seemed to be okay. You just kind of treat it like any other scene."

Bonnie is very aware that, for the cast, the end of the *Harry Potter* series is in sight. "It's been such an important part of all of our lives," she says, "that I don't think any of us will ever forget it, or ever leave *Harry Potter* behind—the memories are too strong for all of us."

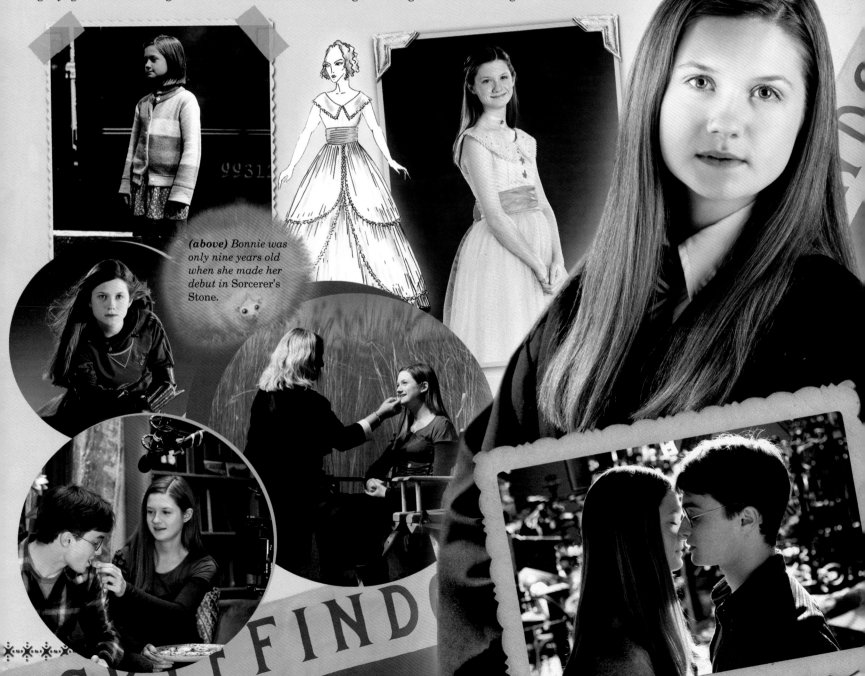

(above) Bonnie was only nine years old when she made her debut in Sorcerer's Stone.

David Thewlis as
REMUS LUPIN

Actor David Thewlis describes his character Remus Lupin as "kindly," "lovable," and "avuncular." He notes, however that Lupin also has a "terrible, dark secret"—that he was bitten by Fenrir Greyback as a child and consequently became a werewolf.

A huge fan of the *Harry Potter* books, David would often refer to them for insights into his character and the story. "We'd always have the book on the set," he says. "There is so much more in the book, and I was always going back to it, underlining and learning passages."

Specifically, David believes that the difficulties Lupin has experienced make him a sympathetic and caring teacher. As Lupin begins training Harry to protect himself against the Dementors, David describes him as "a great comfort" to his student. Those scenes were part of what drew David to the role. "Most of the scenes are conversational ones with Harry," he says, "and I really enjoy doing one-on-one scenes with Daniel Radcliffe."

When Harry and the audience first meet Lupin, the new Defense Against the Dark Arts teacher is down on his luck—and his costume reinforces that fact. "It is a little bit tweedy," says Jany Temime, "with an academic gown that is rather shabby and dirty. A typically English university look, except the gown has pointed collars to make it 'wizardy.'"

In J. K. Rowling's books, Lupin describes the process of turning into a werewolf as "very painful," and the process of becoming an on-screen werewolf was less than comfortable for the actor—involving hours in the makeup chair. "It took an awful long time," David recalls. "But the initial change is quite subtle and I spent only one day in the full makeup." The prosthetic makeup used on David was then transferred to a nine-foot-high animatronic puppet, operated from the inside by a performer on stilts. In its final phase, the werewolf was fully computer-animated. According to David, watching himself become a werewolf was an interesting experience, to say the least.

(above) Concept art for Remus as a werewolf by Adam Brockbank. *(above & right)* Round lantern slides by Rob Bliss for Snape's lecture on lycanthropy.

THE BOGGART

In the third film, Hermione describes Boggarts as ". . . shape-shifters. They take the shape of whatever a particular person fears the most."

Lupin's Defense Against the Dark Arts lesson on how to use the *Riddikulus* charm to repel a Boggart combines horror and comedy. The Boggart appears to the students as, among other things, a giant spider, a snake—and, in Neville Longbottom's case, Professor Snape. Since the *Riddikulus* charm requires its user to force their Boggart to assume a comical form, Neville visualizes Snape dressed in Neville's grandmother's clothes.

David Thewlis laughs as he recalls filming that scene. "I think it was Alan Rickman's worst fear!" Asked in an interview what Snape would have thought, Alan replied: "Snape isn't one who enjoys jokes—I strongly fear that his sense of humor is extremely limited."

The Art Nouveau–style wardrobe holds a Boggart that can take on any form, including a giant cobra that, with the aid of the Riddikulus charm, becomes nothing more sinister than an oversized jack-in-the-box.

THE TIME-TURNER

"I began by looking at astrolabes and astrological instruments," says Miraphora Mina, who designed Hermione's Time-Turner. "I came up with a shape that is a ring within a ring. When it opens, the inner ring can spin. I also found some mottos about time that we had engraved around the outer ring." The Time-Turner is first used by Hermione to attend extra classes, but later she and Harry both use it to save Sirius Black and Buckbeak. "The chain was fitted with a double catch," Miraphora explains. "It could be undone and extended to fit around Hermione and Harry when they both have to go back in time."

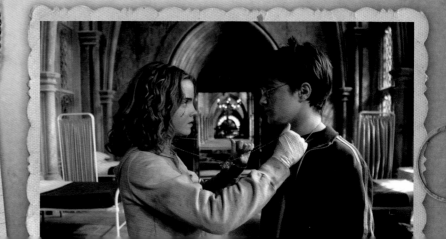

Harry Potter and the Goblet of Fire

"It is simply impossible," J. K. Rowling said on her official website, "to incorporate every one of my storylines into a film that has to be kept under four hours long."

"*Harry Potter and the Goblet of Fire* was the first time we considered splitting one of the books into two films," says David Heyman. "It was longer than the previous books; epic in its sweep and packed with story. Ultimately though, we decided that one film would serve the story best."

Mike Newell (the first British director on the series) thought the book "was a marvelous thriller," and that they could successfully "cut this enormous book down—squeeze it and squash it—into a two-and-a-half hour film."

Praising Steve Kloves's screenplay for its truthfulness and the "sharp, mean, little insights about what it's like to be fifteen," Mike also drew on the experience of his own childhood days at a private school as well as on a popular tradition of English school stories dating back to *Tom Brown's Schooldays*.

Goblet of Fire is the first film in the series not to open on Privet Drive. Instead it begins with an unexpected and disorientating night visit to the old Riddle family home where Voldemort and Wormtail are scheming to kill Harry Potter. Harry awakes from a terrifying

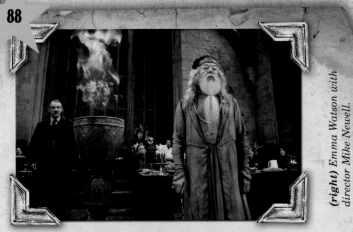

Dumbledore (Michael Gambon) stands beside the Goblet of Fire. Barty Crouch (Roger Lloyd Pack) is in the background.

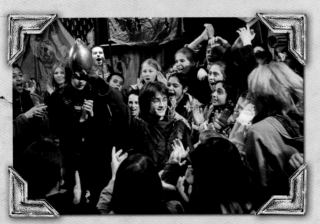

A celebration for Harry (Daniel Radcliffe) in the Gryffindor common room after the first task.

nightmare, leaving the audience wondering whether what we have just witnessed is Harry's dream, or reality. "Harry is a classic hero," says Mike Newell, "in that he begins the film not knowing that there is a desperate plot against his life . . . [but] finds out, a little bit at a time at roughly the same pace that the audience is finding out, so that their identification with Harry becomes even stronger."

The creative demands on the filmmakers were daunting: capturing the spectacle, however briefly, of the Quidditch World Cup and the chaos that erupts with the appearance of the Dark Mark, followed by all the complex sequences involved in putting the Triwizard Tournament on-screen. The tasks themselves involved more visual effects, special effects, and stunt work than in any *Potter* film to date.

(right) Emma Watson with director Mike Newell.

As the novels got longer, the amount of material cut for the screenplays also increased. Among the inevitable omissions from the film version of *Goblet of Fire* were the house-elves, Dobby and Winky, and the novel's subplot concerning Hermione's attempts to establish S.P.E.W. (the Society for the Promotion of Elfish Welfare). "That was disappointing for me," says David Heyman, "because I am a fan of the books, and it was a great story within the story; but, again and again, we were forced to remember that it was Harry's story that we were telling. That was the only way to give the films some form of cinematic structure."

Harry got a love interest (for the moment unrequited), Cho Chang, while Ron and Hermione's friendship seemed to be affected by the pangs of adolescence (and Quidditch star Viktor Krum's interest in Hermione). Emotions come to a bursting point during the spectacular Yule Ball scene—a triumph of set, prop, and costume design, crowd control, and romantic comedy.

In the film, the audience is introduced to other wizarding schools besides Hogwarts—namely Durmstrang Institute and Beauxbatons Academy of Magic. Clémence Poésy (Fleur Delacour), Stanislav Ianevski (Viktor Krum), and Robert Pattinson (Cedric Diggory) portrayed the three Triwizard champions, while Pedja Bjelac and Frances de la Tour played the heads of Durmstrang

Concept art for a robed Voldemort by Paul Catling.

and Beauxbatons, respectively. The film also provided Miranda Richardson with an opportunity for a dazzling cameo performance as *Daily Prophet* reporter Rita Skeeter.

The most notable new cast member, however, was certainly Ralph Fiennes, who took on the role of Harry's nemesis, Lord Voldemort. Prior to *Goblet of Fire*, Voldemort had only been seen as a phantom of his former self. Now that he was to return to power (and to his former body), the filmmakers needed an actor who had, as David Heyman puts it, "the ability to capture the mythic quality crucial to establishing the Dark Lord's legendary status as the most evil wizard of all time."

With the climactic confrontation between the Dark Lord and "the boy who lived," the *Harry Potter* film series entered a new phase.

WARWICK DAVIS
✳ LOOKS BACK ✳

Filming the Yule Ball scenes in the fourth film was exciting for the entire cast— but perhaps most perilous for Warwick Davis, who plays Professor Flitwick. "Flitwick introduces the band," Warwick explains, "and I said to Mike Newell, 'Wouldn't it be funny if, as he introduces them, he sort of dives into the crowd and crowd-surfs?' We all had a laugh. And then on Monday morning I come into work and he says we're going to do it. I said, 'Pardon?'" Mike, it turns out, had done research that weekend with stunt coordinator Greg Powell at a few clubs and thought the idea was great. Warwick "didn't have the heart" to tell him he'd been joking.

"So we set up this sequence," says Warwick, "and I did, as you see in the film, stage dive. They lined up some stunt boys in a certain arrangement who would be the ones that handled me." The experience was somewhat horrifying for Warwick. "I did get handled in some rather unfortunate areas," he laughs. "If you look very closely you can actually see my false teeth fly out of my mouth at one point and then come back in again!"

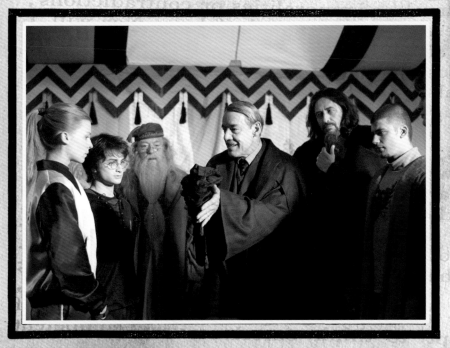

The champions prepare for the first task. From left: Clémence Poésy as Fleur Delacour, Daniel Radcliffe as Harry Potter, Michael Gambon as Albus Dumbledore, Roger Lloyd Pack as Barty Crouch, Pedja Bjelac as Igor Karkaroff, and Stanislav Ianevski as Viktor Krum.

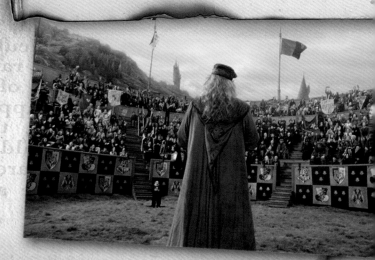

THE COURTROOM

PRODUCTION DESIGNER'S NOTEBOOK

Name: *Stuart Craig*

Detail of the Wizengamot courtroom showing the wall frescoes embellished with gold leaf.

The courtroom in the Ministry of Magic is first seen in *Harry Potter and the Goblet of Fire* when Harry falls into one of Dumbledore's memories (via the Pensieve) and witnesses the interrogation of Karkaroff and the exposure of Barty Crouch, Jr. as a Death Eater.

The architectural form of the set was dictated by Harry's vertical descent into the court. The effect we achieved is reminiscent of a goldfish bowl, focusing the viewer's attention on the victim being cross-examined. The theatrical staging, which encircles the person on trial with robed members of the Wizengamot in a tight bullring of a space, created a highly intimidating atmosphere.

Searching for a different look for this scene, we chose the architectural style developed in the Roman Empire during the fifth century as our inspiration. Known as Byzantine, after the ancient city of Byzantium that is now the modern-day Turkish city Istanbul, the style features multiple domes and round arches.

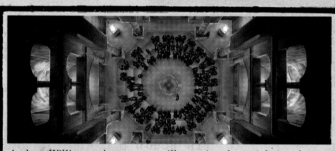

Andrew Williamson's concept art illustrating the aerial view down into the courtroom as seen by Harry when he looks into the Pensieve.

Between walls covered in cracked, peeling plaster and frescoes are tall marble columns embellished with gold that reflects the flames of the open fires. This atmosphere gives the feeling that the court has existed for thousands of years and is steeped in history, while the dark, rich, somber colors make it as threatening as possible.

The floor had two circular designs of inlaid marble, which we simulated using a centuries-old process employed in making covers and endpapers for hand-printed books. Different-colored oil paints are poured onto the surface of a large tray filled with water. The paint floats and is swirled around with a stick. When paper sheets are placed on the surface, they pick up the swirls of oil paint. Lifted and turned over, they look exactly like veined marble. This illusion was made complete with brushwork that added a further layer of textural detail to produce a convincing replica of a marble floor.

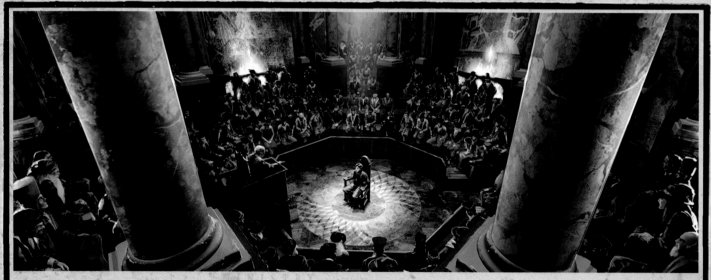

Concept art by Andrew Williamson emphasizing the "bullring" atmosphere of Harry's trial in Order of the Phoenix.

WARNER BROS. PRODUCTIONS LIMITED

"HARRY POTTER & THE GOBLET OF FIRE"

PRODUCTION OFFICE , LEAVESDEN STUDIOS, SOUTH WAY, LEAVESDEN, HERTS WD2 7LT, ENGLAND

CALL SHEET: 1

HOGWARTS

DATE: TUESDAY 4

UNIT CALL ON

BREAKFAST AVAIL. F

LUNCH IN CANTEEN I

DIRECTOR: MIKE NEWELL

PRODUCER: DAVID HEYMAN

WRITER: STEVE KLOVES

EXEC. PRODUCER: DAVID BARRON

LOCATION A STAGE

UPM: TIM LEWIS
PM: DAVID CARRIC
2ND AD: ROBERT P. GR

**ABSOLUTELY NO SMOKING IN STUDIO P

PLEASE WILL ALL CREW WHO HAVE NOT SUBMITTED A CO
THE PRODUCTION OFFICE PLEASE DO S

SET / SYNOPSIS	SC NOS	D
	9pt	D
INT. RON'S BEDROOM HARRY WAKES FROM A DREAM. HERMIONE JUST ARRIVES. RON COVERS HIMSELF IN BED.		
	CHARACTER	P/UP D/R
CAST ARTISTE	U6	

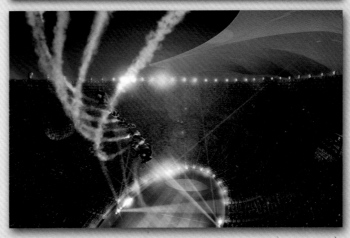

PRODUCER'S DIARY
by David Heyman

When Mike Newell, the director of the fourth film, said early on that he wanted to make a "Bollywood movie," co-producer David Barron and I almost fell off our chairs. We soon realized what he meant was that he was going to make a big entertainment film. The story has many elements: it's a drama, a thriller, a romantic comedy, and a spectacle—and Mike was equal to them all. He's a warm, bighearted man, with a great sense of humor. He understands the theatricality of a moment, yet never loses sight of the truthfulness needed to make it believable.

Mike was the first British director to work on the series, and the first to have actually attended an English boarding school. Consequently, he brought a tremendous humor and reality to the rituals, ceremony, and friendships at Hogwarts.

Voldemort makes his first fully embodied appearance in *Goblet of Fire*, and in the hands of Ralph Fiennes he is captured to perfection. Ralph exudes the cool ruthlessness of a man who has total disdain for love and humanity, and brings a power, complexity, and richness that anchors the dark side of the film.

THE QUIDDITCH WORLD CUP

IRELAND

BULGARIA

> ✳ *Quidditch World Cup supporters' tents may look ordinary on the outside, but inside they are fantastical pavilions.*

Although only a short segment of the fourth film, the events surrounding the Quidditch World Cup required a great deal of creative work to realize on-screen.

As a background location, Stuart Craig chose Beachy Head, a famous landmark on the southern coastline of Britain. At 530 feet above sea level, the chalk headland is the highest chalk sea cliff in Britain—the perfect site for the vast stadium that has to be invisible to the Muggle world.

Sections of the stands were built as studio sets, including the stairway where Harry and his friends encounter Lucius and Draco Malfoy and the official box from which Minister for Magic, Cornelius Fudge, opens the game. The stadium itself, with its thousands of spectators—along with the Irish team's mascot—was created entirely using computer graphics. The crowd wave heralding Krum's arrival was inspired by the elaborate audience waves that have become popular at Korean sports events.

Depicting the Quidditch World Cup as a truly massive event was key to the story: against such a backdrop, the brazenly public display of the Dark Mark clearly indicated the confidence of Voldemort's supporters.

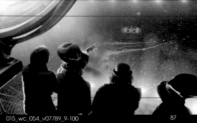

ILM wc_054 08/04/05
015_wc_054_v07789_9-100 10

ILM wc_054 08/04/05
015_wc_054_v07789_9-100 87

ILM wc_048 07/28/0
015_wc_048_v07076_1-227 104

422ND QUIDDITCH WORLD CUP

THE GREATEST MAGICAL EVENT OF THE

YEAR

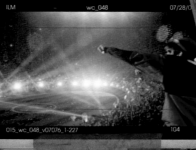

THE FINAL

> *An example of the film's attention to detail: a ticket and program for the 422nd Quidditch World Cup.*

THE DARK MARK

The Daily Prophet

Terror at the Quidditch World Cup

Dark Mark Ignites Unprecedented Wizard Panic

⚡ *(above) Concept art of the Dark Mark hovering above the campsite by Paul Catling. (bottom right) The Dark Mark, designed by Iain McCaig, and as a "transfer" on an actor's arm.*

"**E**veryone's worst fear," is how Arthur Weasley describes the Dark Mark in J. K. Rowling's book *Harry Potter and the Goblet of Fire.* Bringing the first manifestation of this terrifying symbol to screen was the task of the film's visual effects team. Their rendition of the sinister image of a skull with a snake coming out of its mouth appears in the night sky above the spectators' encampment following the 422nd Quidditch World Cup.

The Dark Mark symbol also appears on the arms of Voldemort's Death Eaters. Director Mike Newell wanted the Dark Mark to bubble up through the skin of Voldemort's followers as the Dark Lord got stronger. This was created through a combination of prosthetic makeup and visual effects. The Dark Mark began as a transfer that looked like a faint tattoo. As Voldemort gathered strength, the makeup artists would apply variations of a molded silicone skull-and-snake to each actor's skin, so the mark would appear incrementally more raised and angry-looking. (Ultimately, some of the snake's movement was created using digital effects.) "For the actors, it was quite a startling effect," recalls makeup artist Amanda Knight. "They suddenly realized what it would mean for their character as Voldemort began to get stronger, and they were able to use it in their performance."

Before being applied to the arms of Death Eaters, the Dark Marks are stored in the makeup room (along with a selection of cuts, grazes, assorted wounds, and snakebites) in a neatly stacked pile of—would you have guessed?—pizza boxes!

THE TRIWIZARD TOURNAMENT

Dating back to the thirteenth century, the Triwizard Tournament consists of a trio of tasks that test the bravery, intelligence, and magical prowess of three students from Europe's largest wizarding schools: Hogwarts School of Witchcraft and Wizardry, Beauxbatons Academy of Magic, and Durmstrang Institute. However, in *Goblet of Fire*, things don't exactly go according to tradition. "There's a huge uproar," says Daniel Radcliffe, "because not only do they have the three names: Cedric Diggory, Fleur Delacour, and Viktor Krum, but Harry's name comes out [of the Goblet] as well."

The actors cast to play Cedric, Fleur, and Viktor each needed to be able to embody their particular character's school and nationality. In the cases of Fleur and Viktor, this task was aided by sometimes elaborate costumes representative of the locations of their respective schools: Beauxbatons (France) and Durmstrang (Bulgaria).

French actress Clémence Poésy, who plays Fleur Delacour, describes her character as "graceful, and quite serious." She continues: "In a way, Fleur is what the English think a French girl would be. She's very chic and very 'Miss Perfect' all the time."

Fleur, her sister Gabrielle, and the other Beauxbatons girls arrive at Hogwarts in a distinctive uniform created by French costume designer Jany Temime. "I chose a French blue, which I thought was perfect because everything in Scotland is green, brown, and grey and to have that light blue was so different."

94

(right) Concept art for the Beauxbatons carriage.

Bulgarian actor Stanislav Ianevski thinks of his character, Viktor Krum, as "a manly boy; more a physical being than talkative." The Durmstrang costumes, designed to define the personality of the school and its students, were helpful to the actors. As Stanislav explains: "I really enjoyed filming Viktor Krum's entrance into the Great Hall. As soon as I put that big fur coat on, I become more powerful in terms of the character."

The official Hogwarts champion, Hufflepuff Cedric Diggory, is played by Robert Pattinson. "Cedric is a pretty nice guy," says Robert. "He's honest and he plays fair." Cedric, of course, wears the Hogwarts school uniform and the house colors of Hufflepuff.

For the underage Harry, being chosen by the Goblet of Fire is anything but an honor. "He's immediately back in the limelight again," explains Daniel Radcliffe. "When his name comes out of the Goblet of Fire, he instantly knows that everyone suspects him of some kind of foul play. Because he knows he didn't put his own name in the Goblet, someone else must have done it so that he will get killed."

(right) The fantastically carved Goblet of Fire, designed by graphic designer Miraphora Mina and carved in the prop-manufacturing department. "The idea," says Miraphora, "was that it had been sculpted, but you weren't sure whether it had been finished."

95

Cedric Diggory

Harry Potter

Miranda Richardson as
RITA SKEETER

"I call her 'the caring, sharing face of investigative journalism,'" says Miranda Richardson of her character, *Daily Prophet* columnist Rita Skeeter. "Basically, she'll do whatever it takes to get a story— a story [that] she's already [written] in her head!" For each of her scenes in the fourth film, Rita has a particular, and quite individual, change of costume. These often outrageous outfits were the result of discussions between Miranda and Jany Temime. For Miranda and Jany, Skeeter became an homage to the 1930s Hollywood actress-turned-gossip columnist Hedda Hopper, known

(below right) *Sketches of Jany Temime's costume designs for Rita Skeeter drawn by Mauricio Carneiro.*

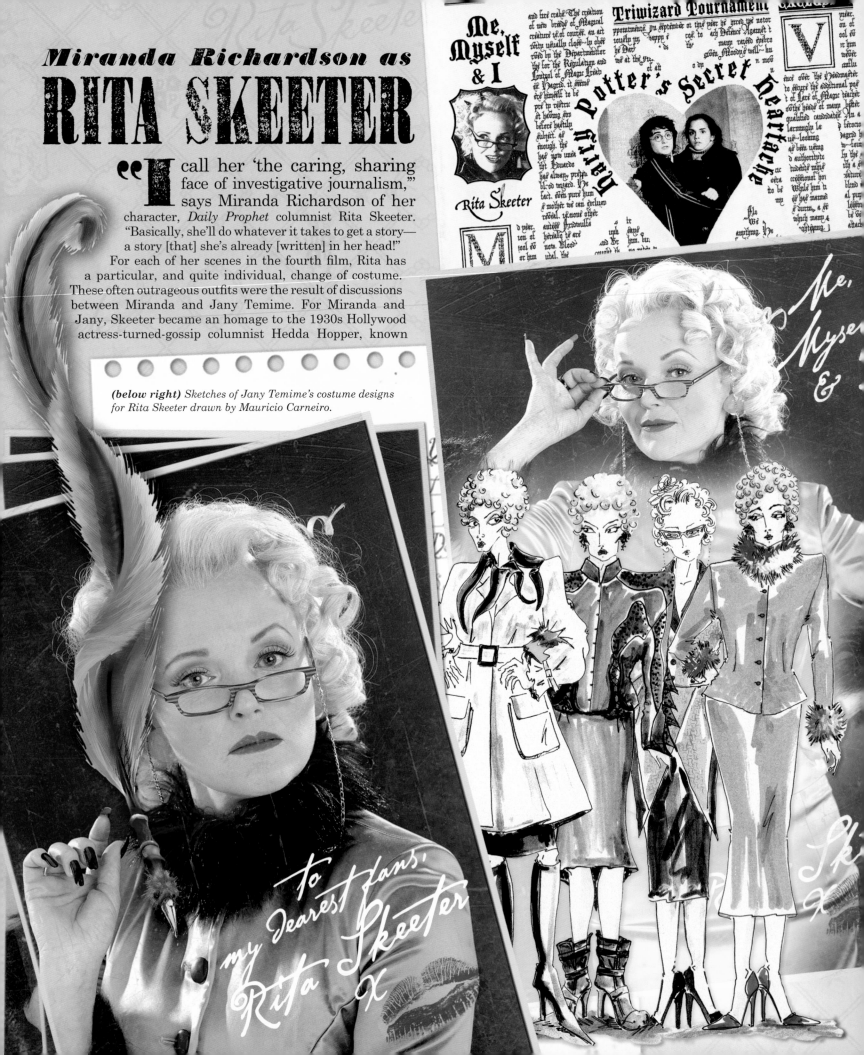

Me, Myself & I

Rita Skeeter

Triwizard Tournament

Harry Potter's Secret Heartache

to my dearest fans,
Rita Skeeter
X

Triwizard Tournament = with Harry

number 0124 THE DAILY PROPHET - PHOTO ARCHIVE

for her idiosyncratic taste in clothes and hats. As Miranda recalls: "We came to the idea that Rita dresses for the occasion. She's never knowingly underdressed. She wants to be right, and it's as much of a duty to her to look right for the occasion as it is to tell the truth—as she sees it."

"You really need the actress [when designing costumes for a character]," says Jany. "You need her to tell you how she sees the role and how she wants to play it; then you can give up designing and simply feed the fantasy of the character. What I first saw in Rita Skeeter was a cruel thirst for power, but Miranda also wanted to bring a touch of madness—a sort of craziness and hysteria to the part."

In attending each of the tasks of the Triwizard Tournament, Rita wears a costume specifically styled to match the event—for example, the dark red leather ensemble with a "dragon skin–like" texture that Rita wears to the first task. But the costume that best typifies Skeeter's personality is the fur-trimmed, green silk suit that she wears when conducting her Quick-Quotes Quill interview with the surprise entrant to the Triwizard Tournament, Harry Potter. "I love that costume," says Jany. "And Miranda loved it and wore it beautifully. We achieved that moment where there is a symbiosis between the actor and the costume. That green was so perfect. It was the color of poison, you know? It said, 'This is poison. Do not drink!'"

Miranda acknowledges that her portrayal of Rita Skeeter is not quite the character described in the books. One detail of Skeeter's appearance that is noted in the novels—the three gold teeth—didn't fit with the actress's interpretation. Miranda and director Mike Newell both felt gold wasn't right for Rita, but that the character still needed a sensational piece of dentistry. "I thought that gold teeth could look very unapproachable," says Miranda. "Having decided that this is somebody who makes herself as beguiling as possible to get the story that she wants, it didn't seem appropriate. Then we both said, at the same time: 'But I *could* see a diamond!'" It was the perfect embellishment for Rita Skeeter who is, after all, an amalgam of sparkling brilliance and total hardness.

97

HARRY POTTER 12 YEARS OLD - ABOUT TO COMPETE AGAINST 3 STUDENTS - VASTLY MORE EMOTIONALLY MATURE. MASTERED SPELLS HP WOULDN'T DREAM OF IN HIS DIZZIEST DREAMS.

HP - ORPHANED IN CHILDHOOD = LEGEND - CONQUERER OF YOU-KNOW-WHO

HARRY POTTER 4 Goblet of Fire
continuity

Character:	RITA SKEETER
Scene:	82 pt
Story Day:	23

Actor:	MIRANDA RICHARDSON
Location:	int/ext.black lake tower 1 water level 4

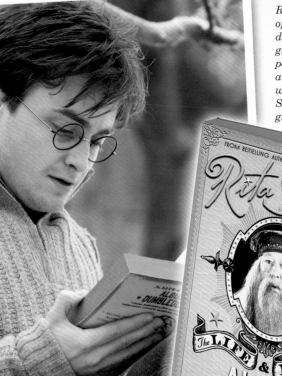

Rita's biography of Dumbledore designed by the graphic arts department to evoke a pulp-fiction look with the use of Rita Skeeter's signature green and pink.

FROM BESTSELLING AUTHOR

Rita Skeeter

The LIFE & LIES of

ALBUS DUMBLEDORF

THE FIRST TASK

(above) Creature sculptor Kate Hill working on a life-sized Hungarian Horntail head.

(left) Concept art by Paul Catling for the Hungarian Horntail.
(bottom left) Another version by Dermot Power.

98

"The main problem with dragons," says Nick Dudman, "is that your audience thinks they know exactly what a dragon looks like. So our job isn't so much to create a dragon, but to create a new look for a dragon that is fresh and interesting but doesn't destroy the image that people have in their heads."

Working from concept art drafted by creature designer Paul Catling, Nick's department built several dragon models, including a life-sized Hungarian Horntail. Forty feet long with a seventy-foot wingspan, this impressive creature was capable of belching real fire at a distance of thirty feet. The model was used in the scene where Harry gets his first glimpse of the dragon he will later encounter in the first task of the Triwizard Tournament.

For the scenes in which Harry confronts the Horntail, the dragon was engineered by the visual effects department. Some of the smaller model studies made in the creature workshop were scanned, providing the necessary digital starting point for the computer animators, who then determined how the dragon would move, and how it would be integrated with the parts of the scenes that were filmed in live-action.

Daniel Radcliffe, having already made three films filled with visual effects, says it was "second nature" to act opposite an imaginary dragon in an imaginary setting, both of which would be added later. While imagining the giant dragon, Dan also had to concentrate on executing the host of physical stunts required by the first task. "Some of the stunts were a bit scary," he says, referring to the sequence in which he falls down the castle roofs. "I was on a wire, and I fell, I think, forty feet very, very fast. That was terrifying, and I'm not ashamed to admit that. It was really scary!"

For the first task, Harry must snatch a golden egg from a nest of dragon eggs guarded by the Horntail. The egg, which contains a clue to the second task, was designed by Miraphora Mina, who took her inspiration for the design from J. K. Rowling's description of the egg as containing nothing but the song of the merpeople. "The outside decoration is quite formal," says Miraphora. "It has an etching of a city—not a mythical, magical city, but maybe a historical place somewhere. To open the egg, you turn a little owl's head on the top and the outer shell springs apart. Inside, I wanted something ethereal to contrast with the solid, gold exterior, so it became a kind of crystal structure where things were going on inside, but you couldn't quite work out what they were."

Miraphora's concept was realized by chief prop modeler Adrian Getley. The inner egg was cast in liquid resin, to which was added pearlescent pigments and small clear crystal balls as the resin hardened. This created the mysterious bubbling effect Miraphora described. The outer case was gold-plated, and, since Harry finally unlocks its secret in the Prefects' bathroom, it had to be totally waterproof!

The golden egg, designed by Miraphora Mina and made by Adrian Getley.

THE PREFECTS' BATHROOM

Window design by Adam Brockbank.

"**W**e've blown up toilets [and] flooded bathrooms," special effects supervisor John Richardson says nonchalantly about the bathroom scenes in the *Harry Potter* films. For the scene between Harry and Moaning Myrtle in the Prefects' bathroom in the fourth film, the filmmakers not only had to create, as they had in earlier films, "a floating ghost," they had to create a magical, luxurious environment as well.

The spa-like bathroom included dozens of taps (cast in bronze for detail and durability) from which differently colored bubbling water flowed into a swimming pool–sized tub. Three windows, including a central window decorated with a moving stained-glass portrait of a mermaid, dominated the bathroom, giving it a magical effect. "Windows and mirrors," says Stuart Craig, "have magic. Reflected or transparent, they give you that layered extra dimension—give you a bit of sparkle."

Shirley Henderson as
MOANING MYRTLE

mm_93_04

VFX0070

KU063641 5216+04

PROPERTY OF WARNER BROTHERS

mm93_04_6fr_timewarp_18mm_tk5 000248

Moaning Myrtle—the bespectacled ghost of a former Hogwarts student killed by the gaze of the Basilisk—is a character both tragic and comedic. As her name implies, Moaning Myrtle does a great deal of lamenting and complaining, to which actress Shirley Henderson added just the right touch. "It's just what came out of me, out of my head. I'd describe her voice as wounded," she told a BBC interviewer. "I did a lot of crying during the scenes, and that aided that kind of gurgly quality I was trying to produce—as if she was choking on water all the time."

"It *is* a moaning role," says Karen Lindsay-Stewart, casting director on *Harry Potter and the Chamber of Secrets*. "We needed someone incredibly clever to pull it off. You didn't want it to get on your nerves." Shirley had already made a name for herself in such diverse films as *Trainspotting*, *Topsy-Turvy*, and *Bridget Jones's Diary*, demonstrating an ability to play any age—a requirement when portraying a character who is both an insecure schoolgirl and an ancient ghost. (Not to mention, Shirley believes she's had at least one experience with a ghost [in a Russian hotel]. So, when Chris told her "to make it truthful," and that "if you believe it, they'll believe it," she felt she had something to draw from!)

The burden of making Moaning Myrtle believable was one shared by the visual effects department, which had to create a version of the character using computer graphics. As visual effects producer Emma Norton explains: "Having her burst out of the plumbing system and dive into the Prefects' bath was quite complex."

Another challenge was the spirit's constant need to move. "I had to be strapped to this harness so it looked as if I was flying and so I could be pushed through the air and twisted and turned over and over again," recalls Shirley. "It's physically very tiring on your body. It also requires a lot of concentration, because there're all kinds of people shouting stuff like 'Turn, do this, look at this,' so they can do all their stuff with the computer effects while I'm trying to act it out. But once you block all that out, it's great fun."

101

HARRY POTTER 4 Goblet of Fire
2nd Unit

Actor:	SHIRLEY HENDERSON	Character:
Location:	INT VFX PREFECTS BATHROOM	Scene:
		Story Day:

As positionned on the toilets

Sleeves of the gown, tucked inside the toilets, showing the arms

the YULE BALL

The Yule Ball—which Professor McGonagall describes in the film as "a night of well-mannered frivolity"—was one of the highlights of *Harry Potter and the Goblet of Fire*, and a lot of fun for the film's production team. In the book, J. K. Rowling describes the event as taking place in the Great Hall where the walls have been covered in silver frost. Stuart Craig and Stephenie McMillan met early on to decide how they would achieve this with the existing Great Hall set.

"I remember Stuart and I looking into the Great Hall and saying, 'Now what can we do to this place to transform it?'" Stephenie recalls. "We had used tapestries successfully in the past, and we started looking at fabrics—difficult because the fabrics had to be really fireproof." Eventually Stephenie and Stuart showed several silver fabrics to Roger Pratt, the director of photography, who chose a stunning and very shiny silver lamé.

Every detail of the hall was covered in silver: the walls, the window frames, and the house mascot lamp supporters with their bowls of fire that, for this sequence, burned with blue flame. The long tables and benches were banished in favor of round tables decorated with fanciful ice sculptures produced by the prop department out of clear-cast resin surrounded by mounds of imitation crushed ice.

This provided a display for the refreshments: a combination of seafood—dressed crab, lobster, prawns, and crayfish—some of which was real and specially treated so as to prevent it from smelling during the shoot, and some of which was molded and cast in resin. (None of it, therefore, was suitable for eating!)

The Yule Ball became what director Mike Newell describes as "a film within a film," a fantastical interlude where everything and everybody looks and feels different. For Jany Temime, it was a wonderful opportunity to dress everyone up to the nines—with, of course, the exception of Ron, doomed to wear his

Concept art for the band by Adam Brockbank.

Hogwarts School of Witchcraft and Wizardry together with the Ministry of Magic request the pleasure of your company at the

YULE BALL

to celebrate Christmas and the Triwizard Tournament

To be held at 19:00 hours, Christmas Day at the Great Hall Hogwarts School. At 21:30 hours the traditional Champions Waltz

Strictly Dress to Impress
See Professor McGonagall for more details.

(below left) Drawing for ice centerpieces by Hattie Storey, inspired by the domes of the Royal Pavilion, Brighton.

hand-me-down dress robes. "The ball arrived at exactly the right age," says Jany, "because they are teenagers, and that's the age when you are very conscious of yourself and when there's a lot of tension starting between the boys and girls."

For the Hogwarts boys, Jany created what she calls a "wizard tuxedo" in satin silk, while Viktor Krum and the young men of Durmstrang had military dress uniforms, and Fleur Delacour had an elegant, pale grey-blue gown with a classic line of French couture. Padma and Parvati had saris in complementary contrasting colors, and Cho Chang had a Chinese-inspired gown in ivory-colored silk.

Creating Hermione's evening dress, however, proved the most daunting. "The pressure," says Jany, "was that she had to be so beautiful you wouldn't recognize her. At the same time, she still had to look like a young girl rather than a woman. I wanted something very romantic, very adorable. It is made out of many yards of silk, layer upon layer. And pink of course! It was a beautiful dress, and she wore it beautifully."

Emma Watson remembers: "I've never worn anything so beautiful. But I was absolutely terrified I was going to rip it or spill something on it. So, I would not sit in it. I would not walk in it. I would not do anything in it apart from what I had to do in it because I was so worried I was going to wreck it!"

Eithne Fennell, chief hair designer on *Goblet*, who contributed to Hermione's new look with a chic hair-style, remembers the impact that Emma made as Hermione when she was dressed for the Yule Ball: "The first time she walked on the set, the whole crew gasped. It was like an intake of breath, because she looked gorgeous."

Emma herself is haunted by another memory from the scene in which Hermione makes her entrance down the grand staircase to the Hall: "I was so nervous about the whole thing," she laughs, "because it's such an anticipated moment. I had so many pointers from Mike Newell about how he wanted it to look, and I got down about three steps and fell down in front of the whole set, which was incredibly embarrassing!"

Despite these anxieties, the Yule Ball was a particularly enjoyable sequence for everyone on the film, especially, as makeup designer Amanda Knight says, for the young actors who had never previously had a chance to look so grown-up and sophisticated: "The kids loved it, we loved it, and it looked fabulous."

Director Mike Newell drew on his own educational experiences when planning the Ball: "I remember thinking about my own time at university when, at the end of every year, there was a very swanky occasion called a May Ball at which there would be formal dancing, but also let-your-hair-down stuff as well, which was always a lot of fun."

The end-of-ball rave featured a wizarding band referred to in the film only as "the band that needs no introduction!" The group's instruments—a twelve-foot-high set of bagpipes, strangely shaped guitars, and enormous transparent cymbals—were made by the prop department, along with the hundreds of chrome megaphones that decorate the stage.

(below) Costume designs by Jany Temime, sketched by Mauricio Carneiro, for Hermione and Viktor Krum.

104

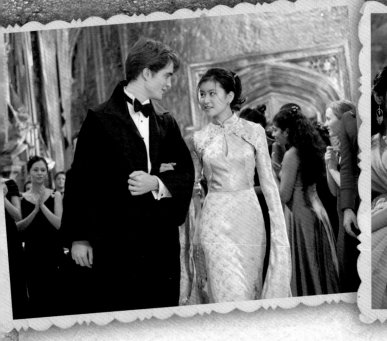

The songs, one of which was "Do the Hippogriff," were written and performed by a group of celebrated Muggle rock musicians, including lead singer Jarvis Cocker and bass player Steve Mackey of the band Pulp; guitarist Johnny Greenwood and drummer Phil Selway of Radiohead; guitarist Jason Buckle, known for his work with All Seeing I; and keyboardist Steven Claydon from Add N to (X).

Can you dance the Hippogriff?
Ma ma ma, ma ma ma, ma ma ma
Flying off from a cliff
Ma ma ma, ma ma ma, ma ma ma . . .

Add to all of the above several gigantic Christmas trees, icicles, and falling snow, and you have a Yule Ball to remember.

(left & right) Costume designs by Jany Temime, sketched by Mauricio Carneiro, for Madame Maxine and Igor Karkaroff.

THE SECOND TASK

During the second task of the Triwizard Tournament, the champions must recover something dear from the depths of the black lake. This meant that the filmmakers had to create a whole underwater world.

The art department began by designing the underwater environments and the creatures that lived there, such as Grindylows and merpeople. The look of the merpeople in particular was based on the anatomy of a sturgeon. "Rather than have the traditional break between the fish and the human parts," explains concept artist Adam Brockbank, "we carried the fishiness up into the human with scales, large, fish-like eyes, and translucent hair, which is rather like the tentacles of a sea anemone."

For the spectators observing the second task from above, Stuart Craig designed special stands inspired by "old Victorian illustrations of seaside piers." During their research, they "found some curious contraptions that were platforms on great long legs that ran on rails under the water," he recalls. "So, rather than just have people sitting on rocks along the edge of the lake, we put them on these rather dramatic mobile viewing stands out in the middle of the lake."

The decision to film the underwater sequences actually *under water* meant that a huge tank—sixty feet on a side, twenty feet deep, and holding close to a half million gallons of water—had to be built, masterminded by John Richardson (no stranger to underwater shooting, having worked on *Raise the Titanic*). "We filmed using a camera on a crane specially adapted to work underwater. So the director and cameraman could follow the action, there was a window in one side of the tank with three-inch-thick glass."

 (above) Concepts of merpeople, Grindylows, and Harry underwater by Adam Brockbank.

WIDER ON
HARRY'S
WONDERMENT

MORE
7
HE MAKES
A POWER-
FUL STROKE
AND DARTS
OFF INTO
THE F.G.

8

WATCH HARRY
CAVORTING ISHILY
HE ENTERS

✳ *(above) Daniel Radcliffe filming an underwater sequence and (right) a storyboard for the sequence by Jane Clark.*

One of the greatest limitations of working underwater is the length of time the actor can hold his breath if he is not wearing an oxygen tank. To avoid having the actors dive and then surface for air over and over again, the crew built a special habitat inside the tank. Daniel Radcliffe and the other actors in the scene—Stanislav Ianevski, Robert Pattinson, and Clémence Poésy—were able to access the tank through an air lock, and retreat to the habitat to rest and catch their breath between takes.

The demands on Dan were great. He had to act with his eyes open, but without a mask or goggles. He also had to hold a lungful of air for up to thirty seconds without letting out any telltale bubbles (since, in the scene, he has gills). "I'm a terrible swimmer," says Dan, "I'm really bad, but being underwater is a different thing than being on the surface. I find swimming underwater relatively easy, and all the stuff in the underwater sequence where you see my face was me—which I'm very pleased about."

The floating figures of Hermione, Ron, Cho Chang, and Fleur's sister Gabrielle, who were all awaiting their rescuers, were not represented by the real actors. "There was no way we were going to tie an actor to the bottom of a tank!" exclaims Nick Dudman. "We used animatronic dummies, made from lifecasts of the actors, which [could] make delicate, floating movements and breathe bubbles out of their mouths."

Once the live-action and animatronic portions of the sequence were shot in the underwater tank, visual effects supervisor Jimmy Mitchell and his team took the footage and began to elaborate on it with layers of digital animation to create one of the film's most dynamic and haunting sequences. "It gave us a great performance around which we could then create the underwater world and give it real depth and scale," he says.

✳ *Concept art by Adam Brockbank of Harry developing gills and (above) leaping fish-like out of the water.*

Brendan Gleeson as
MAD-EYE MOODY

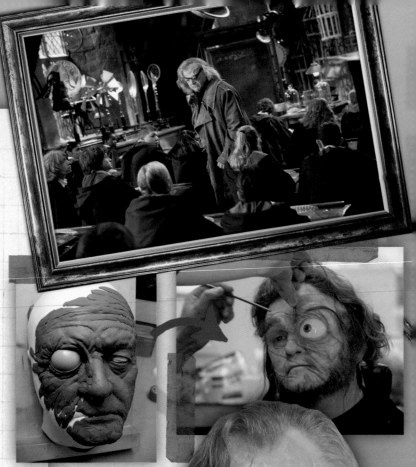

"It was a big surprise to me that Mad-Eye Moody turned out the way he did," J. K. Rowling admitted of her creation in an interview in 2000. "I really like him. I didn't expect to."

Alastor "Mad-Eye" Moody—celebrated Auror and member of the Order of the Phoenix—is one of Rowling's most intriguing and complex characters. It was a challenging role for Brendan Gleeson in the fourth film since he had to portray Moody without revealing that the character was, in fact, Barty Crouch, Jr. disguised by Polyjuice Potion.

Describing the rough-around-the-edges wizard with unorthodox principles, Brendan says: "He is so paranoid and damaged and yet so heroic. There is poignancy in that Mad-Eye has always been very gruff and a man of limited sentimentality. I think Harry has a series of father figures and I've always felt that Mad-Eye was quite a strong one."

Bringing the character to the screen involved not only building Moody an artificial leg and designing makeup to create his badly scarred face—but finding a way to represent his magical, all-seeing eye. The eventual solution was a brass holder strapped to Brendan's face in which the piercing blue eye could swivel around—the movement of it operated by a tiny magnet behind the false eye and a set of radio controls. "Occasionally," says Nick Dudman, "the eye would hit the side of the brass frame, the magnetic link would be broken, and the eye would pop off!"

Moody's possession of a Foe-Glass and other Dark Detectors inspired the revised appearance of the Defense Against the Dark Arts classroom. Stephenie McMillan took a research trip to London's Science Museum and filled the room with lenses and optical gadgets—many of which had been specially designed and built by the studio prop-makers.

108

The inspiration for both Moody's broomstick and costume came from different cinematic genres. His broomstick has the feel of a motorbike from the iconic 1960s road movie *Easy Rider*—with Mad-Eye sitting back on the broom, feet stretched out in stirrups. His wardrobe, on the other hand, brings to mind the costumes worn in the Spaghetti Westerns starring Clint Eastwood. "Moody," Jany Temime says, "is a warrior rider who lives and sleeps in his coat. This is the difference between a garment and a costume. For an actor, the costume should be a second skin." Creating Moody's coat took eighty hours, many of which were spent distressing it so that it would look authentically worn. ("A new coat—it's anonymous," says Jany.) The fabric was treated with bleach, painted with tar, and made to look old and weathered using blowtorches, knives, wire brushes, and sanding machines. "And when you're done with that," says Jany, "because this is a movie and you need copies of every costume, you make four more exactly the same!"

(above) Moody's prosthetic mask.

(below) Concept art for Mad-Eye Moody's trunk; the color image is by Rob Bliss and the sketch by Stuart Craig.

THE THIRD TASK

(above) Maze concept art by Andrew Williamson.

"My favorite task," says Daniel Radcliffe, "was probably the maze, because it's such a scary concept. It's all very dark and there's smoke coming out of the hedges!" Robert Pattinson, who played Cedric Diggory, agrees: "It's the isolation and the fear about not knowing what's round the next corner. As the maze seals up all the time, you're just so disoriented."

To bring the maze to life, John Richardson says: "We created large sections of the maze hedge that moved and developed [their] own persona[s]. The walls were twenty-five feet high and forty feet long, and they could ripple, tilt, and come together and move apart."

Made from steel and operated with powerful hydraulics, the moving maze had a built-in fail-safe device to ensure nothing could go wrong while the four actors were inside. The authenticity of the effects impressed the actors. As Robert recounts, "There were real explosions going off, and the whole maze is moving, so you're running around, actually fearing for your life! You got much more into it and that was quite helpful."

But the dangers of the maze are only a prelude to what happens when Harry and Cedric finally seize the Cup. "Once you have that, then you're the winner," says Dan. "But, of course, everything spirals out of control."

Indeed it does, when the two boys discover that the Triwizard Cup is, in fact, a Portkey designed to take Harry directly to Voldemort. "As Harry completes each of the tasks, so he moves a little closer towards Voldemort's plan and purpose for him," says *Goblet of Fire* director Mike Newell. "As he gets successfully through the third task, it's as if the hand of Voldemort has reached out and snatched him."

The three-handled Triwizard Cup was designed to look like an ancient trophy made of silver and crystal. The crystal bowl was cast in resin, and small pieces of plastic wrap were added to it as it hardened, creating an intriguing organic texture.

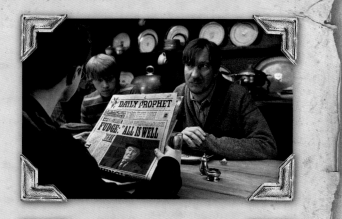

Harry Potter and the Order of the Phoenix

With *Harry Potter and the Order of the Phoenix,* the production team found themselves tackling what was—and would remain—the longest book in the series.

Once more, the series had a new director. While the appointment of David Yates would prove to be permanent, *Order of the Phoenix* was the only film in the series not adapted for the screen by Steve Kloves. Stepping capably into his shoes was Michael Goldenberg, who was undaunted by the length of the book and decided to take a sculptural approach to the screenplay—choosing key moments and themes as tent poles upon which the rest of the story could be supported.

"David Yates always referred to it as a political film with a small 'p.'" says Michael Goldenberg. "It's about a situation that recurs in history over and over again. This is what happens when people are forced to fight back—when power gets concentrated. I can't speak to what Jo had in mind when she wrote the book, though I did have my own personal emotional response to what was happening in the world at the time and, inevitably, that is going to find its way in."

David Yates had a similar take on the film, and viewed it from the perspective of its youthful characters. "It's about rebellion," he says, "and it's about understanding the limits of what adults can do and achieve for you. It's also about discovering how difficult the world can become and how sometimes you have to make your own way."

(right) David Yates (right) directs Daniel Radcliffe as Harry (left), Matthew Lewis as Neville Longbottom (center), and the rest of Dumbledore's Army in a training scene in the Room of Requirement. Yates loved the story's student rebellion.

110

esting those limits was Hogwarts High Inquisitor Dolores Umbridge, played brilliantly by Imelda Staunton. "The Lady in Pink!" exclaims David Heyman. "She's incredibly gifted and she has wonderful comic timing, but Umbridge isn't just a caricature, she's a woman of real complexity. I predict Umbridge is going to stay in peoples' memories."

With Umbridge and Fudge controlling the media, the filmmakers made great use of the *Daily Prophet* as a storytelling device. According to Goldenberg, "The media is a character in the novel—it's a major force that Fudge is controlling." Not to mention the fact that a newspaper with moving photos is, as Goldenberg says, "uniquely cinematic."

In addition to politics ("with a small 'p'"), the film also addressed the changing relationships among the young principal characters. "What was exciting for me," says David Yates, "was the fact that Rupert, Emma, Dan, and the rest of the cast were maturing, and the story that Jo writes in the fifth book dips into some pretty big, interesting issues that affect us all when we're growing up."

Order of the Phoenix continued the unique synergy between humor and danger that had become characteristic of the series. For example, Grawp—Hagrid's giant half-brother—seemingly dangerous in his own right, develops a schoolboy crush on Hermione. (Interestingly, while J. K. Rowling says she does not normally think of the films while working on her books, she admits to thinking briefly of the film version when she wrote Grawp into the book and wondering how his scenes would be filmed. Not that it gave her any pause: "That's the glory of being a novelist," she said in a British television interview in 2007.)

HELENA BONHAM CARTER AND MATTHEW LEWIS

✳ LOOK BACK ✳

Neville Longbottom (played by Matthew Lewis) and Bellatrix Lestrange (played by Helena Bonham Carter) have a truly torturous relationship: Bellatrix drove Neville's parents to insanity. For the scene in the fifth film where the two come face to face in the Ministry of Magic, Helena had some ideas about how to reflect this relationship on-screen. "I thought I could brandish the wand like a sort of Q-tip," she told *Entertainment Weekly*, "and clean out his ear. Sort of torture it. But unfortunately he moved toward the wand as I was prodding it. And it actually perforated his eardrum."

Matthew now laughs about the incident, but did say he was deaf in that ear for a couple of days. "Helena plays the character really well," he told IndieLondon. "[She's] sadistic and twisted about it." Helena was most apologetic, but the fact remains that the incident was, oddly, very much in character.

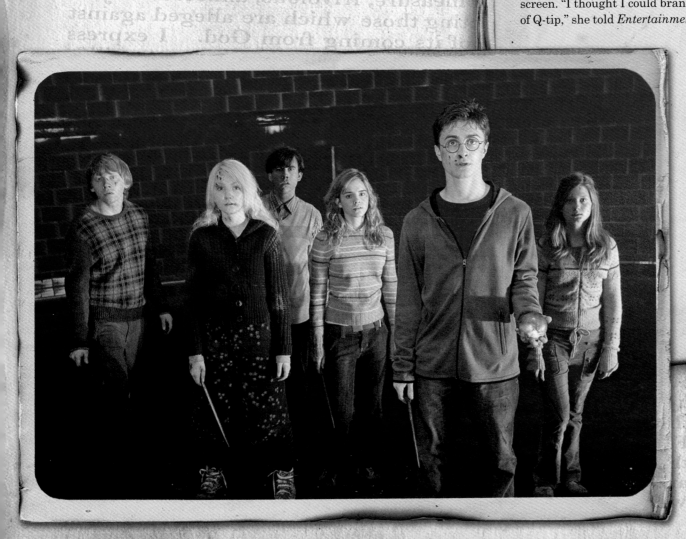

(left) From left: Ron (Rupert Grint), Luna (Evanna Lynch), Neville (Matthew Lewis), Hermione (Emma Watson), Harry (Daniel Radcliffe), and Ginny (Bonnie Wright) in the Department of Mysteries.

MINISTRY OF MAGIC

PRODUCTION DESIGNER'S NOTEBOOK

Name: _Stuart Craig_

In designing the Ministry of Magic, I asked myself several questions: What would give it credibility? What would allow me to take a visual approach? What would separate this set from all the others and make it unique and interesting?

Because the Ministry is situated underground, we decided it would be fun to place it beneath Whitehall, the road in the center of London where the offices of the British government's Ministry of Defense are located. We chose a street off Whitehall as the ideal spot for the iconic red telephone box that was to serve as an elevator connecting the Muggle world to the wizarding world.

For the interiors of the Ministry, we took our inspiration from the architecture used in London's Underground transport network. I asked to see disused parts of the railway system, some of which dated back to the beginning of the twentieth century, and found fantastic architectural examples of imposing entrances with classical columns and cornices—all produced in ceramic tiles, which are perfect for building underground as they are impervious to water.

This impressive tile work gave me the inspiration I needed. With no windows onto the outside world, everything at the Ministry is a cut-off interior, and the lighting was going to be minimal. The high gloss of the glazed tiles would compensate for this low light by giving the place an interesting, reflective look. From this basic premise, we began to design the whole set, creating an interior world that is walled and floored entirely in deep red, green, and black ceramic. It is also filled with huge fireplaces—gilded with brass leaf—for all the wizards arriving via the Floo Network.

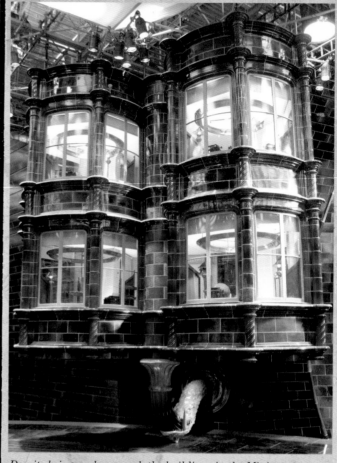

Despite being underground, the buildings in the Ministry of Magic have many windows that look out onto the atrium.

The one location in the Ministry that did not involve much real construction was the Hall of Prophecy. A dark space filled with glass spheres on glass shelves that go on endlessly in every direction, it is a massive crystal palace covered in dust and cobwebs. We populated the set with fifteen thousand real glass spheres, but that number was multiplied to near infinity by the visual effects department, who expanded the scope of the hall with computer-generated imagery.

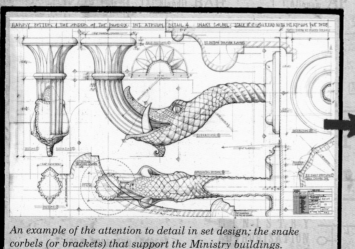

An example of the attention to detail in set design; the snake corbels (or brackets) that support the Ministry buildings.

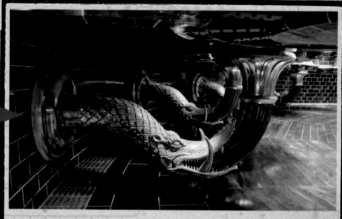

Part of the Ministry of Magic set showing the elaborately carved snake corbels in place.

had long admired David Yates. He has always had a great energy about his filmmaking, and he is particularly confident in handling political subjects in an entertaining way—which was exactly what we needed for *Order of the Phoenix*. His previous films had been marked by consistently powerful performances, and it was important that Dan, Rupert, and Emma (and, in fact, all our cast) continued to be challenged.

Among the new members of the cast in *Order of the Phoenix* was Evanna Lynch as quirky Ravenclaw student Luna Lovegood. Three professional actresses were being considered

for the role, but they were going to *play* Luna; they weren't actually going to *be* Luna. Time was of the essence as we were going to film with Luna quite soon. We decided to do one more open call and put ads in the newspaper and on the radio. We expected a couple of thousand young girls, but nearly fifteen thousand showed up for the audition—several of whom were in their forties! Everyone was seen, but our casting director, Fiona Weir, eventually narrowed it down to thirty-six girls, whom she put on tape. As soon as we saw Evanna, it was clear there was only one Luna.

The fifth film finally offers Harry a bit of romance and his first real, though admittedly quite chaste, grown-up kiss, with Cho Chang. On set, there was a lot of laughter, and some discomfort, as for many of the crew who had known Dan since he was just ten years old, it was like watching their son make out close-up!

(below) Daniel Radcliffe on the set with David Heyman.

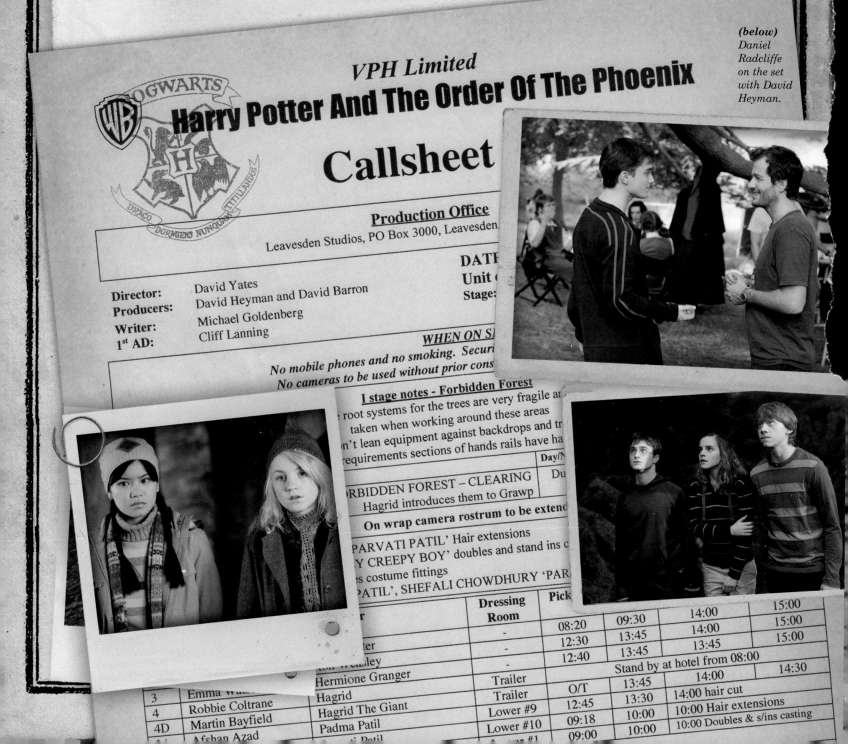

VPH Limited
Harry Potter And The Order Of The Phoenix

Callsheet

Production Office

Leavesden Studios, PO Box 3000, Leavesden.

DATE
Unit
Stage:

Director:	David Yates
Producers:	David Heyman and David Barron
	Michael Goldenberg
Writer:	Cliff Lanning
1st AD:	

WHEN ON S

No mobile phones and no smoking. Securi
No cameras to be used without prior cons

I stage notes - Forbidden Forest

root systems for the trees are very fragile a
taken when working around these areas
n't lean equipment against backdrops and tr
requirements sections of hands rails have ha

	Day/N
FORBIDDEN FOREST – CLEARING	Du
Hagrid introduces them to Grawp	

On wrap camera rostrum to be extend

'PARVATI PATIL' Hair extensions
Y CREEPY BOY' doubles and stand ins c
s costume fittings
PATIL', SHEFALI CHOWDHURY 'PAR

	Dressing Room	Pick			
		08:20	09:30	14:00	15:00
		12:30	13:45	14:00	15:00
...ter	-	12:40	13:45	13:45	15:00
...on Weasley		Stand by at hotel from 08:00			
Hermione Granger	Trailer		13:45	14:00	14:30
3 Emma Wa... Hagrid	Trailer	O/T	13:30	14:00 hair cut	
4 Robbie Coltrane Hagrid The Giant	Lower #9	12:45		10:00 Hair extensions	
4D Martin Bayfield Padma Patil	Lower #10	09:18	10:00	10:00 Doubles & s/ins casting	
Afshan Azad ...ti Patil		09:00	10:00		

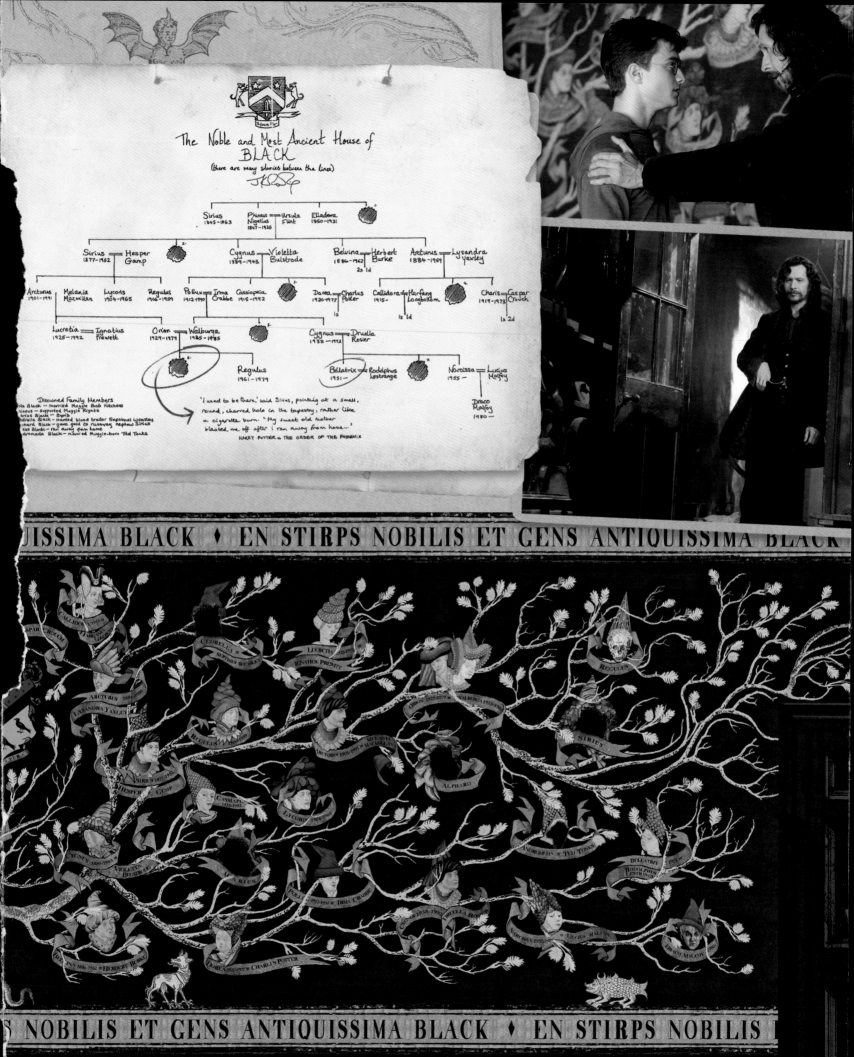

THE BLACK FAMILY TREE
TAPESTRY

As he studies the family tree of the Noble and Most Ancient House of Black on a tapestry in number twelve, Grimmauld Place, Harry begins to understand the complex relationships between the Blacks and the Malfoys. Initially, the family tree was to have been created on a vertical tapestry hanging on the staircase or in one of the hallways. But when the decision was made to have it line the walls of an entire room, with the tree's branches spreading out in all directions, the filmmakers needed to know who else might appear as part of the extended Black family (but had not been mentioned in the books).

To understand Sirius's lineage, the filmmakers turned to J. K. Rowling. Producer David Heyman explains: "Jo's knowledge of the world of *Harry Potter* is so deep. What's in the book is but the surface. I called Jo and told her we were going to show the Black family tree and asked if she could help fill it out because there are only a few names mentioned in the book. An hour later, I received a diagram showing several generations of Blacks complete with birth and death dates, gaps for family members like Sirius who had been disowned, and who married whom—and when."

As for the added names never mentioned in the books? "There are many stories between the lines," says the author.

Armed with Jo's detailed chart, props concept artist Miraphora Mina set to work. "As I began drawing the tree and putting in all Jo's references," she recounts, "I looked at lots of examples of old tapestries and found medieval faces that I felt would lend themselves to the addition of hats and beards—to being turned into witches and wizards."

Thought was given to having the tapestry professionally woven, but considerations of time and cost prevailed. Instead, scenic artists painted Miraphora's depiction of the Black family genealogy onto genuine tapestry wool. The final touch was to make the tapestry look old and worn, complete with burn holes in the material wherever disowned members of the family had once appeared.

(above) Bellatrix Lestrange's likeness on the Black tapestry. Notice the carefully created damage to the tapestry's fabric.
(right) J. K. Rowling's diagram for the Black family tree.

HEROES & VILLAINS

TIMOTHY SPALL AS PETER PETTIGREW

Describing his experience playing Peter Pettigrew, Timothy Spall says: "It's one of the smallest parts I've ever played, but everywhere I go in the world I'm recognized." Often, according to Timothy, simply as "the rat dude" from the *Harry Potter* films.

Timothy takes his role as "the rat dude" very seriously, and seems to know Wormtail (Peter's nickname) inside and out. "He's conniving and cunning," says Timothy. "He uses his natural weakness and vulnerability to get people to believe that he's hard done by, but there's a tinge of genuine vulnerability. We all meet people that we despise and feel sorry for in equal measure, and I think he is one of those people."

Reflecting on the moment when he begs Harry to spare his life in *Harry Potter and the Prisoner of Azkaban*, Timothy says: "I think he believes it when he's doing it, but, at the first opportunity, he's back with Voldemort—back on what he thinks is the right side." The actor points out, however, that Peter wouldn't hesitate to grovel back to Harry and his friends if he thought they were on the winning side. As Timothy puts it: "He's allowed himself to stay on the edges of power by being subservient and ingratiating."

(below) Wormtail's knife.

GEORGE HARRIS AS KINGSLEY SHACKLEBOLT

Playing a wizard was the realization of a childhood dream for actor George Harris. He had many rabbits as a child and spent time alone in the forest collecting food for them. "While I was there," he says, "I used to imagine that I was a magician—jumping from stone to stone and casting spells."

Describing his approach to the role, George says he was inspired by Westerns. "I like to think of him not as a gunslinger," he says, "but as somebody who comes to town—like a U.S. Marshal—to solve problems."

George was closely involved in developing Kingsley's on-screen look. Feeling that a conventional suit was inappropriate, he suggested that he might wear traditional African Agbada robes, which became the inspiration for his distinctive costume. In addition to the robes, George added a further personal touch: "I love to wear beads and bangles, so apart from the earring that was indicated in the books I also wanted the beads, which make me feel very comfortable."

(below) Kingsley's broom.

HELEN McCRORY AS NARCISSA MALFOY

"**S**he might be a baddie," says Helen McCrory of her character, Narcissa Malfoy, "but she's a good mother." Her actions in *Harry Potter and the Half-Blood Prince*, she points out, are in the interest of saving her son.

Helen is fascinated by the conflict that Narcissa must face when Lucius Malfoy is sent to Azkaban: "When you have a cause that has served you all your life, you think it's in your blood," she explains. "Suddenly, when the person in charge allows your husband to be sent to prison and, in essence, asks for the life of your child, it doesn't seem to serve you anymore."

Discussing her on-screen relationship with Bellatrix Lestrange, Helen denies any competition between herself and Helena Bonham Carter to outdo one another in terms of evil madness, joking that Helena has cornered the market on "absolutely batty" insanity. "I'm trying for a different sort of madness," she says, "the sort of haughty, exterior madness."

Much of Narcissa's "haughty exterior" is created through hair, makeup, and costuming. "You have a sense of a woman who, when she walks down the street, owns the street," says Helen, adding, "and every street she goes to."

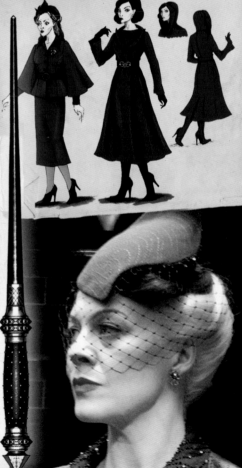

Imelda Staunton as
DOLORES UMBRIDGE

When Imelda Staunton was told that she would be "great for the part" of Dolores Umbridge, she found it difficult to accept this sentiment as a compliment—not surprising since the character is described as odious and toad-like in the *Harry Potter* novels! In fact, producer David Barron jokes that Imelda will never forgive him for saying that he immediately thought of her for the role.

Having now played Umbridge, Imelda has an intimate understanding of the character. "I think there are probably a lot of people like that, who outwardly are very charming," she says. "But they're charming because they believe they're doing the right thing. And, of course, they are always the more frightening people, because they don't see any other side. There's no compromise."

At the premiere for *Harry Potter and the Order of the Phoenix*, J. K. Rowling remarked to a reporter that Imelda's performance had "the perfect blend of saccharine and evil"—a fitting description for someone who doles out punishment with a metaphorical spoonful of sugar.

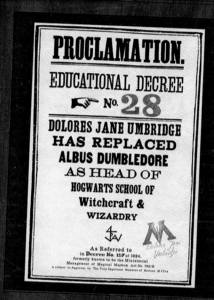

PROCLAMATION.
EDUCATIONAL DECREE
No. 28
DOLORES JANE UMBRIDGE
HAS REPLACED
ALBUS DUMBLEDORE
AS HEAD OF
HOGWARTS SCHOOL OF
Witchcraft &
WIZARDRY

As Referred to in Decree No. 157 of 1924, formerly known to be the Ministerial Management of Magical Mayhem Act No. 792/B & subject to Approval by The Very Important Members of Section M1Tra

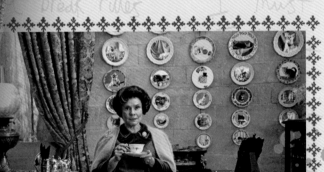

MINISTRY OF MAGIC
DEPARTMENT OF
MAGICAL
EDUCATION

(below & right) Swatches of pink costume materials and one of Jany Temime's costume designs for Dolores Umbridge, sketched by Mauricio Carneiro.

Quality 246
Width 140
Metres 36
Shade M/13
UMBRIDGE
LAURENT GARIGUE
Quality VISCOSE + ACETATE
Width 140
Metres 2.5 m

UMBRIDGE
JOELS
Quality 2625
Width 140
Metres 50m
Shade 2625
UMBRIDGE
Bernstein +
Quality C 7214
Width
Metres
Shade LINTON TWEEDS

BANNED

(right) The Black ancestral crest with the family motto Toujours Pur ("Always Pure").

(left) The drawing room and grand piano.

(right) Grimmauld Place is revisited in Deathly Hallows – Part 1. Set decorator Stephenie McMillan says that the kitchen remains the same as it was seen in Order of Phoenix with one exception: "It doesn't have Mrs. Weasley there keeping it clean, so on the whole it's a lot dustier!"

(left) Sirius Black (Gary Oldman) in his ancestral home in Order of the Phoenix.

SIRIUS & BELLATRIX FAMILY FOES

(below) Storyboard sketches for the moment when number twelve, Grimmauld Place materializes.

"There's some very evil goings-on in Sirius Black's history," says actor Gary Oldman of the character he plays. "There's the light and the dark in Sirius's family—but we all have light and dark within us, and it's up to us what we choose to do with it. That's what defines who we are."

Sirius and his cousin, Bellatrix Lestrange, represent two different paths: both born into a family infected with pureblood mania and embracing Lord Voldemort, Sirius rebels against the bigotry, eventually joining the Order of the Phoenix, while Bellatrix embraces it.

"She's obviously got a personality disorder," says Helena Bonham Carter of her character, Bellatrix. "She is a sadist. She loves all the Unforgivable Curses and gets joy out of causing pain with the Cruciatus Curse." While Sirius describes Bellatrix as his "deranged cousin," J. K. Rowling also calls her Voldemort's "last, best lieutenant."

"She's a genuine follower of Voldemort," says Helena, "unlike like Lucius Malfoy, who serves out of fear. Bellatrix was willing to go prison for fourteen years for him and was proud to do so. I think she genuinely loves Voldemort. She's a true fanatic."

Both actors speculated on how their two characters might have related to one another in childhood. "I'm sure at one time," says Gary Oldman, "when we were kids, we played very nicely together." Helena agrees jokingly: "I bet we played doctors and nurses when young!"

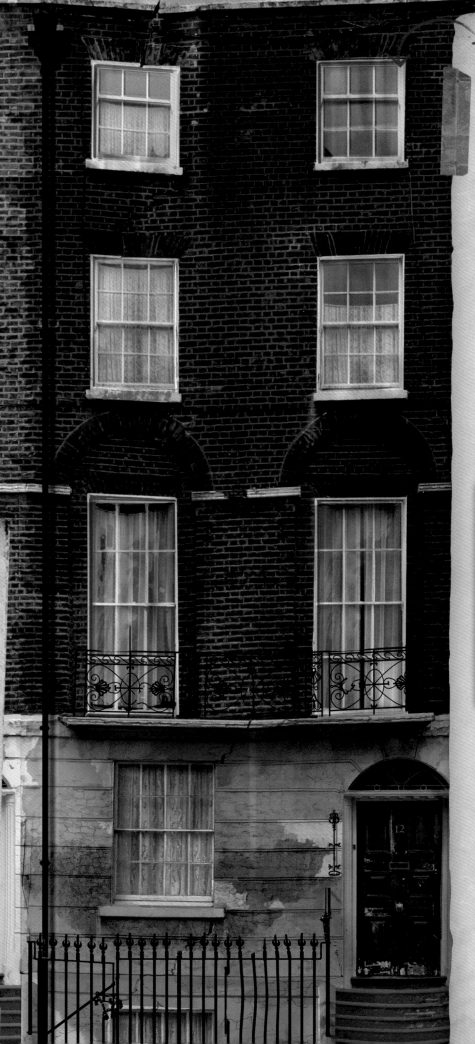

No. 12 GRIMMAULD PLACE

"It's a spectacular set," says Gary Oldman of number twelve, Grimmauld Place, Sirus Black's home as depicted in the films. "It's this rather dark and dingy cobweb-covered mausoleum."

To create that atmosphere, Stuart Craig began with the idea of a house that appears between two other houses. "We had a drainpipe on the front of the building that ran the whole height from top to bottom," he says, "so we literally imagined the houses on either side of the drainpipe spreading apart—and, in that gap, this additional house."

That idea inspired the look of the interior of number twelve, with everything feeling narrow and elongated. The high-ceilinged rooms have tall, thin windows that are mirrored so they can't be seen out of—making the place feel more enclosed. The rooms are furnished with beds and wardrobes built to be taller than normal so as to fit in with the long, lean look of the house.

Stuart decided that the dark aspects of the Black family's history would be hinted at in the interior decoration based on "the color of blue-black ink."

"We bought lots of old furniture at auction," says Stephenie McMillan, "and it was all a rich, brown mahogany; but then we had it painted a dark ebony black so it looked really spooky."

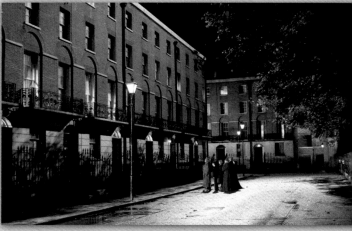

The kitchen's long, narrow table was specially designed and made, and the thirteen-foot-high dressers were stacked with old silverware, pewter, and gold-rimmed china cups and plates to which the Black family crest was added. Curtains and hangings were in velvet, and many of the walls were covered in a dark grey striped silk—a material that can be aged to look old, and which has a sheen that can't be achieved using wallpaper.

J. K. Rowling visited the studio when the set for Grimmauld Place was being constructed for the first time. The author had described many aspects of the gloomy house without going into great detail, so Stephenie wondered how she would react to the specific designs. "I had a chance to explain my ideas about all the paintwork being black and having grey silk on the walls," she says. "And then, in the next book in which Grimmauld Place appears, Jo described the walls as covered in grey silk. So the actual set design got into the book."

ANDY LINDEN AS MUNDUNGUS FLETCHER

"**L**et's just say Mundungus is a little bit wayward," says actor Andy Linden. The fact that his character—reluctant Order of the Phoenix member Mundungus Fletcher—was a less-than-consummate hero was one of the things that Andy found interesting about the role. That kind of person, he says, is more interesting to play: "You can have a lot more fun . . . than if you're playing the ultimate goody-goody."

Mundungus is certainly no Good Samaritan. "He's an opportunist," says Andy. "If there's a deal to be done, he wants in on it." As Andy interprets the character, Mundungus is an ally of Harry Potter and the Order—but not by choice. "He is coerced," says Andy, who believes that rather than helping Harry, Mundungus would "sooner be out wheeling and dealing."

"One of the many things I enjoy about Jo Rowling's books is the depth of the characters she has created. As the books progress, layers are peeled away, and we gradually realize that her characters' motives are rarely either black or white—Jo is comfortable with varying shades of grey." —David Heyman

NATALIA TENA AS NYMPHADORA TONKS

Born on the day after Halloween, Natalia Tena loved stories of witches when she was a child, and liked to believe that witches had left her on her parents' doorstep when she was a baby. "On my eighteenth birthday," Natalia laughs, "instead of a cake, my mum bought me a broomstick!"

It is no surprise, then, that Natalia has greatly enjoyed playing one of the Order of the Phoenix's youngest members. Her childhood fascination with witches aside, Natalia identifies with Tonks's ability to change her physical appearance. (Tonks is a Metamorphmagus.) "From the age of thirteen until now," says Natalia, "I've had my hair every color—black, red, blue, green—and I do feel that your hair can reflect your mood."

"She's very playful," adds Natalia. "At one point, she's making the kids laugh by changing into a pig. The situation's serious enough, so Tonks thinks, 'Why make it worse? I'll give you a wink and a smile and change into a duck for you and make the evening a bit better.' Always death and Voldemort!" she laughs. "Let's chill out a bit!"

DAVE LEGENO AS FENRIR GREYBACK

"**G**reyback is caught between being a werewolf and being a man," says Dave Legeno of his character, Fenrir Greyback. "He's transformed so many times that he still retains elements of werewolf in him, even when he's in his 'untransformed' state. He *likes* being a werewolf, and he doesn't want *not* to be a werewolf. He's happy. He just wishes everyone would join with him."

As a result, while the world might view Greyback as a brutally violent character whose one aim in life is to infect as many people as possible with the curse of lycanthropy, Dave chose to think of him as a social outsider: "What I found in him was a sense of isolation, that if the world rejects him as an outcast—as it often rejects all kinds of individuals with differences or problems—then to compensate he wants to infect others so they can become like him and he doesn't feel so separate from the rest of the world." Dave adds that he wanted his portrayal to be completely original, "because there's no other werewolf in history that can be compared to Greyback."

WANTED

BY THE MINISTRY OF MAGIC

FENRIR GREYBACK

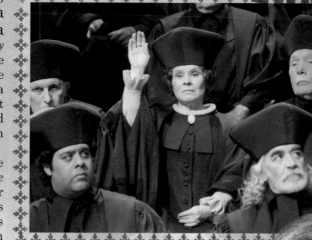

While relishing the vicious, pink-attired professor as a "cracking good part," Imelda acknowledged in an interview with *The Sunday Telegraph* that it was challenging to make Umbridge a formidable foe for Harry when she "could easily have been ludicrous." As she further explained, it was a process of discovery: "David Yates was wonderful at helping me make sure that she was complicated and difficult, had many layers to her, and was to be seen as a real threat."

Drawing on the rich descriptions of Umbridge in the novels, the creative team behind *Order of the Phoenix* was able to bring out the character's sinister duality in their design of the sets, props, and costumes associated with her. Great attention to detail was paid to her office décor, including her kitsch collection of decorative plates, featuring meowing kittens, decorating the rose-pink walls. The set decorators created 134 plates, a process that involved photographing and filming kittens with baskets, goldfish bowls, crystal balls, miniature witches' hats, balls of wool, and other cute props. Photos were then combined with borders taken from real plates, and additional bordered plates were created with green screen centers so that the moving, filmed kittens could be added later.

Umbridge's passion for pink is best reflected in her choice of outfits. Jany Temime spent months hunting down different fabrics: "I chose a lot of soft materials for her— velour, velvet, mohair, and soft, handwoven tweeds. Everything is in pink but, little by little, as we discover Umbridge's true character, the colors change from lovely pastel shades of grey-pink to deeper and darker tones, ending with a terrible, explosive fuchsia when her aggressiveness is finally exposed."

Little-girl brooches of cats and butterfly-shaped buttons accented these pretty-in-pink ensembles, while Dolores's makeup matched the color transitions of her clothes with a range of increasingly strong shades of pink lipstick, nail varnish, and blush. With Umbridge's public face so well made-up, Imelda was able to focus on the more subtle aspects of the character and on perfecting the innocent "*Hem, hem!*" with which she makes her menacing presence felt.

A letter from Umbridge to McGonagall.

Minerva,

I would like to bring to your attention the insolent behaviour, in class, of Mr Potter. The following reprimandable incidents occured under my authority:

1- Potter shouted at me in class.
2- Potter called me a liar in class.
3- Potter alleged that He Who Must Not Be Named has returned.

I trust you will consider these transgressions with due severity.

Dolores Umbridge

Dumbledore's Army

Hermione Granger
Ron Weasley
Harry Potter
George Weasley

Fred Weasley

Ginny Weasley
Luna Lovegood
Neville Longbottom
Padma Patil
Parvati Patil
Cho Chang

Zacharias Smith
Seamus Finnigan
Marietta Edgecombe

"**D**umbledore's Army," says Daniel Radcliffe, "is basically a guerrilla revolutionary organization. And it's Harry who's the teacher, using the knowledge that he has gained over the last five years to train other people and teach them how to fight if they are called upon to do so."

Harry, though, is not so keen to take on this responsibility at first. Hermione and Ron eventually persuade him to take on this important role in the conflict with Voldemort. "That is one of the really touching elements to Hermione and Harry's story," says Emma Watson. "Even when he doesn't have faith in himself, she does. And that's what friends are for."

After the inaugural meeting of the group at the Hog's Head in Hogsmeade, Neville Longbottom finds the Room of Requirement in Hogwarts that becomes the army's headquarters. "In the book, the room was sort of 'cushiony,' with cushions, and bookshelves filled with books," says Matthew Lewis, who plays Neville in the films. "But in the film, there're lots of mirrors everywhere and steel grills on the floor. It's a really atmospheric set that looks like an underground fight club in Hogwarts."

Stuart Craig explains why he wanted to diverge from the description in the book to what he describes as an empty, neutral space in which the only significant features—apart from its curious half-suspended columns—are the many mirrors. "Photographically, the reflections offered exciting possibilities," he says. "But they were also appropriate for the young army in that they reflected them and their needs back to themselves."

Although they are training for what will likely be the battle of their lives, the D.A. members also have some lighter moments in the Room of Requirement. "They're practicing some spells together when Ron comes up and says, 'Oh, yeah, it's all right, I'll go easy on you,'" recalls Emma Watson. "And to Hermione that's patronizing and sexist and represents everything that she is completely against. And so she just takes Ron out—absolutely, completely, and utterly!"

123

McGonagall (Maggie Smith) dancing with Ron (Rupert Grint).

Deputy Headmistress Minerva Mc-Gonagall is described in the books as having a look that makes Harry think she is "not someone to cross." Actress Maggie Smith echoes this description: "I suppose I'm the one who keeps them in order," she says. "I care very much about them, obviously, but I'm really fairly fierce."

McGonagall's "emerald green robes" were the starting place for costume designer Judianna Makovsky, but it was the actress herself who suggested adding a touch of Scottish influence. As a result, she acquired a Celtic brooch and an outdoor hat that was a cross between traditional wizard headgear and a deerstalker—with a hint of plaid and a modest cockade of game-bird feathers. Clearly, Maggie was paying attention to the fact that McGonagall appears in the book in a "tartan dressing gown."

McGonagall always has the best interest of Hogwarts' students at heart, but can sometimes be stern. Maggie's pitch-perfect comic timing, however, serves to balance that sternness on film—from her encounter with Mad-Eye Moody in the fourth film when she learns he has turned Draco Malfoy into a ferret, to a scene from the same film that the actress says is most memorable for her. "I had to try to teach Ron Weasley to dance, and that was pretty strenuous!" she says with a laugh. "Poor Rupert! I mean, I've got two left feet too, so we both looked pretty silly!"

Professor McGonagall in her Animagus form.

Matthew Lewis as NEVILLE LONGBOTTOM

After reading *Harry Potter and the Sorcerer's Stone*, ten-year-old Matthew Lewis put on his dressing gown as a wizard's robe, got some sticks from the garden to use as wands, and, with a friend, "started firing spells." "I got the first three books," he says, "and read them one after the other. I thought they were fantastic—absolutely brilliant—and I couldn't get enough of them. Every time I finished a book, I felt like I'd lost a lot of friends until the next book came out. I was really caught up in the whole universe."

Matthew remembers lining up at a bookshop in his hometown of Leeds to buy *Goblet of Fire*, which he read cover to cover in only four days. "After that," he recalls, "I knew that I wanted to be—I *had* to be—a part of the film in some way." An opportunity to attend an audition in London arose. "I was such a fan of the story," Matthew says, "just to be at the audition was spellbinding, never mind landing a part like Neville Longbottom!"

Describing his role, Matthew says: "Neville's a very shy and vulnerable boy who is easily bullied because he's clumsy, forgetful, and very nervous around other people. But Harry looks after him, and Neville really looks up to Harry because of the courage he constantly shows every year."

Early on, the film's makeup and wardrobe departments fitted Matthew with a fat suit, a set of false teeth, and what he calls "stuff to make my ears stick out." These bits of physical transformation were invaluable to Matthew. "When, as an actor, you look in the mirror and don't see yourself but see the character, it does really help put you into the role."

Like the other central characters, Neville's personality develops through the series. "He's evolved a lot over the years," says Matthew, "and eventually he comes into his own and changes beyond anyone's expectations. He's still not the perfect hero. He's just a normal kid who's trying to get by and, as the films progress, has to take on a great deal of responsibility. Of course, he's still the same Neville, really: still very forgetful, still a bit clumsy, and he's still got his Gran! But look at him! He can do spells now; he's leading the resistance; he's not as shy or vulnerable as he used to be; he stands up for himself and stands up for his friends."

Matthew has enjoyed playing the same character for ten years. "Every year," he says, "just bringing a little bit more to the part of Neville—adding layers—has been even more demanding than playing a completely different character."

AZKABAN PRISON

Helena Bonham Carter as
BELLATRIX LESTRANGE

H. 0 geH ४⋀ ⋂25⋏

WANTED
BY THE MINISTRY OF MAGIC

BELLATRIX LESTRANGE

...RANGE IS A KNOWN D...
...RDERER. FUGITIVE FR...

...TH EXTREME

...FORMATION
...LEASE CONTA...
...ROR OFFI...

...RD...
...WARD OF 1,000 G...
...EST OF BELLAT...

"There's a dilapidated quality to her," says Helena Bonham Carter of her character, Bellatrix Lestrange, "in the way that she was once intensely glamorous and very beautiful—but has gone to seed." Helena saw Bellatrix as "an out-of-control child," and wanted to incorporate into her performance a sense of Bellatrix's suffering during her fourteen years in Azkaban prison.

The actress worked closely with Jany Temime to devise a series of outfits that combine delicate embroidery with armor-like protection, focusing on her femininity with a tightly laced corset that enhances her waist and bust. "I've done witches before," says Helena, "and I've done the hag look, and I thought, 'This time I've got to be sexy!'"

The "Bellatrix look" was exaggerated through Helena's collaboration with makeup artist Amanda Knight: "Helena wanted to have rotten teeth and nasty nails that were long and gnarled," Amanda recalls, "and I remember her painting bags underneath her eyes and sinking her cheeks to make herself look evil and nasty—but then counteracting that with lots of eye shadow, dark lipstick, loads of mascara and eyeliner. There are several things about her look that clash with one another, but it works for Helena."

The finishing touches to Bellatrix come from a hairstyle that Helena describes as "conspicuous," a collection of bird-skull rings and pendants, and a wand similar to the one used by Voldemort—a curved, claw-like extension of her hand. "It gives me a long arm," says Helena. "It gives me extra length. It's quite useful, and it's good for doing your hair!"

125

(above) Bellatrix's claw-like wand and *(below right)* a reference picture of jewelry worn by Bellatrix in the movie.

AZKABAN PRISON

⋀ ⊥ 9

THESTRALS

"Thestrals are brilliant," says Daniel Radcliffe. "If you can imagine the apocalypse, they look like the type of things that the Four Horsemen would be riding." While Thestrals pull the Hogwarts "horseless carriages" unseen by most of the students, they are visible to anyone who has seen death—including Harry Potter and Luna Lovegood. "They're big, black, and bony with really big wings," says actress Evanna Lynch, "And they're nice creatures. Well, I don't know if all of them are, but Hagrid's lot is because he's tamed them."

The Thestrals first became visible to movie audiences in *Harry Potter and the Order of the Phoenix*, requiring the filmmakers to decide what the creatures would look like. Visual effects supervisor Tim Burke recalls director David Yates wanting the Thestrals to have a regal air about them. "As they're non-speaking characters, we had to convey that through movement," he says. "The way horses and stallions carry themselves is an indicator of how character is conveyed through physical stature, stance, and pose."

The initial design by concept artist Rob Bliss depicted a creature that was strange and scary, yet noble and elegant. Sculptures made from the artwork served as references for digital animators down the line. The modelers took great care to capture the subtleties of coloring in Rob's detailed skin textures—pale mottling under the belly and the translucency of the wings—so as not to lose them in the animal's overall black coat.

As one would expect, the depiction of imaginary creatures presents various challenges. Visual effects producer Emma Norton explains: "No one knows how a Thestral [flies]. What does it do with its legs? Does it prance through the air? We thought that would be silly, so we had the animal tuck them up. It was just a trial-and-error process."

Another revision was needed when the time came to make the Thestrals fly with Hogwarts students on their backs. Their wingspan, as initially designed, no longer appeared wide enough to support the animal and its rider; so, for those scenes, the wings were made larger.

And when David Yates wanted a baby Thestral to drink from a pool? "The Thestral's legs were so long and its neck so short that its head wouldn't reach the ground!" recalls Emma. "In order to take a drink, it had to stand with its legs wide apart, like a giraffe."

(above) A maquette sculpted by Kate Hill. *(right)* Thestral concept art by Rob Bliss. *(below)* Evanna Lynch (Luna Lovegood) with director David Yates and head of visual effects Tim Burke, who is holding a Thestral head.

Evanna Lynch as LUNA LOVEGOOD

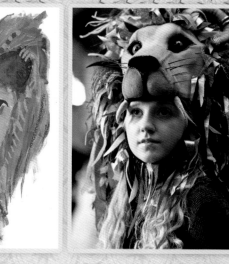

"**S**he literally is Luna," Emma Watson told the BBC about her costar Evanna Lynch, who plays dreamy Ravenclaw student Luna Lovegood. "I can't tell the difference between her on-camera and off-camera!"

If Evanna seems particularly at home in the Harry Potter universe, it's probably because she's been a self-professed obsessive fan of the books for years. Always in the know about Potter goings-on, Evanna found out there was going to be an open audition in London—a plane ride away from her home in County Louth, Ireland. "My mother hates it when I quote this," laughs Evanna, "but she thought I had a 'snowball's chance in hell.'" Eventually Evanna's father agreed to accompany her to the audition.

The one who would be Luna, of course, was Evanna, though she had to go through the usual process of call-backs and, later, a screen test with Daniel Radcliffe.

At one point, Evanna recalls, while still waiting

(top right) Actress turns designer: Evanna Lynch's concept art for Luna Lovegood's lion hat—worn when supporting Gryffindor at Quidditch matches.

to hear about the part, someone from the studio phoned and asked that she please not shave her eyebrows. Evanna was flabbergasted, but encouraged. "My sister said: 'If they're looking at your eyebrows you must be very close!'" It wasn't long before she arrived on the set with her own handmade "radish-like" earrings (a staple of Luna's wardrobe).

The earrings weren't the last thing Evanna designed for her character. "She likes to do little things herself," says Jany Temime. Using this as inspiration, Jany designed clothes for Luna with an arts-and-crafts look to them that were a little more "wizard child" than those of her peers. In the sixth film, Evanna even helped design the lion headdress she wears to show her support for the Gryffindor Quidditch team. "I wanted it to look like it was eating her head," she said in an interview on her fan site.

Evanna's journey from fan to film star may seem out of a fairy tale, but she wasn't truly awestruck until she met J. K. Rowling. "It was amazing," she says of the experience, stressing what an impact Rowling's writing has had on her. "It's a big part of my life, you know?" She says it's "hard to put into words" how much the books mean to her, but the fact that the walls of her bedroom have her favorite *Harry Potter* quotes painted on them speaks volumes.

Evanna is noticeably less serious when she describes the acting process, saying: "Being Luna is kind of natural."

127

(above) Luna's dress for Professor Slughorn's Christmas party.

(right) Luna's list of lost items.

LOST.

✦ 1 earring (with beetlewings).
✦ Pair of stripey socks.
✦ School Cloak — Black.
✦ Purple Quill (woodpecker, with special markings)
✦ Pair of school shoes
✦ 'Bubble Bum Booster' kit (still in wrapper)
✦ Book : 'Fantastic Beasts and Where to Find Them'
✦ another Book : 'Easy spells to fool Muggles'
✦ Bottle of sum-solving ink, Turquoise 25

PLEASE RETURN to LUNA LOVEGOOD
By the end of term
Thankyou.

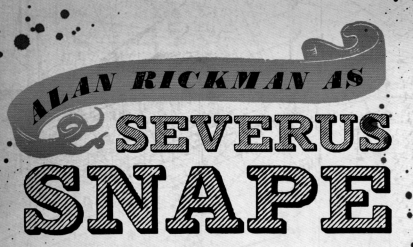

ALAN RICKMAN AS SEVERUS SNAPE

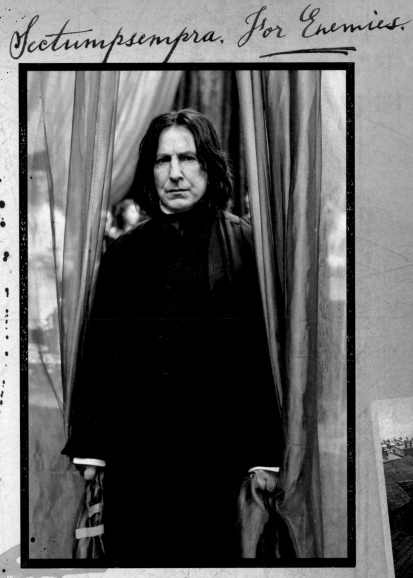

Alan Rickman was J. K. Rowling's first choice for the role of Severus Snape, but the actor himself was not so sure. "I said to Jo Rowling, 'Look, I can't play him unless I know him,'" he recalled in an April 2009 interview. Rowling appealed to him by sharing a key piece of information about Snape that she hadn't yet told anyone else. Armed with that revelation, Alan was convinced, and readily slipped into Snape's stark black robes and wig of greasy hair, giving the character a very distinct personality.

Through most of the series, Snape reveals very little about himself to Harry or to anyone else. Sometimes more can be learned about Snape's personality through visuals than through dialogue. His old copy of *Advanced Potion-Making*, for instance, is full of notes penned by Snape in his youth. These meticulously designed notes, penned in an aggressive, angular style, speak of an isolated, lonely adolescence.

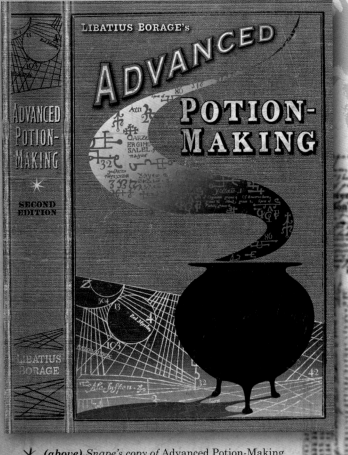

(right) Snape's home town of Spinner's End was inspired by industrial landscapes in the north of England. Production designer Stuart Craig says: "The smoking mill chimney in the distance and the back-to-back, terraced housing made an interesting contrast to the wizarding world."

(above) Snape's copy of Advanced Potion-Making from his days as a Hogwarts student, in which he refers to himself as "The Half-Blood Prince."

When the art department created the set for Snape's home in the mill town of Spinner's End, they saw it as an opportunity to explore his background and emotional state. Rowling had described the house as full of books, so set decorator Stephenie McMillan made sure that books were everywhere—lining the walls in bookcases, piled on the floor, and even resting on the hallstand. "But," she notes, "they were all toned down so they were very dark brown, or very dark blue, or black."

Stephenie also added "very simple black silhouettes and landscapes" to the décor that could have belonged to Snape's parents (from whom he inherited the house). When Alan came on the set, she watched as he surveyed the house. After considering the setting, he said simply, "I don't think there'd be any pictures in here." Stephenie agreed and removed most of them. "That felt right to me," she says. "Snape is quite an anonymous character, so it was very good that the set has an anonymous texture."

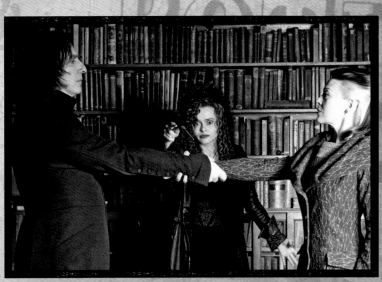

Snape (Alan Rickman) makes the Unbreakable Vow with Narcissa Malfoy (Helen McCrory).

Concept art by Andrew Williamson for Snape's home.

129

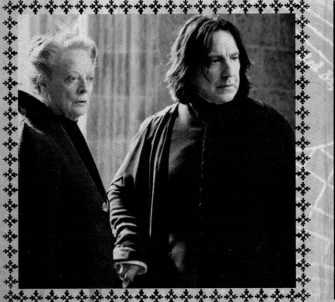

Snape (Alan Rickman) and McGonagall (Maggie Smith).

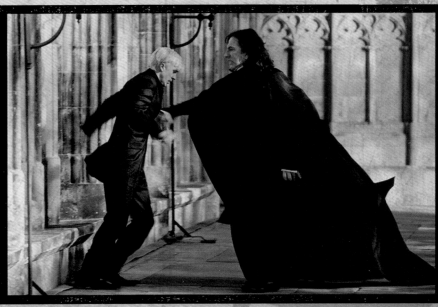

Snape (Alan Rickman) confronts Draco (Tom Felton) in a scene from Half-Blood Prince.

Harry Potter and the Half-Blood Prince

"It wasn't in the book, and it wasn't originally in the script, either," says producer David Barron of the spectacular opening to *Harry Potter and the Half-Blood Prince*, "but the moment we started shooting, David Yates said, 'I've had this idea!'"

For the second time in the series, a *Harry Potter* film does not open on Privet Drive; rather, the sixth film open as Voldemort's Death Eaters stage a terrifying attack on London. Screaming through Trafalgar Square and up Charing Cross Road (all painstakingly recreated in digital imagery), the Dark Lord's emissaries explode into Diagon Alley, destroying Ollivanders wand shop and wreaking havoc. Then, in an astonishing sequence, they rip through the business center of London and destroy the Millennium Bridge spanning the Thames.

According to producer David Heyman, this dramatic opening reflects a concept integral to the series: "We really like the idea that these magical places are so close to us—that the wizarding world exists right next door to our world, around every corner.

Witnessing a Death Eater attack on places both magical and familiar reinforces that fantastic possibility."

Despite this action-packed beginning, David Yates—returning to direct his second *Harry Potter* film—feels the key to the story lies in its characters. "We've all grown up with them," he says. "There was something about the early books and movies [that] was all about the world and the joy and extraordinariness of that world. But that's a given now, and what we're experiencing with the stories at this point is that we really have a relationship with the characters and it is one that we want to continue."

At the core of J. K. Rowling's books—and at the heart of the film adaptations that capture the essence of her novels—is a sense of discovery. Harry uncovers, piece by piece, the history of Voldemort and the way in which his own life and fate are linked to those of the Dark Lord. At the same time, and often in a lighter vein, the central characters make discoveries about themselves, their emotions, and their ever-changing relationships to one another.

"The romance in the film," says Daniel Radcliffe, "is very strong and very, very entertaining." After Harry's first kiss in *Order of the Phoenix*, it is Ron's turn. Ron's first kiss, however, is rather more comedic than romantic. "She's very touchy-feely," says Rupert Grint, giving Ron's view of Lavender Brown, "she's very in-your-face, quite sort of hands-on. She's a bit insane really!"

Adding to the humor in the sixth film is the awkward relationship between Hermione and Cormac McLaggen (played with a perfect deadpan by Freddie Stroma), which is solely intended to make Ron jealous. "Cormac is just so slimy and horrible!" says Emma Watson. "He makes Hermione's skin crawl, but she realizes that out of everyone she could pick to irritate Ron, Cormac would probably irritate him the most!"

Of course, the film also provides Harry with another kissing scene—this time with Ginny Weasley. "Harry feels incredibly strongly about Ginny," says Dan, "but her brother is his best mate, so he doesn't want to jeopardize that. At the same time, he really wants to kiss her. So it's a bit of a dilemma."

David Yates says: "One of the big, continuing themes is friendship and the boundaries of friendship: what you get from your friends, how your relationships with your friends have changed over time, and how, in a way, friendship is often as special as any other kind of relationship."

(below) Harry (Daniel Radcliffe) and Luna (Evanna Lynch) arrive at Slughorn's Christmas party.

(above) Concept art of the approaching Dark Mark storm over London by Andrew Williamson.

REVISITING DIAGON ALLEY

With the continuing rise of the Dark Lord in *Harry Potter and the Half-Blood Prince*, the wizarding world comes under increasing threat, and one of the casualties is Diagon Alley. Looking back to how the street appeared in the early movies, James Phelps, who plays Fred Weasley, describes it as "very alive and very happy and jolly."

However, in a stunning sequence during the opening minutes of the sixth film, we see the Death Eaters rampaging through the street, the destruction of Ollivanders wand shop, and the kidnapping of its proprietor by the werewolf Fenrir Greyback. "The consequences are dire," says Stuart Craig of the huge transformation that has taken place. "We are now in oppressive times. The mood has changed."

(above) Set decorator Stephenie McMillan pastes up a "WANTED" poster in Diagon Alley for the Death Eater Bellatrix Lestrange.

AMYCUS CARROW IS A SUSPECTED DEATH EATER. KNOWN ASSOCIATE OF HE-WHO-MUST-NOT-BE-NAMED.

★ APPROACH WITH EXTREME CAUTION! ★

IF YOU HAVE ANY INFORMATION CONCERNING THIS PERSON, PLEASE CONTACT YOUR NEAREST AUROR OFFICE.

☞ REWARD ☜

THE MINISTRY OF MAGIC IS OFFERING A REWARD OF 1,000 GALLEONS FOR INFORMATION LEADING DIRECTLY TO THE ARREST OF AMYCUS CARROW.

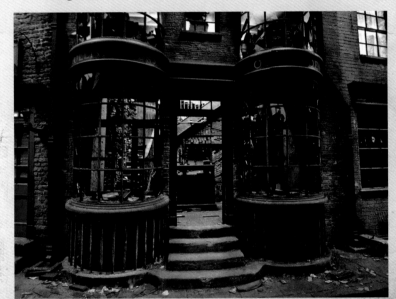

It has, indeed. The once-crowded array of shops—Madam Malkin's Robes for All Occasions, Eeylops Owl Emporium, Quality Quidditch Supplies, and Gambol and Japes Wizarding Joke Shop—all stand empty, their darkened windows boarded up or pasted over with Ministry of Magic "WANTED" posters.

(left & above) Following the attack of the Death Eaters, it is as if Diagon Alley has been drained of color. Everything is seen in monochromatic shades of grey. Despite devastation in the street, however, one shop remains full of bright lights and colors (mostly orange), where it is possible to purchase such "Masterpieces of Modern Magic" as Extendable Ears and Ton-Tongue Toffees: Weasleys' Wizard Wheezes!

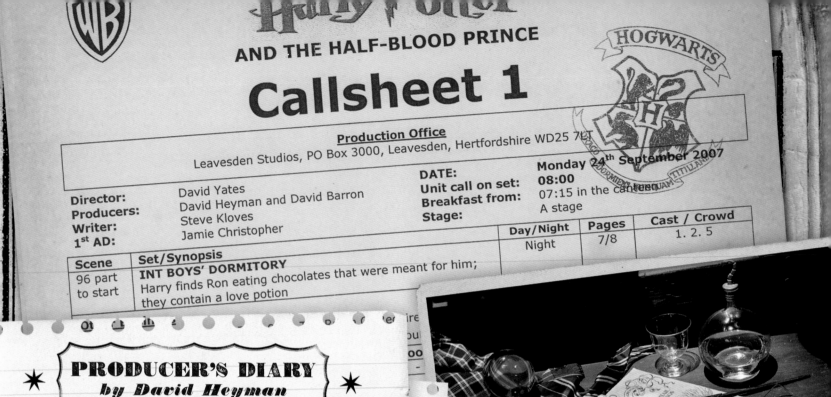

Production Office
Leavesden Studios, PO Box 3000, Leavesden, Hertfordshire WD25 7LT

		DATE:	Monday 24th September 2007
Director:	David Yates	Unit call on set:	08:00
Producers:	David Heyman and David Barron	Breakfast from:	07:15 in the canteen
Writer:	Steve Kloves	Stage:	A stage
1st AD:	Jamie Christopher		

		Day/Night	Pages	Cast / Crowd
		Night	7/8	1. 2. 5

Scene	Set/Synopsis
96 part to start	**INT BOYS' DORMITORY** Harry finds Ron eating chocolates that were meant for him; they contain a love potion

David Yates directs Daniel Radcliffe and Michael Gambon in the cave scene.

★ PRODUCER'S DIARY ★
by David Heyman

Harry Potter and the Half-Blood Prince was, in some ways, the most difficult of the adaptations. It is hard to drive a narrative forwards in a story that is constantly looking backwards. Harry is quite passive as Dumbledore shows him Voldemort's history, and although Voldemort's history is a part of the story, the Dark Lord himself never appears in the present. Also, the narrative drive was interrupted every time we cut away to Voldemort's past. When Steve Kloves delivered his script, however, it was the most complete first draft I have ever seen. He had reduced the number of "memories" and focused on the relationships instead of the narrative drive. While we all loved the memories in the book, they posed a problem for the film, and so Steve had made a benefit of a potential problem. One of the great pleasures of the *Harry Potter* films is the characters, and for all the magic and adventure, they are the key to the films' success. I think the characters in *Half-Blood Prince* are richer and deeper than ever before, and David Yates finds the humanity in each one, whether they be on the dark side or the light.

I love the humor in *Harry Potter and the Half-Blood Prince*, and think it is the funniest of all the films. I particularly enjoy the romantic interplay between Ron and Hermione, who cannot acknowledge that they are in love and do everything possible to make each other jealous. In Jessie Cave's final audition for the role of Lavender Brown with Rupert, David Yates told them to abandon the script and to improvise. Jesse perfectly captured Lavender's annoying obsession, and it was great to see Rupert's discomfort as she found any excuse to get closer to him. When it came time to filming the celebration after the Quidditch match where Lavender grabs Ron and they "snog," Dan made sure to be on set for every take. And he took every opportunity to make fun of Rupert, just as Rupert had done with him the year before!

The sixth film is about Dumbledore preparing Harry for his future—a future that will involve the final confrontation with Voldemort. (It is also a future without Dumbledore, though Harry does not know that.) Dumbledore has been an ever-present, guiding force in Harry's life. It was he who called Harry to Hogwarts—the first real "home" Harry ever knew—rescuing him from the drudgery of life with the Dursleys. And for almost six years, he's been a father figure to Harry. With Dumbledore gone, Harry has nobody to turn to for guidance. His education is over. He is now a man.

Name: *Stuart Craig*

CONFIDENTIAL

DMB-05 No 6283··

Right from the first film, when number four, Privet Drive is bombarded with letters from Hogwarts, you get a strong indication of the impact that graphic artists Miraphora Mina and Eduardo Lima, together with their assistant Lauren Wakefield, have had on the *Harry Potter* films. By crafting all the graphic and printed materials mentioned in Jo's stories, such as books, newspapers, "WANTED" posters, signs, cereal boxes, invitations, exam papers, and packaging for Honeydukes sweets and Weasleys' Wizard Wheezes, the graphic arts department has done a superb job of bringing these important details to the screen.

There's no clear-cut way in which we work together; it's more trial and error. Miraphora and Eduardo come up with ideas and treatments, and then it's a case of "Can you just try this?" or "Could you make *this* a bit less important and increase the impact of *that*?" Having been on this project for ten years and eight films, we know the territory pretty well, and have developed some distinct aesthetics.

Cover and illustration from Hermione's copy of The Tales of Beedle the Bard.

Messrs. Moony, Wormtail, Padfoot and Prongs's Marauder's Map, first created by the graphics team for Prisoner of Azkaban.

As graphic designers, Miraphora and Eduardo are unbeatable. They've designed the Marauder's Map, the *Daily Prophet* (in its two different styles, before and after the paper was taken over by the Ministry of Magic), and *The Quibbler*, as well as all the Hogwarts textbooks such as *The Monster Book of Monsters*, the *Advanced Potion-Making* textbook (including the old copy with Snape's handwritten notes), the complete works of Gilderoy Lockhart, and Rita Skeeter's *The Life and Lies of Albus Dumbledore*.

When Jo Rowling was shown copies of their interpretation of *The Tales of Beedle the Bard*, which they made for *Deathly Hallows*, she was so moved she asked if she could take one home with her. Of course, Miraphora and Eduardo happily gifted her one.

Their work has such a strong impact because it is thoroughly researched. The subject matter may be fantastic, but you see all kinds of influences from art and culture—whether ancient runes or Victorian typefaces—that give a sense of history to their work. This clever pastiche produces mysterious echoes of things that are strangely familiar or that you might dimly understand—quite like magic. I should note, too, that they also designed the book you are now reading!

One of the many issues of the Daily Prophet created by the graphic arts department.

The *Half-Blood Prince* also charts a sig-nificant change in the relationship between Harry and Dumbledore, as Dumbledore entrusts Harry with the significant task of uncovering Horace Slughorn's dark secret. "In a way," says David Yates, "Harry becomes an investigator, a detective. He does it by taking on quite a manipulative strategy, so it's an interesting maturing of the character, which Dan was very keen to explore. This is an older Harry who is beginning to see the world in a slightly more complex way."

A specific detail contained in an unaltered memory of Slughorn's—during which he reveals to the young Tom Riddle key information about Horcruxes—is essential to the Dark Lord's destruction. "He has forever regretted it," says actor Jim Broadbent of Slughorn's encounter with Riddle, "because that's what really set Voldemort on the path to becoming such an evil force. In a way, he was responsible for letting that juggernaut start rolling."

As for Harry's involvement in Dumbledore's plan, Daniel Radcliffe says: "I think Dumbledore realizes why he has to involve Harry, and he takes him on a mission, near the end of the film, because he views it as a sort of rite of passage. He is initiating Harry into what he's going to brave to do after Dumbledore dies." That mission takes Harry and the Headmaster to one of the most visually exciting sets in the film: a remote, crystal-filled cave where, it is thought, one of Voldemort's Horcruxes is hidden.

The Hogwarts Quidditch stadium was updated in the sixth film. "This is super-deluxe Quidditch [as] you've never quite seen it before," says Stuart Craig. "As we all know, Quidditch takes place not on the flat field but in midair. So, they're are more towers, and they're closer together, giving more opportunities for weaving in and out and creating a greater sense of speed with things whizzing by in close proximity."

"I love Quidditch!" said David Yates during filming. "We're doing 'comedy' Quidditch," which has never been done before. Ron's trying to compete for a place in the team and he's terrible at Quidditch! His biggest fault is his fear. Poor old Ron!"

★ LOOK BACK ★
JAMES AND OLIVER PHELPS

James and Oliver Phelps, who play Fred Weasley and George Weasley, respectively, enthusi-astically confirm that their favorite set piece of the *Harry Potter* films is the lavish one created for Weasleys' Wizard Wheezes. It is clear, they say, that the pro-duction team "really thought" about how Fred and George would have decorated—even going so far as to paint the building orange to match their ginger hair. The twins also enjoyed their shop's inventory. According to Oliver: "There's a ten-second pimple remover cream," he says, "which I think would make a fortune if they sold it to the Muggles."

As for which twin is depicted in the larger-than-life statue that graces the front of the store (lifting his top hat to re-veal something new each time)? James re-marks: "It's not every day that I see a twenty-foot version of myself," adding, "It's Fred . . . because I'm the better-looking one." Oliver, however, begs to differ—noting that it is, in fact, George, because his is "the funnier face."

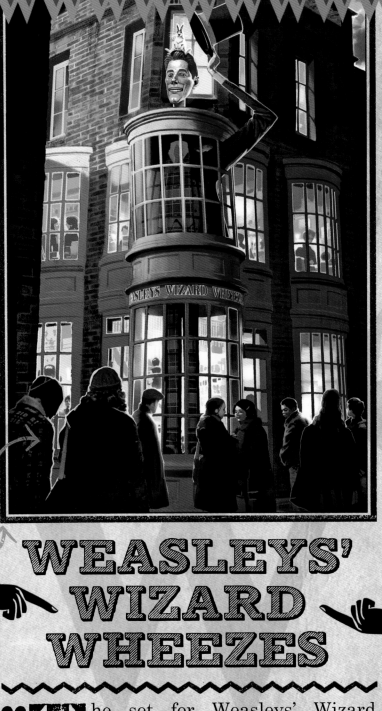

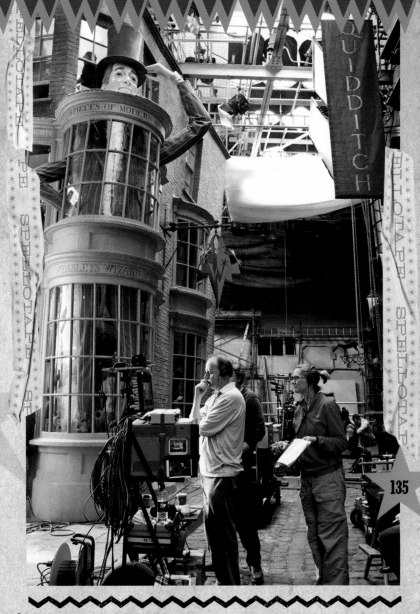

WEASLEYS' WIZARD WHEEZES

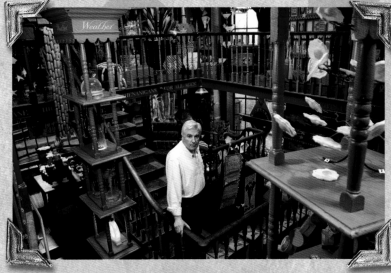

(above) David Yates directing James and Oliver Phelps (Fred and George Weasley) in their Diagon Alley shop. (below) Stuart Craig inside the store.

"The set for Weasleys' Wizard Wheezes," says James Phelps (Fred Weasley), "had so much detail in it that you could stay in there for days and not see it all."

Although on-screen for only a short time, it took months of work and the talents of a great many people to bring to life the Weasley twins' joke shop and magical emporium—starting with the ambitious exterior featuring a gigantic moving figure of one of the twins that opens and closes its mouth, raises its eyebrows, and tips its top hat to reveal an appearing and disappearing rabbit.

The process began in the art department, where conceptual artists began visualizing the catalog of amazing tricks, jokes, and gags on offer in the shop—all of which were created in a style recalling the cheap plastic and tin toys and brightly colored sweets enjoyed by children in the 1950s. Even the packaging for the Weasley products was designed by Miraphora Mina and Eduardo Lima with unsophisticated graphics, printed in garish colors on low-quality paper.

TURN OVER FOR MORE!

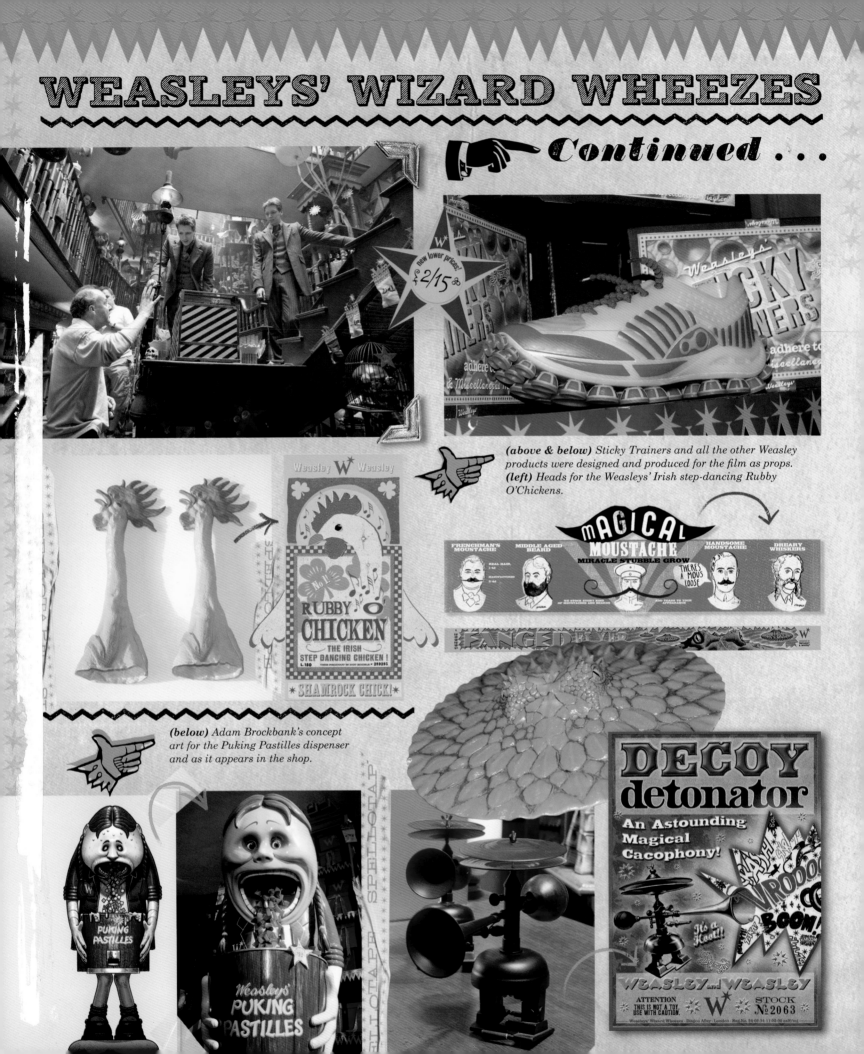

new lower prices!
£2/15

(above & below) Sticky Trainers and all the other Weasley products were designed and produced for the film as props.
(left) Heads for the Weasleys' Irish step-dancing Rubby O'Chickens.

Weasley W Weasley

No.11

RUBBY O' CHICKEN

THE IRISH STEP DANCING CHICKEN!

L.150

SHAMROCK CHICK!

MAGICAL MOUSTACHE
MIRACLE STUBBLE GROW

FRENCHMAN'S MOUSTACHE	MIDDLE AGED BEARD		HANDSOME MOUSTACHE	DREARY WHISKERS

THERE'S A MOUS LOOSE

FANGED

(below) Adam Brockbank's concept art for the Puking Pastilles dispenser and as it appears in the shop.

PUKING PASTILLES

Weasleys' PUKING PASTILLES

DECOY detonator

An Astounding Magical Cacophony!

VROOO

BOOM!

It's a Hoot!

WEASLEY and WEASLEY

ATTENTION
THIS IS NOT A TOY. USE WITH CAUTION.

W

STOCK No. 2063

Weasleys' Wizard Wheezes, Diagon Alley, London

WEASLEYS' FAMOUS
UNLUCKY DIP!

Drawing on memories of crudely designed charity collecting boxes in the shape of children and animals that used to be found outside British shops, concept artist Adam Brockbank designed a display stand for tubes of Ten-Second Pimple Vanisher, featuring a head with pimples that came up and went down.

As for the Puking Pastilles dispenser, Adam notes: "We wanted it to be kind of funny and disgusting at the same time," says Adam, "So we came up with a giant, slightly-badly-sculpted kid throwing up into a bucket, so you can fill a cup under the stream of Puking Pastilles and then go and pay for it." Prop-maker Pierre Bohanna explains: "We made this wonderful, crazy, six-foot-tall girl vomiting a never-ending stream of Puking Pastilles. Brilliant nonsense! Great fun!"

Pierre and his colleagues also had to produce thousands of vivid green and purple pastilles to be "puked," along with Edible Dark Marks and the various sweets found in the Weasleys' Skiving Snackbox, such as Fainting Fancies and Nosebleed Nougat.

In addition to sweets—and the love potions that catch Hermione's and Ginny's eye—the designers and prop-makers created an amazing range of magical and mechanical novelties such as Sticky Trainers for walking up walls, Fanged Frisbees, Screaming Yo-yos, Decoy Detonators, and Boxing Telescopes . . . as well as a tin toy of Dolores Umbridge that runs along a tightrope, muttering, "I will have order!"

(left) Adam Brockbank's art for the Screaming Yo-yo.

137

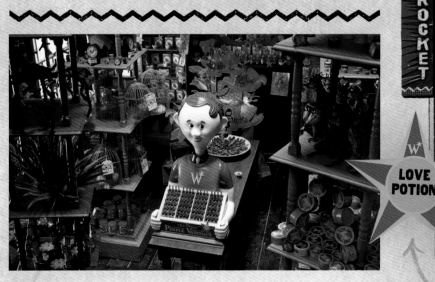

(above) A corner of the Weasley's shop set that took weeks to fill with products before filming began, including a display stand for Ten-Second Pimple Vanisher and, behind it, the purple flower-shaped Love Potion stand.

Jim Broadbent as
HORACE SLUGHORN

"**I** was a lavatory seat—in a voice-over," Jim Broadbent joked to *The Daily Telegraph*. "But this is a first," he continued, "The first armchair anyway." Jim's character, Professor Horace Slughorn, makes his first appearance in *Harry Potter and the Half-Blood Prince* disguised as a lilac-striped armchair—a disguise that magically falls away when he stands up.

To animate the change in form, visual effects supervisor Tim Burke realized Jim needed to "play" the armchair. The actor was put onto a special rig that allowed him to sit with his arms out in a position that roughly mimicked an armchair. "At the correct moment in the shot," says Tim, "we lifted him up, and he basically shook himself out. Then we drove all of the animation from that."

As Slughorn transforms back into himself, it becomes apparent that he is wearing pajamas made from the same light purple cloth as the chair. These nightclothes were created first, with a fabric found by Jany Temime. Then, a chair was upholstered in the same fabric. The grey paneling on the walls of the borrowed house where Dumbledore and Harry first discover Slughorn was also chosen

with the professor's "lavendery-purple color in mind," according to Stephenie McMillan.

Once back at Hogwarts, the predominant colors for Slughorn's clothes shift to a palette based in rust, brown, and beige, giving Slughorn a look that Jany describes as "faded grandeur." Slughorn's wardrobe has been accumulated and worn over twenty years or more, and all of his outfits—his classic woolen suits, his fur-trimmed winter coat, even his richly decorated damask robe—have all seen better days.

Costume fabricator Tim Shanahan and his colleagues are responsible for making newly made costumes look old and worn through a process known as "breaking down." With Slughorn's clothes, Tim and his team "thinned out the fibers in areas where you would logically have wear: around the shoulders, cuffs, and pockets . . . [and] washed them with solutions of powder that remain in the material as if it's an accumulation of many years of dust."

Jim describes Slughorn as ". . . eccentric. He's passionate about his work, incredibly knowledgeable, and sort of obsessive. But he's also flawed as well. There is a dark secret in his past, which he bears heavily."

(right) Concept art of the armchair transforming into Slughorn by Adam Brockbank, a storyboard by Jim Cornish, and a costume sketch by Mauricio Carneiro—all showing Slughorn with a moustache (as he was originally going to appear). (below) Slughorn's office and potion bottles. The graphic arts department estimates that they have created at least 150 potion labels.

Tom Felton as
DRACO MALFOY

Actor Tom Felton is not recognized in public as often as some of his Harry Potter costars. For his role as Draco Malfoy, his brown hair is bleached a pale, nearly white blond, changing his appearance dramatically. While he may joke about the peroxide going to his head, Tom is serious when talking about some of his co-stars. Imelda Staunton? "They say 'roll cameras,' and she just gets this psychotic look in her eyes." Jason Isaacs and Helen McCrory? "The best evil family anyone could ever ask for." Alan Rickman? "Literally, you give him three lines: he'll take a minute and a half to say them."

When he was cast as bullying Draco, Tom was one of the few children on the set who had had previous professional acting experience. Tom recalls sitting with a group of seven other boys at the *Sorcerer's Stone* auditions—the rest of whom were diehard *Harry Potter* fans trying their luck. They were asked to name their favorite scene in the book. "Of course I hadn't read it," Tom recounts. "The guy next to me said, 'Oh, Gringotts, I love the goblins!' So I just said the same as him—'I love the goblins, they're brilliant.' Straight away Chris Columbus saw through that, and I'm pretty sure it gave him a little internal laugh. That could have helped me."

A couple of years older than Daniel Radcliffe, Tom says they were polite to one another but did not bond as friends until they both got a little older. Watching *Harry Potter and the Sorcerer's Stone* recently, Tom hopes his acting has come a long way since then: "I was watching the little scene between Daniel and [me] and just thinking 'Oh my God,'" he laughs. "Not Dan or the film—but just looking back on myself thinking, '. . . How did you get away with that sort of thing?' I like to think we're both a bit better now than we were then!"

Tom Felton originally auditioned for the roles of both Harary and Ron before being cast as Draco Malfoy.

T om has thoroughly enjoyed playing a more complex side of Draco in the *Half-Blood Prince* and *Deathly Hallows* films. As Dumbledore's would-be assassin in the sixth film, Tom's performance received praise from critics, fans, and his fellow actors. In an interview with Rebecca Murray, Daniel Radcliffe stressed that Felton was the key to the film's story. "I think for Tom to come in . . . and give this performance in the sixth film is remarkable," he said emphatically. "And it's a fantastic performance."

With Lucius Malfoy in jail, Draco takes on his responsibilities as a Death Eater but, as Dumbledore is able to see clearly at the end, is not completely sure of what he is doing—or that he is on the right side. His "posturing" is even reflected in his costumes—very formal and stark black, the kind of things that his father might have worn. An emotional fight scene between Draco and Harry in a Hogwarts bathroom was a highlight for both actors to film. "It was great," Tom told *Blast* magazine. "We did our own stunts; it was a week of being rigged up in a bathroom filled with explosives."

When asked about the end of the series, Tom is reflective and notes how many happy memories of his childhood he will be leaving inside Leavesden Studios. He is grateful that his character appears in the epilogue and is sincerely looking forward to filming it. "It's all beautifully left to interpretation, isn't it?" he told the *Wall Street Journal* of the scene and the speculation that Draco has changed for the better at that point: "One thing I got from that final scene is that there is a recognition moment between Harry and Draco as they put their kids on the train—and it's a very real moment, and very touching."

141

(above) Storyboard sketches by Stephen Forrest-Smith for the scene in *Half-Blood Prince where Harry confronts a sobbing Draco.*

(above) Draco's cartoon of Harry drawn by Eolan Power, son of concept artist Dermot Power. The cartoon appears in *Prisoner of Azkaban.*

THE CAVE

(left) A sketch for the cave's location by Stuart Craig. (right) Concept art of an Inferius by Rob Bliss and a storyboard of the Inferi dragging Harry underwater drawn by Stephen Forrest-Smith. (below right) Concept art for the boat by Stuart Craig.

One of the unique challenges for the team of filmmakers working on the sixth film was the creation of a cave in which Voldemort has hidden a piece of his soul, and which is a backdrop for one of the film's climactic scenes.

"We asked ourselves what the cave was like," says Stuart Craig. "Was it extraordinary? Was it intimidating and frightening? And how could it be created so as to make it believable?"

To achieve an appropriately dark and intimidating look for the exterior entrance to the cave, Stuart and his team turned to the dramatic seven-hundred-foot-high Cliffs of Moher on the west coast of Ireland. Once they had this model for the exterior in mind, they began researching locations that could provide a model for the interior of the cave.

Having considered populating their interior with rock formations such as the stalactites and stalagmites found in limestone caves, they went on to explore a quartz crystal cave in Switzerland and the massive salt mine in Merkers, Germany, that, during the second World War, was the hiding place for a vast stash of Nazi gold and stolen artworks. There, fourteen miles underground, they found an immense cavern of salt crystals that became the primary inspiration for the Horcrux cave.

(below) The cave set surrounded by green screen and (above) in the finished film with the digitally added background.

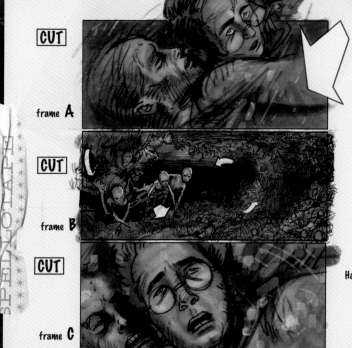

SPELLOTAPE

Camera static.
start on Inferi woman,
they drop through water and
frame.
Harry looks to the side.

CUT

frame A

Harry's POV.
Inferi rising up.
Two Inferi children afeatured
amid them..

CUT

frame B

Extreme close up Harry.
Inferi BG.
Harry's eyes star to lose their vitality.

CUT

frame C

2nd May 20
Scene 1

SPELLOTAPE

Since it was decided that the cave would be two hundred feet long, it clearly could not be built as a full-sized studio set. Instead, the filmmakers decided to create a virtual set by filming the actors against a green screen and then digitally adding in the background, water, and the Inferi. The visual effects department based their designs on concept drawings of the cave and the underground lake by Andrew Williamson, and of its Inferi population by Rob Bliss.

143

To build the island where the Horcrux lay hidden, the filmmakers used a combination of fiberglass and resin. The island's elaborate crystalline form was lit from below to create haunting patterns of luminosity.

Overall, the cave needed an atmosphere that was utterly foreboding. "It was always going to be a really scary scene," says visual effects supervisor Tim Burke. "Instead of grotesque horror, we tried to play on the psychological and eerie creepiness of the scene."

 (right) *The scoop that Dumbledore uses to drink the potion was designed to resemble a fossilized shell trapped in a crystal. Sixty different prototypes were created before the finished piece was molded and made.* **(left)** *The fake Slytherin locket.*

Harry Potter and the Deathly Hallows – Part 1 and Part 2

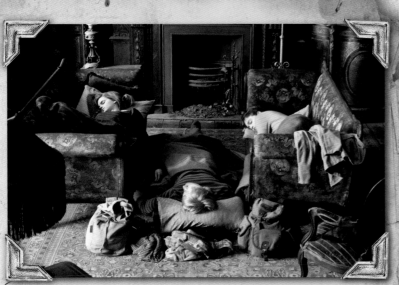

Hermione (Emma Watson), Ron (Rupert Grint), and Harry (Daniel Radcliffe) hide out at 12, Grimmauld Place while on the run.

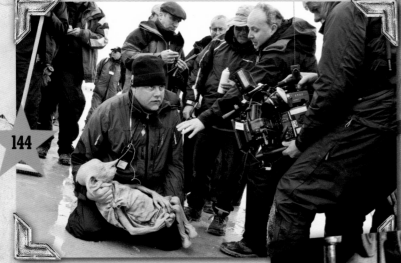

Filming Dobby's emotional death scene.

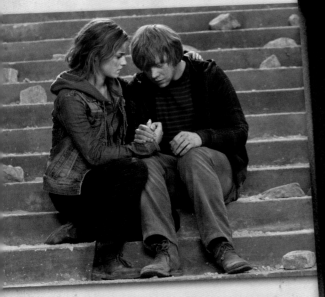

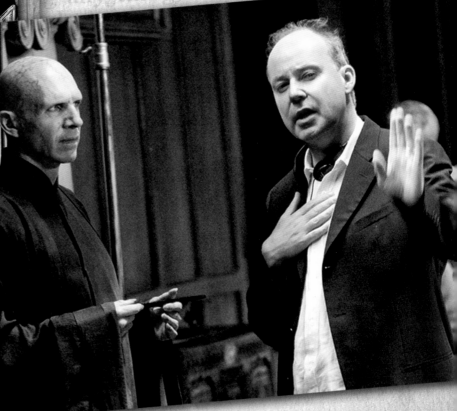

(above) *Hermione (Emma Watson) comforts Ron (Rupert Grint).* **(right)** *David Yates directs Ralph Fiennes as Lord Voldemort.*

Once the *Harry Potter and the Deathly Hallows* book was published, it became clear that adapting the novel as a single two- or three-hour movie would prove impossible. "It would have compromised not just the individual film but the overall story, because it is one story," says producer David Heyman. "There was so much resolved emotionally and practically in the last book that we would have had to leave out, the ending would have not made sense and would have been really unsatisfying."

Having accepted the decision to split the book into two films, the filmmakers were faced with the next challenge: deciding the ideal point in the narrative to break the story. The original thought was to end with the death of Dobby the house-elf, but it was noted that the previous three films had also ended with a death, so the working idea was to end *Deathly Hallows – Part 1* with Harry, Ron, and Hermione, captured by Snatchers and taken to Malfoy Manor. "I thought it would be a great cliff-hanger," recalls Yates. "But when I viewed the first cut with Mark Day, my editor, I felt a lack of completeness. So we went back to the original plan, ending with Dobby's burial. It was much more satisfying, and quite moving." There is still a cliff-hanger, however, as the last image of the movie is Voldemort destroying Dumbledore's tomb and stealing the Elder Wand.

Yates saw the two films as having two very distinct styles. He describes *Harry Potter and the Deathly Hallows – Part 1* as an

"intimate, edgy road movie. The trio is isolated and alone and vulnerable in this dark, dangerous world, so I wanted everything to feel slightly rougher and more real." To that effect, much of the shooting was done with handheld cameras and the film's palette of colors was limited to muted, modern tones. In contrast, Yates saw the second film as "much more operatic and epic. It has big battles and lots of destruction. The color palette was very rich, the red of fire and blood, so it feels quite different to *Deathly Hallows – Part 1*."

Embarking on two movies that would be opening within eight months of each other was a major undertaking. For Daniel Radcliffe it was "the only way to do it," although he admitted during filming that the process of simultaneously making two movies was demanding. "It's quite mad!" he said at the time. "On one day, you might do a scene that's right at the beginning of the first part, and then, the next day, something that's right at the end of the second, where you're covered in blood. So it's a friendly atmosphere of chaos—which I find rather enjoyable!"

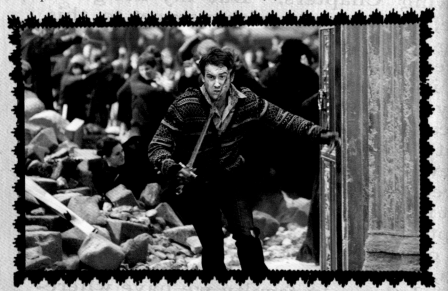

With production of both films in full swing, filmmakers focused on another key component to capturing the richness and texture of the complex, imaginative story—the music score and its composer. For the final *Harry Potter* story, "we thought it would be lovely if John Williams would round out the series," says Heyman. However, when Williams was not available, "Alexandre Desplat was the person we immediately turned to." "A new voice can add something to the films," says producer David Barron. "And Alexandre's sensibility brought something distinct and beautiful."

Wrapping up an eight-film story arc that was already a combination of several composers' work "was tricky," Desplat admits. "You have to blend well-known themes as elegantly as you can and with respect for the previous composers, at the same time bringing in your own ideas." Yates describes Desplat's energy and passion for the work as "a joy to watch. The music is beautiful. He took on the challenge of redefining the musical landscape of *Harry Potter* with grace, humor, compassion, and empathy for the characters as the films came to their climax."

(top) Neville (Matthew Lewis) shows that he is a true Gryffindor when he heroically slays Nagini with the sword of Godric Gryffindor, the house founder. (right) The seven Harry Potters.

DANIEL RADCLIFFE

LOOKS BACK

Daniel Radcliffe has seen a lot playing Harry Potter over eight films: Quidditch stunts, hours filming underwater in a tank, dramatic kissing scenes. Nothing could have prepared him, however, for playing seven different characters all disguised as Harry.

In *Harry Potter and the Deathly Hallows – Part 1*, Harry is a wanted man and must be camouflaged when he travels from number four, Privet Drive to The Burrow. "Fleur, Hermione, Ron, the Weasley twins, and Mundungus all take Polyjuice Potion and transform into me," Dan explains, "which means that I have to give impersonations of all those other actors—all those other characters."

The filming experience was confusing, to say the least. Dan likens it to tracing paper: "You're laying one picture over another, over another, over another—that's basically how it works with the seven Harrys. We'd shoot one version with me as one of the characters, and then the camera would stay in exactly the same place, and we'd shoot another version with me as another character—and then, basically, they'd just lay them on top of each other." And what was the most gratifying moment of all of this as an actor? "I was most pleased about how good I looked in Fleur's costume," laughs Dan. "There was a glam-rock feel to the whole thing."

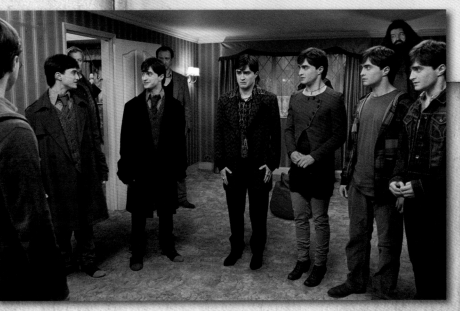

MALFOY MANOR

PRODUCTION DESIGNER'S NOTEBOOK

Name: *Stuart Craig*

For Malfoy Manor, we took our inspiration from Hardwick Hall, a fantastic sixteenth-century mansion built during the reign of the first Queen Elizabeth. A unique building, Hardwick has massive windows—so much so that the ratio of glass to masonry is quite high. When it's dark inside, the window panes have a mysterious, slightly threatening, and rather magical quality. We made a concept illustration that depicted a huge house with enormous windows—the eyes of the building, so to speak—that were, in fact, blind. That exterior, seen as Snape approaches the gate on the front drive, creates a very impressive and intimidating initial look at the Malfoy home.

To bring the building into the wizarding world, we added a roof with spires. The silhouette was terrific, and because the manor is a real departure from the architecture in the rest of the film, I think those pitched roofs convey something rather otherworldly—and provide a link back to the Gothic style that *Harry Potter* audiences are familiar with. And, of course, spikes and points tend to add a somewhat aggressive, menacing feeling.

From the entrance hall, with its huge fireplace and Tudor portraits, you climb a double staircase to an upper floor

Severus Snape arriving at Malfoy Manor as envisioned by concept artist Andrew Williamson.

One of portraits in Malfoy Manor painted by Rohan Harris using the face of Chris Eldridge, senior modeler in the prop-manufacturing department.

that is filled with long windows. The vast ceiling on that floor is decorated with elaborate plaster moldings and a great chandelier, which plays an important part in the events that unfold within the manor. That no other doors lead out of that room was not a conscious decision—it's just that none were necessary. However, it is altogether appropriate that you feel, even subconsciously, once you're up there, you're trapped!

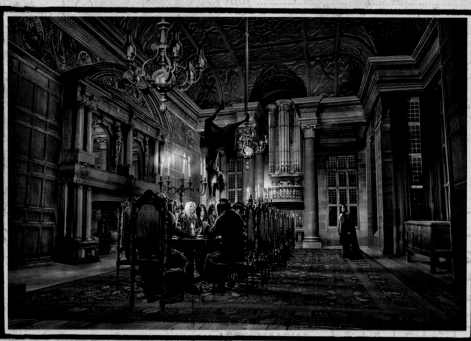

Charity Burbage (hanging above table) being tortured at Malfoy Manor. Concept art by Andrew Williamson.

When the idea of dividing *Harry Potter and the Deathly Hallows* into two films was initially floated, I was opposed to it. We had never split one of the books into two films, so why now? However, as Steve Kloves began work on his adaptation, it soon became clear how much we would have to omit that was absolutely integral to the resolution of the series in order to squeeze the book into a two-and-a-half-hour, or even a three- or four-hour, film. And the resulting film would have been confusing, incomplete, and unsatisfying. So we made the decision to turn *Deathly*

Hallows into two films. It was the only way to do justice to the book and to the series.

Deathly Hallows – Part 1 is a very different film from the previous six. This is a "road movie." For the first time, the *entire* film takes place away from Hogwarts. Harry, Ron, and Hermione are on the run—trying to discover how to defeat Voldemort before they are captured and Harry is killed.

The *Harry Potter* books have touched so many people from so many different cultures and walks of life. They are timeless. I hope something of the spirit with which the books are infused has come across in the films. It all began with Jo Rowling. I feel blessed and proud to have been able to play, for more than ten years, in the world that she created.

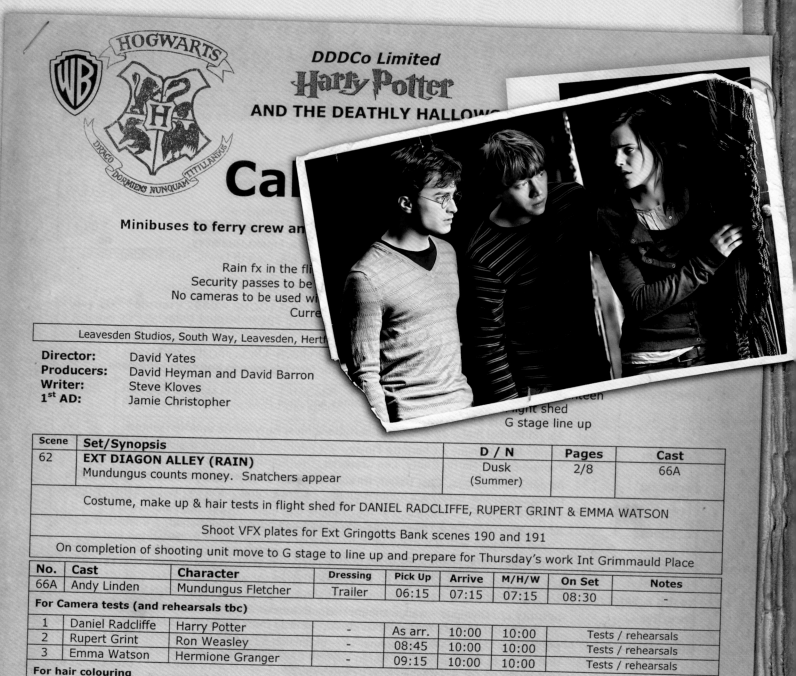

HOGWARTS

DDDCo Limited
Harry Potter
AND THE DEATHLY HALLOWS

Ca...

Minibuses to ferry crew an...

Rain fx in the fli...
Security passes to be...
No cameras to be used w...
Curre...

Leavesden Studios, South Way, Leavesden, Hertf...

Director:	David Yates
Producers:	David Heyman and David Barron
Writer:	Steve Kloves
1ˢᵗ AD:	Jamie Christopher

...een
...ght shed
G stage line up

Scene	Set/Synopsis		D / N	Pages	Cast
62	**EXT DIAGON ALLEY (RAIN)** Mundungus counts money. Snatchers appear		Dusk (Summer)	2/8	66A

Costume, make up & hair tests in flight shed for DANIEL RADCLIFFE, RUPERT GRINT & EMMA WATSON

Shoot VFX plates for Ext Gringotts Bank scenes 190 and 191

On completion of shooting unit move to G stage to line up and prepare for Thursday's work Int Grimmauld Place

No.	Cast	Character	Dressing	Pick Up	Arrive	M/H/W	On Set	Notes
66A	Andy Linden	Mundungus Fletcher	Trailer	06:15	07:15	07:15	08:30	-
For Camera tests (and rehearsals tbc)								
1	Daniel Radcliffe	Harry Potter	-	As arr.	10:00	10:00		Tests / rehearsals
2	Rupert Grint	Ron Weasley	-	08:45	10:00	10:00		Tests / rehearsals
3	Emma Watson	Hermione Granger	-	09:15	10:00	10:00		Tests / rehearsals
For hair colouring								
18	Oliver Phelps	George Weasley	Lower 6	O/T	11:00	11:00		Hair colouring
Stunts		**Character**	**Dressing**	**Pick Up**	**Arrive**	**M/H/W**	**On Set**	**Notes**
Greg Powell		Coordinator	-	O/T				

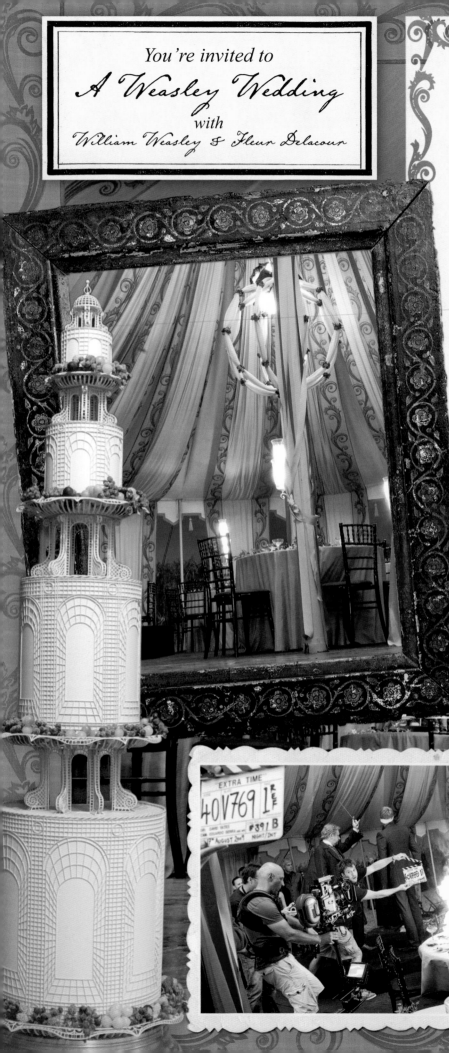

"I had never been to a wedding before," says Domhnall Gleeson, who plays Bill Weasley, "and the first wedding I go to is my own, which is kind of weird! And it's not even real!"

Despite being held at The Burrow, the filmmakers decided that Bill Weasley's wedding to Fleur Delacour would have been paid for by Fleur's parents, so it would be a lavish affair and decidedly French in its design.

The four-tier wedding cake—created not in a kitchen but in the prop-manufacturing department—was decorated with delicate "icing" designs based on trellis arches, called treillage, found in eighteenth-century French gardens.

While they were helping with the catering, prop-makers produced some four thousand artificial tartlets, mini éclairs, and chocolate-covered cherries and strawberries, all displayed on cake stands that had to be made in flexible rubber so that when the wedding reception ends in a fight with the attacking Death Eaters, none of the actors or stunt performers would be injured by metal and breaking glass.

For French designer Jany Tamime, the Weasley wedding offered a wonderful opportunity to create some glamorous couture. Bill's wedding suit is a fashionable piece of French tailoring (Jany says that Fleur would have made sure her future husband went to a Parisian tailor!), but all the Weasley men look stylish in elegant suits with a touch of glitter.

Special wedding outfits were designed for everyone on the guest list, including Luna Lovegood, who wears a sunflower-yellow dress, and her eccentric father, who has a golden-yellow velour jacket and a waistcoat with pink and green shapes based on a child's toy windmill.

As mother of the groom, Mrs. Weasley for once escapes her knitted skirts and jumpers and wears a silk dress in turquoise shades of green and blue with a checkered pattern that, like the Weasley house, has no straight lines or right angles. "I love it!" says actress Julie Walters. "It's very *wedding* and it's very Mrs. Weasley!"

(left) Concept art of the wedding tent in front of The Burrow.

The wedding tent that was connected to The Burrow by a covered awning was inspired by the type of marquee popular in Edwardian England—but with a little magical exaggeration in the height of the roof.

There's something fantastical about the Weasleys' crooked house having such an elaborate fantasy in the garden. "It is the contrast of two things," says Stuart Craig. "This elegant marquee standing in the middle of a great expanse of marshland, with no visible civilization for miles around."

Made of a material called semi-canvas and woven in Pakistan, the marquee was lined with amethyst-colored Indian silk printed with a purple decorative border using a French motif of scrolls of foliage.

Black imitation-bamboo chairs were chosen for the guests, and garlands were created for the tent poles around which black visual-effects butterflies would flutter.

But while the set begins as a wedding celebration, it becomes a battlefield when the Death Eaters attack The Burrow looking for Harry. As a result, the crystal candle shades on the tables had to be made out of rubber glass, and the marquee and everything in it had to be flameproof for scenes where things start to catch fire.

If the wedding was to be the proverbial calm before the storm for Harry, at least it was a moment of true loveliness.

149

(clockwise from left) Matyelok Gibbs as Aunt Muriel; Ginny (Bonnie Wright) as a bridesmaid; Luna (Evanna Lynch) dances with her father (Rhys Ifans).

THE MINISTRY OF MAGIC

When J. K. Rowling wrote *Harry Potter and the Order of the Phoenix*, she revealed that there were direct links between the British Ministry of Magic and the country's Muggle politicians and civil servants.

The filmmakers took this as their cue to establish the Ministry in the heart of central London, deep beneath the offices of the various departments of the British Muggle government. As in the books, the Ministry of Magic is reached by an elevator in a red telephone box—the kind that have been part of the British landscape for more than eighty-five years.

Taking his inspiration from London's underground railway stations, Stuart Craig created an interior design for the Ministry filled with shiny, tiled surfaces. Following the author's description, the atrium features the Fountain of Magical Brethren with its golden figures of a wizard, a witch, a centaur, a goblin, and a house-elf.

Despite this harmonious image, we begin to see that all is not as it should be. "When we get to see the Ministry for the first time," says producer David Barron, "there are various political elements that suggest the world of Big Brother." For example, a huge, magical portrait banner of Cornelius Fudge hanging in the atrium depicts the Minister in the style of 1930s posters from the former Soviet Union.

"Cornelius Fudge is a typical politician," says producer David Heyman with a smile, "trying to make the situation seem better than it is and to make people seem more secure than they might necessarily be." However, a new Minister for Magic, Rufus Scrimgeour, is introduced to audiences in *Harry Potter and the Deathly Hallows*. Bill Nighy, who portrays Scrimgeour, talks about his speech at the beginning of *Deathly Hallows*: "You need a rousing speech to reassure everyone that the state is strong enough to protect them," he says, "but I also

Entrance to the Ministry

(right) Concept art by Adam Brockbank and (below) by Andrew Williamson.

MINISTRY OF MAGIC

★ MINISTRY OF MAGIC ★
VISITOR
No. 09786

This pass is issued subject to the Ministry of Magic Health and Safety Regulations (345-01 & 346-01) and should be returned to reception before leaving the premises

☞ This badge must be displayed at all times

Minister R. Scrimgeour

tried to make it a little bit ambiguous—to indicate that he [is] not personally 100 percent convinced that what he is saying is true. And how could he be, really, given the forces against which they are pitted?"

Scrimgeour's days are clearly numbered; and when Voldemort's Death Eaters take over the Ministry, he is tortured, killed, and replaced.

Under the Death Eaters' control, an alternative centerpiece replaces the Fountain of Magical Brethren in the Ministry's atrium. Concept artist Adam Brockbank took his inspiration from Russian monuments of the Soviet era depicting workers striving for a better world. "The new sculpture," says Stuart Craig, "shows superior, glorified wizarding figures supported on the hunched backs of oppressed Muggles writhing in pain." In its many forms, the Ministry of Magic seems to reflect various political ideologies in the Muggle world. As J. K. Rowling said, when interviewed in 2007 at Carnegie Hall: "You can see in the Ministry even before it's taken over, there are parallels to regimes we all know and love."

151

MINISTRY OF MAGIC

IDENTITY CARD

THIS IS TO IDENTIFY

CATTERMOLE, Reg

NAME

Magical Maintenance

DEPARTMENT

L 110 MMMM-1987/005

MINISTRY OF MAGIC

IDENTITY CARD

HE WHO MUST NOT BE NAMED

Ralph Fiennes as Lord Voldemort

"To play evil is really impossible," says Ralph Fiennes of his role as Lord Voldemort. "I think you have to think of someone with human anger, human frustrations, human fears."

Initially, Ralph had reservations about accepting the part of Harry Potter's nemesis. A glimpse of the concept art being developed for Voldemort's on-screen appearance changed his mind. "They'd taken photographs of me and morphed them into this frightening, reptilian-looking creature," he recalls. "I got a real buzz off it, and that's pretty much when I thought, 'Oh, this would be cool to do!'"

The realization of that snake-like look took shape in Nick Dudman's prosthetic makeup shop. Early experiments were carried out on a runner working at the studio who agreed to have his head shaved, and submitted to elaborate face and body makeup. The process involved masking the man's eyebrows with a prosthetic material, covering his skin with a formula that Nick describes as having a "translucent, milk-white quality," and airbrushing a network of purple veins onto his face and body.

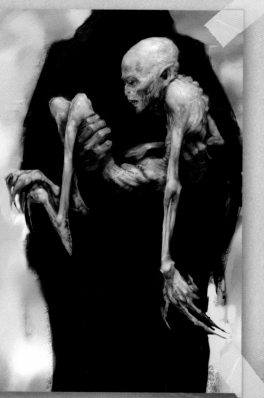

(above) Costume sketch by Mauricio Carneiro and Ralph Fiennes wearing Jany Temime's costume of dark silk robes.
(below) The process of digitally transforming Ralph's face.
(left) Concept artist Rob Bliss's image of Voldemort before receiving his new body.

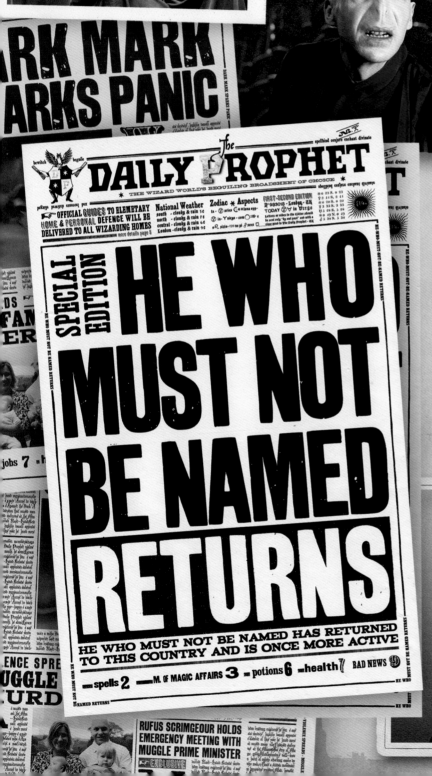

To avoid putting Ralph Fiennes through such a complex and time-consuming process each time he filmed, key prosthetic makeup artist Mark Coulier suggested creating the same effect by using custom transfers made by a company that manufactures imitation tattoos. It proved something of a nightmare to organize—computer artwork that replicated the vein effects had to be accurately scaled to registration points on Ralph's body so that they could be locked together in the correct positions on his head, neck, and shoulders—but the end result was worth the trouble. "The transfers are on a water-permeable membrane," explains Nick. "When they're transferred, that membrane has a creepiness to it that gives the skin a slightly unwholesome quality. It resulted in a look that was different than anything I'd seen before."

For Ralph, the look gave him an opportunity to explore how Voldemort feels when he begins inhabiting his new body: "We see him touching, feeling his head, feeling his face, feeling how a muscle might move, or what it's like to walk again—testing this whole new body for the first time."

The final step in the process of transforming Ralph into Voldemort involved removing Ralph's nose so that he would match the reptilian description of the Dark Lord in the novels. Early experiments with additional prosthetic makeup were unsuccessful, as makeup simply could not hide the actor's features. Eventually, the reptilian effect had to be created digitally—frame by frame—in every scene in which Voldemort appears.

Early costume ideas from the first film of a black-cloaked figure gave way to dark, silky robes that the actor describes as being like a "flowing, floating reptile skin." Describing Voldemort's wand, concept artist Adam Brockbank says: "I had in mind that it was carved from a bone, probably a human bone. A fine, sharp, tapering, slightly curved bone that comes to a sort of knuckle or joint, with a kind of hook on the end, like a claw. It's quite an evil shape—like an evil, bony finger."

To complete the character beneath the special effects, makeup, and costume, Ralph Fiennes focused on Voldemort's lost humanity. "I wanted him to be really deeply, humanly evil," he says. "Not an idea of evil. And that comes from fear, frustration, [and] unhappiness."

153

Voldemort's wand, designed by Adam Brockbank.

DAILY PROPHET
THE WIZARD WORLD'S BEGUILING BROADSHEET OF CHOICE

SPECIAL EDITION

HE WHO MUST NOT BE NAMED RETURNS

HE WHO MUST NOT BE NAMED HAS RETURNED TO THIS COUNTRY AND IS ONCE MORE ACTIVE

spells 2 — M. OF MAGIC AFFAIRS 3 — potions 6 — health 7 BAD NEWS

DARK MARK SPARKS PANIC

RUFUS SCRIMGEOUR HOLDS EMERGENCY MEETING WITH MUGGLE PRIME MINISTER
EXCLUSIVE

GODRIC'S HOLLOW

or Harry Potter, visiting Godric's Hollow, the country village where Voldemort killed his parents, is a deeply moving and disturbing experience. Daniel Radcliffe says that enacting that episode in *Harry Potter and the Deathly Hallows – Part 1* was "very, very emotional."

When planning began on the penultimate *Potter* film, Stuart Craig and locations manager Sue Quinn explored a number of country villages, including Lavenham, a well-known village in Suffolk with picturesque, fifteenth-century half-timbered houses. Lavenham would become the inspiration for the film version of Godric's Hollow. "This was a very good look that we hadn't used before," says Stuart, "and quite different from the Gothic, stone-built architecture of Hogwarts and Hogsmeade."

The decision was made to build the village as a physical studio set, with views of Lavenham added digitally to extend the set into an entire village. However, unlike most of the *Potter* sets, Godric's Hollow was built not at Leavesden but at nearby Pinewood Studios. "Pinewood has this splendid old garden," Stuart explains, "part of the original estate before it was a studio, and there is a magnificent cedar tree there. It seemed a great idea to have the graveyard where Lily and James Potter are buried underneath the spreading branches of this great tree."

154

IN LOVING MEMORY OF

JAMES POTTER • LILY POTTER

BORN 27TH MARCH 1960 | BORN 30TH JANUARY 1960

DIED 31ST OCTOBER 1981 | DIED 31ST OCTOBER 1981

THE LAST ENEMY THAT SHALL BE DESTROYED IS DEATH.

Hermione's P.O.V. as she walks to H—

Reverse past Harry, as— walks towards him.

Camera cranes up as— gets closer.

SHOT CONT'D

Hermione look— down to whe—

Pity in Hermione's eyes.

Tears fill Harry's eyes as he sta— at the tombstone of his parents

CUT TO

Angle past Harry and Hermione onto the tombstone.

CUT TO

(left & above) Harry and Hermione in the churchyard from storyboard (drawn by Stephen Forrest-Smith) to screen.

The village of Godric's Hollow, complete with church and churchyard was constructed at Pinewood Studios.

So, the set was constructed around this one cedar tree. It included the church, with specially created stained-glass windows, the churchyard with its lych-gate and gravestones, two streets, an inn, the derelict Potter cottage, and Bathilda Bagshot's house—where Harry has his near-fatal encounter with Voldemort's serpent Nagini.

The scenes were shot at night, with a great deal of artificial snow. "We used forty tons of synthetic snow," recalls John Richardson. "We had to cover all the pavements, roofs, windows, and trees. There were storms while we were putting down that caused problems, but clearing it up afterwards was an even bigger task."

The results looked spectacular but took their toll. "We turned the garden at Pinewood into a building site, and we ruined the lawn," confesses Stuart, "but they were very understanding, and when we were finished, the garden was entirely replaced."

It might seem a lot of work to film one tree but, says Stuart, "it was a lovely tree and worth it."

Sacred to the Memory of

KENDRA DUMBLEDORE

Died 18 November 1899
Aged 48 years

and her daughter

ARIANA

Died 1 May 1900
Aged 13 years

WHERE YOUR TREASURE IS,
THERE WILL YOUR HEART BE ALSO.

Gravestone concepts by Eduardo Lima for (left) Dumbledore's sister and mother and (right) Ignotus Peverell with the sign of the Deathly Hallows.

THE LOVEGOOD HOUSE
The Quibbler
Editor: X. Lovegood

In the seventh book by J. K. Rowling, Ron Weasley describes the Lovegood house as looking like "a giant rook," the castle-shaped piece in a chess game.

That became the inspiration for the Lovegood house in *Harry Potter and the Deathly Hallows*. As Stuart Craig explains, "Jo Rowling says very clearly that it's a black tower. Nothing ambiguous about that; it was quite a precise instruction. What we tried to do was to make it as interesting as possible: not just a cylindrically shaped building, but a tapering, leaning, distorted cylinder."

Care was taken in choosing the scenic backdrops for the sets. "The magical houses that are not visible to the rest of the world," says Stuart Craig, "work very well in desolate landscapes. An area of moorland near the Yorkshire village of Grassington in northern Britain provides the beautiful vistas around the Lovegood house." The garden, however, contains Dirigible Plums, a fruit not usually found in the Yorkshire countryside.

Because the building is shaped like a cylindrical tower, the rooms had no flat wall surfaces. For the kitchen, the set designers took their cue from the book and built a stove, sink, and cupboards that were curved to fit the walls.

156

The Lovegood house features various painted decorations by Luna inside and outside that were specially designed by the artist and illustrator Thomasina Smith, inspired by Evanna Lynch's drawings and J. K. Rowling's companion book to the *Harry Potter* series, *Fantastic Beasts and Where to Find Them*.

"The house has been, if you like, lovingly vandalized by Luna," says Rhys Ifans, who plays her father, Xenophilius. "She's got her drawings right across the house. It just feels like a really happy place to grow up."

The main room in the house is Xenophilius's workspace, where he prints *The Quibbler*, the eccentric, often controversial, alternative paper of the wizarding world. This required not only piles of back issues of *The Quibbler*, but also a full-sized, working printing press.

(below left & right) Two views of the Lovegood house. Sketch by Stuart Craig and illustration by Adam Brockbank.

"We based it on an American press from 1889," says Stuart Craig, "but we added to the original mechanism, and, with the help of the special effects department, we had the newsprint on a conveyor belt system—rollers rushing across the ceiling, up and down the walls, and into the guillotine. The result was more dynamic and more fun." As Evanna Lynch remarks, "It's a perfect sort of place where all those crazy stories would be printed."

Xenophilius also wears a necklace with a symbol that, as he explains to Harry, Ron, and Hermione, represents the Deathly Hallows. Describing the character he portrays in the film, Rhys says, "He's kind of jumpy and busy and eccentric, you know. But not mad."

For Jany Temime, Xenophilius's character was shown in his clothes. "He has causes, this man," she says. "He believes in things. I wanted all the layers of his costume to express the layers of his personality. Because he is so isolated and works at home, I wanted to make it feel as if he's in his pajamas all the time. He wears a beautiful antique handwoven coat and a waistcoat made up of pieces of Luna's [childhood] embroidery—a puzzle representing his daughter worn close to his heart."

For Evanna Lynch, the look was perfect. "They brought Rhys to meet me," she recalls. "He came in his robes and he had all these funny things on and, for just a few moments, I forgot myself and felt, 'Oh, that's dad!'"

THE QUIBBLER
Nº 28929 · The Wizarding World's Informative Voice · SPECIAL EDITION £1/4
UNDESIRABLE
Nº 1
HARRY POTTER
REWARD: 10,000 GALLEONS ON HIS HEAD Pt 20
EXCLUSIVE How to Identify Mudbloods
mergo publications

The graphic arts department designed seven different covers of The Quibbler *and printed around five thousand copies.*

KEEP OFF THE DIRIGIBLE PLUM

THE DEATHLY HALLOWS

The first of the Deathly Hallows to appear in the films was the Invisibility Cloak, given to Harry by Dumbledore in *Harry Potter and the Sorcerer's Stone*. Several versions of the cloak were created using a velvet fabric embossed with planetary and alchemic symbols. One of these versions was lined with a green screen material. For scenes where Harry was supposed to disappear, Daniel Radcliffe would flip the green-screened cloak over as he put it on, allowing his body to be blended into the background by visual effects.

The ring that cost Dumbledore his hand—and ultimately his life in *Harry Potter and the Half-Blood Prince*—contained the Resurrection Stone, the second of the Hallows revealed to the audience. Fortunately for the prop designers, the last book came out before their work needed to be finished, allowing them to integrate a crucial detail into the final design. As Hattie Storey remembers, "We learned it needed the symbol for the Deathly Hallows etched on it." In *Harry Potter and the Deathly Hallows – Part 2*, the stone comes into Harry's custody, concealed inside the first Golden Snitch he caught, a prop that opens via a practical mechanism.

The last of the Deathly Hallows was the Elder Wand, which turned out to be in Dumbledore's possession. This was another case where the prop makers found out that something they had designed previously would take on added significance. Luckily, Dumbledore's wand was already quite distinct. The prop is made of English oak, with a bone inlay inscribed with runes. "What makes it very recognizable," says Pierre Bohanna, "are the outcroppings of nodules every two or three inches."

Elder Wand

Invisibility Cloak

DROPS TO FLOOR

73 PT.
INV. CLOAK DROPS TO FLOOR

Resurrection Stone

(left) A concept of Death designed and illustrated by Ben Hibon. The idea of Death as a puppeteer (used as a transition in the final animation) came directly from this drawing, which also shows Death's robe made of shredded pieces of fabric. (below) Concept art by Adam Brockbank of Voldemort opening Dumbledore's tomb in search of the Elder Wand.

(above) Dumbledore (Michael Gambon) extracts a memory with the Elder Wand in Goblet of Fire.

THE TALE OF THE THREE BROTHERS

Crucial to Harry's journey in *Harry Potter and the Deathly Hallows* was his discovery of the Deathly Hallows. In J.K. Rowling's book, this information was delivered through a story read in *The Tales of Beedle the Bard*, a book bequeathed to Hermione by Dumbledore. Director David Yates; production designer Stuart Craig; the tale's director Ben Hibon; and Dale Newton, sequence supervisor for Framestore (Europe's largest visual effects studio, which animated the Hippogriffs, centaurs, and house-elves among many other important aspects of the *Harry Potter* films), decided to render the story in a separate animated sequence, collaborating to find just the right elements to tell this fable-like tale.

"We knew it was going to be stylized and told very graphically," Newton said in an fxguide.com interview, "but not exactly how. Then the producers suggested creating something in the vein of Lotte Reiniger. What we got out of that was a certain simplicity and naivety." Reiniger was a German-born animator who worked from the 1930s through the 1950s making mostly short films based on fairy tales and classic stories. Her animations were distinguished by their use of hand-cut paper silhouettes and lyrical, elastic movements. As he was also inspired by Asian shadow plays, Hibon proposed merging the two styles. It worked. The final touch was laying a grainy paper texture colored with sepia tones over and behind the animated figures.

"When we designed the characters, we tried to purposely design puppets. We *should* feel as if we're watching a very clever puppet show and not a traditional animated movie," explained Newton in an Animation World Network interview. "We were also very conscious that the attitude of the characters had to be read through their entire pose. The silhouettes also enabled us to play on a certain theatricality. The hands do so much of the talking—Death's hands, for example, are almost as expressive as his face."

(above) *The interior of* The Tales of Beedle the Bard, *designed by Miraphora Mina and Eduardo Lima of MinaLima Design.* **(left)** *An early concept for Death inspired by Dervish dancers, designed and illustrated by Ben Hibon.*

RETURN TO GRINGOTTS

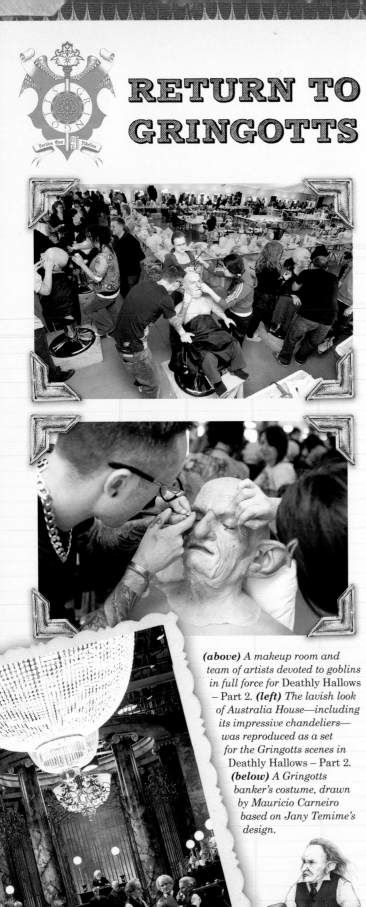

While the *Deathly Hallows* films introduced viewers to places they had been waiting to see, the story also revisited familiar locations, giving filmmakers a chance to explore them in greater depth. Gringotts bank, first seen in *Harry Potter and the Sorcerer's Stone* was originally filmed in the banking hall at Australia House in Central London. In *Deathly Hallows – Part 2*, Harry, Ron, and Hermione, accompanied by Griphook the goblin, return to Gringotts to obtain the Hufflepuff cup Horcrux hidden in the Lestranges' bank vault. "There's a dragon guarding the treasure. It smashes out of its shackles, smashes through the top of a cave hundreds of feet above, smashes through the banking hall, and up through the glass roof, so Gringotts became a set built at Leavesden," says production designer Stuart Craig.

The opportunity to embellish upon the previous set was one the designers could not resist. "We had the tellers' desks from the first movie," says art director Hattie Storey, "which we repainted and revamped a bit, adding a bit more molding for definition. We also had the registers and scales and the rest of the props, but added some very nice curly quills, and many more gold coins." The carts the goblins use to transport money and jewels had their original wooden wheels replaced with metal ones and their tops covered with a cage. The bank's floor was re-created using the same faux-marbleization technique that was employed to make the floors for the life-sized chessboard in the first film and the Wizengamot courtroom in the third. Huge sheets of paper are placed onto oil paint swirls that float on the surface of a six-foot square vat of water. "Once the paper is removed and dried," explains Craig, "the best parts are digitally photographed and then reproduced on printers that can create stronger sheets up to twelve feet wide."

The return to Gringotts gave creature effects supervisor Nick Dudman the opportunity to "do the job I always wanted to with the goblins," he says. "The technology of prosthetics has advanced greatly since the first film." Goblin ears, noses, and chins, and in some cases, full headpieces were created. The number of goblins seen in the bank this time was so many—more than sixty of them—that the creature shop organized an assembly line of makeup artists to paint faces and hands. Dudman's team also inserted each hair individually onto heads and eyebrows because, "There simply isn't a better way to do it," he explains. To guarantee continuity across the multiday shoot, every detail down to the precise angle of a goblin's eyebrow was recorded. This complex makeup had to be redone for each day of filming.

Actor Warwick Davis also returned to Gringotts as Griphook the goblin. In *Sorcerer's Stone*, he had only voiced the crafty banker, while also playing the part of the bank teller who asks Harry for his key. *Deathly Hallows – Part 2* gave Davis the opportunity to revisit the incalculable goblin, this time in both voice and body. (In total, Davis performed five different characters in the *Harry Potter* series, if you count the choir director in *Harry Potter and the Prisoner of Azkaban* separately). Davis appeared as both Professor Flitwick and Griphook in the final two films, their scenes often scheduled on alternating days. "They were very, very different," recalls Davis. "Opposite ends of the scale. Flitwick is a lovely, amusing character, but he didn't have any particular bearing on the storylines of the films. Griphook is an integral part of the plot. You don't know whether you trust him or not, and he's essentially a villain, which is more fun to play." Davis shows no preference between the two, but, "If I was to hang out with one of them, I'd have a Butterbeer with Flitwick."

In addition to undergoing a four-hour prosthetic makeup process each day of filming to become Griphook, Davis wore dark contact lenses and false teeth that were sharpened to such a point that, he recalls, "I'd have to be very careful when I talked during a scene. If I wasn't, I'd bite my tongue, which happened a bit too often for me."

(above) A makeup room and team of artists devoted to goblins in full force for Deathly Hallows – Part 2. *(left) The lavish look of Australia House—including its impressive chandeliers—was reproduced as a set for the Gringotts scenes in* Deathly Hallows – Part 2. *(below) A Gringotts banker's costume, drawn by Mauricio Carneiro based on Jany Temime's design.*

Once Harry, Ron, and Hermione have recovered the Hufflepuff cup, they escape on the dragon that guards the Gringotts vaults. The digital designers who worked on the dragon were tasked with creating a very different type than any seen before in the films. Almost completely devoid of color, this dragon's skin texture had to be scarred and ragged. "The Gringotts dragon has been kept underground in a dark cave all its life," says visual effects supervisor Tim Burke. "It's emaciated and partially blind. It's been maltreated and tortured by the goblins in the bank, so it's weakened but still very dangerous." The dragon is imprisoned in a circular colonnade that Stuart Craig describes as an "architectural cage, on a massive scale. The area is carved out of solid rock, similar to the Treasury of Petra in Jordan."

(left) Concept art of a Gringotts cart from *Sorcerer's Stone.* *(below)* Harry (Daniel Radcliffe) in the Lestranges' vault.

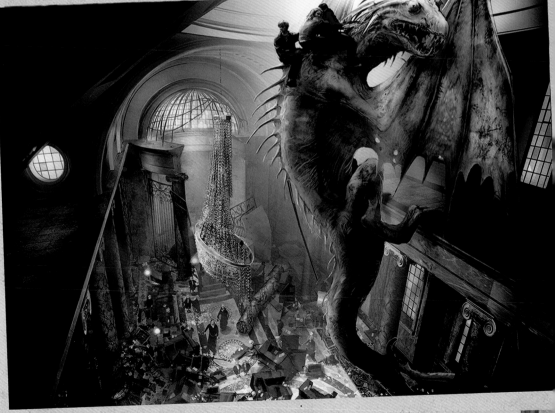

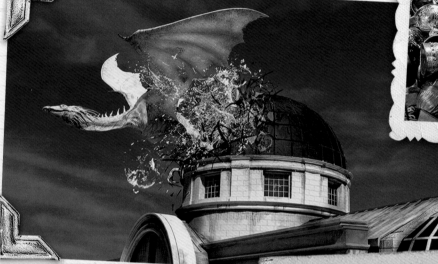

(left) Concept art by Paul Catling of a dragon bursting through a tower in the Gringotts building with Harry, Ron, and Hermione on its back. *(below)* Concept art by Andrew Williamson of the scene before, where the dragon climbs the walls of the bank.

161

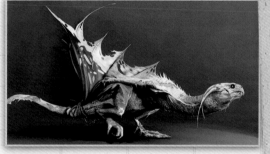

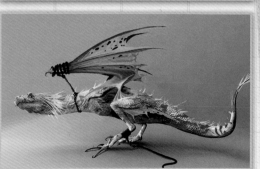

(above) Two pieces of concept art by Paul Catling, exploring the appearance of the Gringotts dragon could look like. Attention was paid to the fact that it had been chained up indoors and was malnourished.

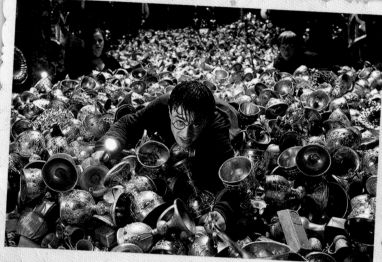

THE RESISTANCE

Harry, Ron, and Hermione travel to Hogsmeade as a way to get back into Hogwarts to search for the remaining Horcruxes. The trio is given refuge in the Hog's Head Inn. Harry discovers that the inn is owned by Aberforth Dumbledore, Albus's younger brother, and that Aberforth has been working with the Order of the Phoenix.

Aberforth is played by Ciarán Hinds. "What's interesting is that there was obviously a friction between the two brothers, and they separated," says Hinds. "They have nothing in common. But at the same time, Aberforth's commitment to the cause is there. It's just not particularly done with good grace." Hinds was overjoyed at being asked to play the part. "I was just thrilled to be asked to be in the story at all," Hinds admits, "Because I got in by the skin of my teeth! And to be Michael Gambon's younger brother was even more of a thrill." Three prosthetics subtly allowed Hinds to resemble Gambon: adding little bags under his eyes, creating a higher forehead, and giving him a straighter, fuller nose bridge. "Mine's a bit crooked and thinner," says Hinds. "So, it's just these three features that transform the whole face."

Aberforth is a reluctant collaborator, rebuking his brother for keeping secrets from Harry and placing him in such a dangerous position. "In a way, Aberforth is like the last test," says Daniel Radcliffe. "He's giving me another chance to turn back and to pack it all in, actually, and it's the moment when Harry decides to go, 'If I don't carry on with this, what am I going to do?'" Harry asks for Aberforth's help to get into the castle, and Aberforth speaks to a portrait hanging in the underground room.

Hermione recognizes the portrait as that of Ariana Dumbledore, the sister of Albus and Aberforth, who died at a young age. She turns and disappears down a path into the distance. When she returns, she's accompanied by Neville Longbottom, who is slightly worse for wear but happy to see them. He leads them through a newly created tunnel into Hogwarts.

162

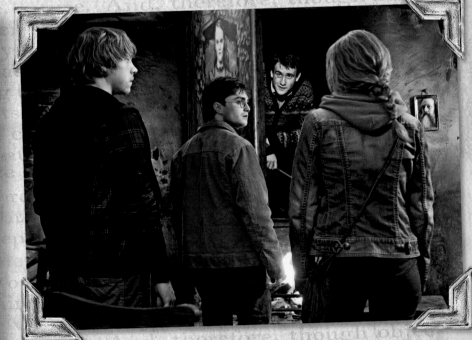

(top and inset) Ciarán Hinds as Aberforth Dumbledore. (left and above) The portrait of Ariana Dumbledore (Hebe Beardsall) at the Hog's Head Inn. When the portrait swings open, Ron Weasley (Rupert Grint), Harry Potter (Daniel Radcliffe), and Hermione Granger (Emma Watson) reunite with Neville Longbottom (Matthew Lewis).

"Hogwarts is a shadow of its former self," says David Heyman. "The Death Eaters have taken charge and any infraction of their rules is met with considerable brutality." Neville is bruised and bloody and has a terrible story to tell about how much the school has changed under Headmaster Severus Snape. As he guides them under the Hogwarts grounds, he explains how the students who are standing up to the strict discipline and punishments give hope to the others. Then he comes to the end of the passage and pushes open a portrait that reveals these same students, the remnants of Dumbledore's Army, who have taken refuge in the Room of Requirement.

Harry, Ron, and Hermione are greeted by a sea of familiar faces, including Seamus Finnigan (Devon Murray), Dean Thomas (Alfie Enoch), Luna Lovegood (Evanna Lynch), and Cho Chang (Katie Leung), who are encouraged by Harry's reappearance. "His very presence inspires them," says producer David Barron. "It gives them confidence that they are not alone."

Harry's strongest supporter is Neville Longbottom (portrayed by Matthew Lewis), who appears to be the de facto leader of the group. But Neville is not in great shape. "He's slimmed down," says Matthew Lewis, who was honestly glad to be rid of the padding he had worn under his costume for years. "We're trying to suggest he's living underground at Hogwarts, and he's been this resistance leader. So, he's not had time to eat, and he's been stressing out." Neville also bears bruises and wounds, the result of refusing to follow the lessons taught by their Death Eater professors.

These remnants of Dumbledore's Army have been living in the sparest version of the Room of Requirement. The glass cabinets last seen in *Harry Potter and the Half-Blood Prince* are back under the supporting dropped columns but remain empty. The only furnishings consist of a few tables, sleeping bags strewn over the floor, and several levels of hammocks hanging from the beams.

163

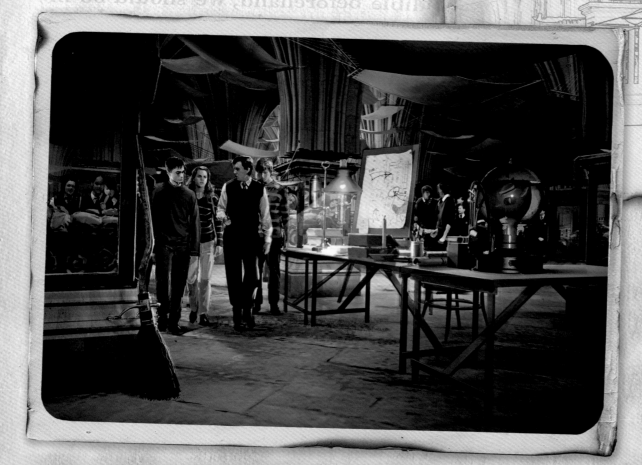

(top) Neville Longbottom brings Hermione, Ron, and Harry to the Room of Requirement, the hidden headquarters of the resistance. *(middle)* Development sketch of the Room of Requirement by Andrew Williamson, who also created digital concept artwork of an unfilmed view *(left)*, which shows the hammocks and equipment used by the members of Dumbledore's Army.

DESTROYING THE HORCRUXES—
HUFFLEPUFF CUP AND RAVENCLAW DIADEM

✦✦✦✦✦✦✦✦✦✦✦✦✦✦✦✦✦✦✦✦✦✦✦

Even if Harry, Ron, and Hermione find the remaining Horcruxes, they still need to figure out how to destroy them. It's Ron who offers a solution. "He has the idea to use a Basilisk fang to destroy the Horcruxes," says Rupert Grint, "the way Harry did with Tom Riddle's diary in the Chamber of Secrets." Harry sets out to find Rowena Ravenclaw's diadem, and Ron and Hermione head down to the Chamber of Secrets.

As the Chamber was to appear for only one scene, it was decided to reconstruct it digitally, with the majority of the set wrapped in green screen. The toothy skeleton of the Basilisk Harry killed was a new creation by Nick Dudman's creature department. When Hermione stabs the Hufflepuff Cup Horcrux, a rush of water from the subterranean chamber drenches them. Caught up in the danger and excitement, Hermione and Ron finally take the opportunity to express their true feelings for each other.

"There are battles raging outside," explains David Heyman, "but after they succeed at their task, there's a moment where they're alone. And they kiss for the first time. We've been desperate for the two of them to get together all along, and they finally do."

The two actors had always had a sibling-like relationship, so the prospect of having to kiss was daunting. "Because I've known Emma since we were little kids, I thought it would feel weird," Rupert Grint admits. "I got quite nervous about it the more I built it up in my head." Emma Watson had similar feelings. "Rupert and I were nervous that it might look disingenuous as we were so desperate to get it over with," she admits. "But this was ten years' worth of tension and hormones and chemistry and everything in one moment. We had to ace it."

Director David Yates decided not to tell them when the kiss would be filmed until the day it was actually shot. "The morning we shot it, I said to Rupert, 'Don't be Rupert. Just be Ron,'" says Yates, who gave similar advice to Emma Watson. "Let Hermione take over," Yates told her. "In her eyes, I saw her decide that she had to go for it. And she really went for it, much to Rupert's surprise."

"They had this big kiss," David Heyman remembers, "and then they came apart and there was some laughter, because, of course, it was awkward. And I think that's exactly what David Yates wanted. It was truthful and natural and lovely."

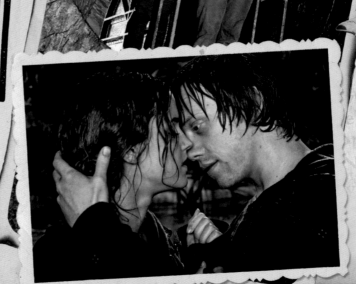

*(above left to right) Skeletal remains of the Basilisk on the Chamber of Secrets' green screen set; Hermione (Emma Watson) and Ron (Rupert Grint) prepare to enter the Chamber; the Hufflepuff Cup. **(bottom left)** Ron pulls out a Basilisk fang. **(bottom right)** Hermione and Ron (finally) share a kiss.*

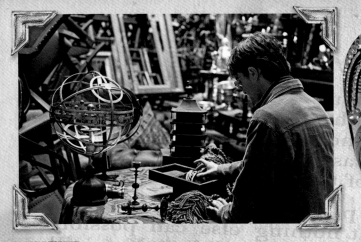

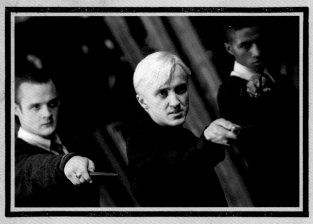

H arry returns to the Room of Requirement to recover and destroy Rowena Ravenclaw's diadem. For this iteration, the Room was piled high with mountains of artifacts. "The fact that they were looking for a tiara—this tiny little jewel of an object—in something so massive and complicated just made the task all the more impossible," says Stuart Craig.

Craig and Stephenie McMillan first produced a model of the artifact-filled Room of Requirement out of small Styrofoam blocks, then a second model filled with doll's furniture. McMillan had already gone through the studio's stock, including furniture from the previous Harry Potter films. "We had thirty-six desks," she recalls, "all the tables of the Great Hall, all the benches, all the professors' stools. The trophy cabinet dressing. The chess pieces from the first film. The party dressing from Slughorn's party." Stuart Craig remembers going to "every auction and every sale-room for secondhand furniture. And even then, we cheated, and each [pile of artifacts was stacked on] a series of big plywood boxes. The furniture was just one or two layers on top of that. And, finally, visual effects took all of that and made it that much bigger."

Inside the Room, Harry is confronted by Draco Malfoy and his cronies, Blaise Zabini and Gregory Goyle—and then Goyle releases Fiendfyre from his wand. The flames spread quickly, enveloping the room, and develop into recognizable creatures that pursue the trio, including a winged dragon, a snake, and a wolf. These were created digitally, but John Richardson's special effects team also placed areas of controlled flames around the room. "We certainly felt the heat," says Tom Felton, "so it's a mixture of visualizing what's going to be there and seeing what's right in front of you."

To make their escape, Harry, Ron, and Hermione use brooms to fly over the flames, though Harry turns back to rescue Draco and Blaise from the top of the pile—Goyle has fallen into the Fiendfyre. For this scene, the brooms were mounted on a track and flown at a high speed past a table on a hydraulic ramp that tilted and collapsed at the proper moment. At the same time, the broom flier would link arms with the stuntman on the table and swing him onto the back of the broom, cowboy-style.

(top left) Harry (Daniel Radcliffe) locates the diadem Horcrux in the Room of Requirement. (top middle) The Ravenclaw Diadem. (top right) Perched on mountains of furniture, Hermione and Harry discover they're not alone. (above) Gregory Goyle (Josh Herdman), Draco Malfoy (Tom Felton), and Blaise Zabini (Louis Cordice). (below) Harry saves Draco from the Fiendfyre in concept art by Andrew Williamson.

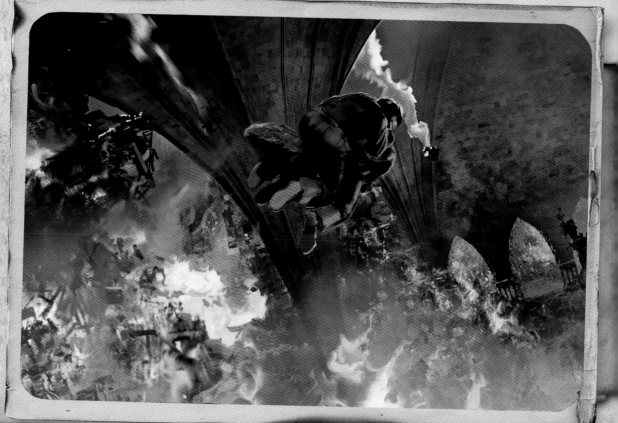

DESTROYING THE HORCRUXES—
HARRY POTTER AND NAGINI

"**H**arry knows his and Voldemort's destinies are intertwined," says David Heyman. "Confronted with the choice to go out and face the Dark Lord or allow everyone else to die, Harry is prepared to meet his fate."

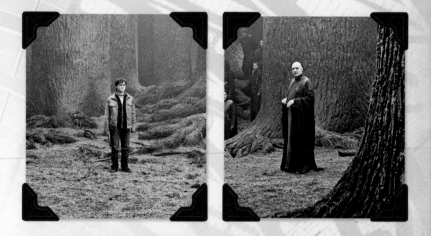

After viewing Snape's memories in the Pensieve and accepting the truth of the prophecy, "neither can live while the other survives," Harry meets Voldemort in the Forbidden Forest. "One of my favorite scenes is when Harry takes that long walk alone to save everybody else," says David Yates. "There's something really beautiful and haunting in his resolve."

"Dan was amazing," adds David Heyman. "He conveyed a wisdom and a maturity in those scenes that was way beyond his years. He really considered the emotions and the reasons behind each of Harry's actions and brought a real truth to his performance."

Once Voldemort performs the *Avada Kedavra* spell, Harry finds himself in a ghostly white version of King's Cross station, where he is joined by Albus Dumbledore. One idea was to have it be a very "burnt out" white, another was to have it resemble an ice palace. For several weeks, the crew experimented with underlit floors and covering everything with white fabrics. Eventually it was decided that the set would be rendered by the special

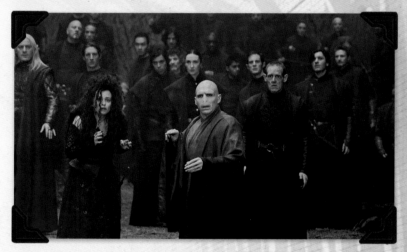

 166

effects team. "The end result was a very simple set," says Craig. "A very white platform surrounded with white walls. It was a big, white, physical set, but it was enhanced by visual effects, which made it magical in the end."

To better provide for enhanced lighting effects, Daniel Radcliffe and Michael Gambon shot the scene on a white stage instead of in front of green screen. The station itself is minimalist, with just the columns, roof, and platforms for definition. In the computer, a mist was added to enhance dimensions, and a bright horizon line provided an additional light source. Then one more effect was added at the filmmakers' request: The columns phased in and out of opaqueness, which adds to the room's ethereal impression.

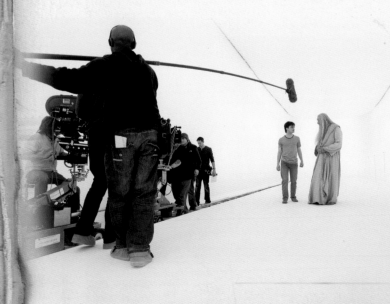

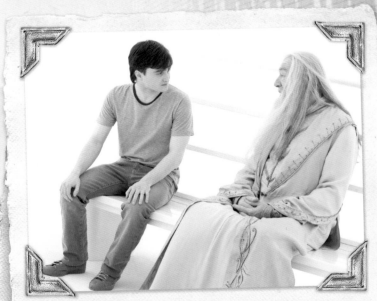

(top left and right) Harry (Daniel Radcliffe) accepts his fate and faces Voldemort (Ralph Fiennes) in the Forbidden Forest. *(middle)* Voldemort and his Death Eaters seem surprised at Harry's arrival. *(above left and right)* Harry questions Dumbledore (Michael Gambon) on the all-white set of King's Cross station.

Meanwhile, back at Hogwarts, the battle continues. "There's a bit more to Neville than meets the eye," says actor Matthew Lewis, confirming what we always felt about the tall, gangly wizard. In *Harry Potter and the Deathly Hallows – Part 2*, Neville is given the opportunity to prove this as he fights against the Death Eaters. "Neville never seemed to be a lionhearted person, not someone who deserved to be in the proud house of Gryffindor," Lewis explains. "But Harry always believed in him and that made Neville start to believe in himself, and all the strength and valor that was bubbling just beneath the surface finally comes out. Now he's become this brave freedom fighter, which is really cool and very rewarding."

At the castle's wooden bridge, Neville and Seamus plant explosives to curtail an invasion, though the whole of Hogwarts is protected by a magical shield. "Neville stands before this huge number of Death Eaters," says David Heyman, "and he's feeling very confident and full of bravado." And then the shield disappears. "All of a sudden, Neville is scared beyond belief," continues Heyman. "And he begins to *run*."

When it appears that Harry is dead, however, and all is lost, it is Neville who takes up the cause, facing Voldemort with Sorting Hat in hand. "By the end of the battle, Neville has been battered and bloodied, but he refuses to give up the fight," says director David Yates. "There's something wonderful about that. He limps forward all bloodied and battered and delivers a speech that they're not going to give up, which is basically suicidal. He must be insane—everybody knows he's going to be killed. And Matt did it really, really well."

"He and he alone stands up and confronts Voldemort," says David Heyman. "And we're so proud of this underdog, this outsider."

Having proved himself deserving, Neville pulls the Sword of Gryffindor from the Sorting Hat, and eventually uses it to destroy Nagini, Voldemort's snake and the last Horcrux. Now the way is clear for Harry Potter to defeat the Dark Lord.

(top) Concept art by Andrew Williamson of the Battle of Hogwarts. (left) Neville Longbottom proves deserving of wielding the Sword of Gryffindor. (below) A full-scale model of Nagini, the final Horcrux. (bottom) Concept art of Nagini by Paul Catling for Harry Potter and the Goblet of Fire.

THE BATTLE OF HOGWARTS

For the battle of Hogwarts, Stuart Craig redesigned Hogwarts' iconic structure with a "ruined" profile. "Whether you're building up or tearing down," he explains, "the profile still has to be strong and recognizable."

Craig also redesigned the Grand Staircase in order to accommodate the battle scenes. "The staircase needed to be more massive," he says, "so you could literally wage a war on it." Thousands of pieces of rubble were cut out of huge blocks of polystyrene and strewn on the stairs and across the courtyard. "Of course, these had to be lightweight," says property master Barry Wilkinson. "There were actors running or falling on them, many of them kids, so you couldn't have real rocks." Several prototype shapes were designed and hundreds of each style were made. The chips that came from sculpting these were then turned into smaller rocks. Each rock prop was coated with kiln sand to give it a rough texture.

Demands on cast schedules necessitated the final battle and the destruction of Hogwarts to be filmed before other scenes that took place in a still-intact school. So once filming of the battle was completed, Wilkinson and his team removed every piece of debris and the construction team restored Hogwarts to its original glory.

Senior visual effects supervisor Tim Burke describes the battle of Hogwarts sequence as "a roller-coaster ride. There's an incredible pace to it." The special effects team had scanned the one-twenty-fourth-scale model of Hogwarts built at Leavesden several years earlier in order to create a virtual version, which proved vital to implementing the sequence. "We created a digital miniature with which we had amazing flexibility," says Burke. "If we were working with a physical model as we had done in the previous films we would have been limited. With the digital version, David Yates could continue to develop the sequence, and we were able to apply his new concepts and ideas."

Concept art by Andrew Williamson of Hogwarts on fire.

(above) *Voldemort's army of Death Eaters in the elaborate armor created by the costume department.*

(right) *Berel-anne Cohen puts the finishing touches on Voldemort's final costume.* **(far right)** *The battle of Hogwarts scenes are a combination of practical special effects (such as fire) and digital effects added later.*

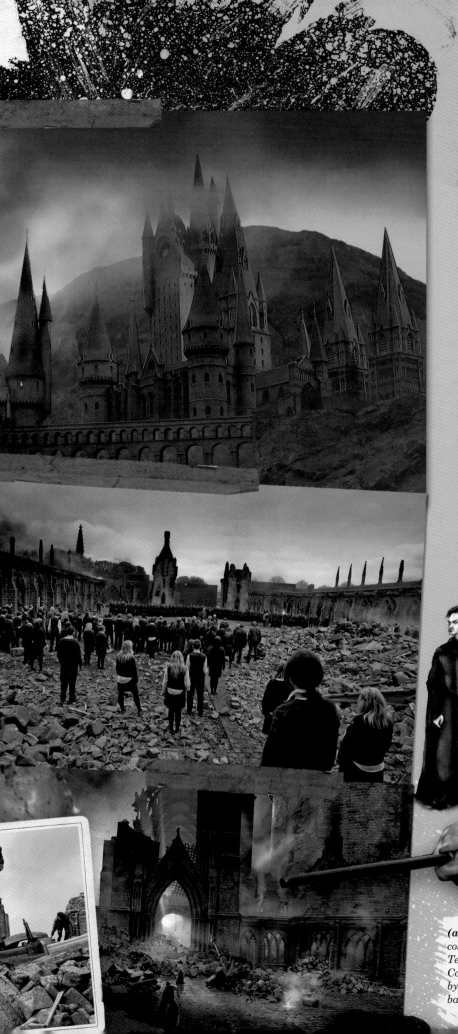

Although visual effects were crucial to the sequence, there was still a massive amount of filming and battle choreography that had to be coordinated. Actor Nick Moran, who played Scabior, a Snatcher for the final two films, had assumed that the battle would be mostly done with green screens. Then, early one morning, he found himself charging down a hill, "in front of a thousand extras, attacking Hogwarts," he recalls. "When I first read the scene, I thought it was only going to be me running down a hill shouting at the forces behind me that would be computer generated, but it was real. The scale of it was unbelievable. You can imagine how much power I felt with this literal army of extras behind me, screaming at the top of their lungs."

There were two significant changes made for the film version of the battle. The first was moving the location of Severus Snape's death from the Shrieking Shack to the hitherto unseen interior of the boathouse. "I designed it with huge windows so that you're aware of the water in and around it," says Stuart Craig, "and of the great battle of Hogwarts burning above it." Craig felt the boathouse was a very atmospheric and romantic place to die. He garnered high praise from Alan Rickman after the filming of Snape's death scene. "He said to me afterwards, 'Thank you for the set. It helped.' In films, that's quite unusual."

Director David Yates made another significant alteration to the battle by turning the climactic confrontation between Harry Potter and Lord Voldemort into an even bigger confrontation. "It worked beautifully in the book, but I figured we had waited a long time to see this," he explains. Yates constructed a scene where the adversaries duel throughout Hogwarts, then fall off a high balustrade together and twist into each other. "They become each other for a moment," Yates describes.

169

(above) Death Eater costume designs by Jany Temime, drawn by Mauricio Carneiro. (left) Concept art by Andrew Williamson of the battle of Hogwarts.

NINETEEN YEARS LATER

✦✦✦✦✦✦✦✦✦✦✦✦✦✦✦✦✦✦✦

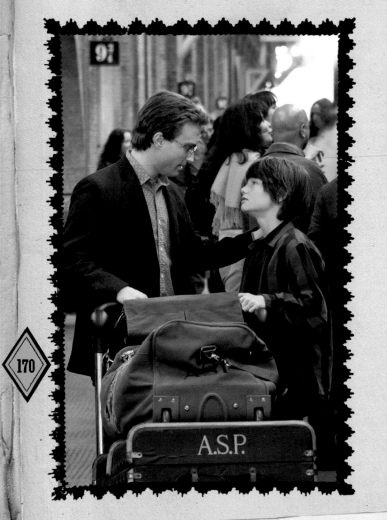

In an epilogue that looks forward nineteen years, King's Cross station is visited one more time, as Harry and Ginny, Ron and Hermione, and even Draco and his wife bring their children to Platform 9¾ to send them to Hogwarts. Director David Yates was grateful for the closure this scene provided. "Things are right back to that first moment in King's Cross," he says. "I think the people who really love the movies and the books will find it moving, because some of them were reading this material when they were kids. That's why I think Harry Potter is the most extraordinary thing. It has the capacity to move people, because of that real impact it's had on all those young lives."

Aging up the cast raised the question of whether it should be done practically, with makeup, or with visual effects. The first makeup tests seemed acceptable, "[b]ut, of course, every thirty-eight year old looks different," says Yates, "because some people have naturally youthful looks and some people just age more quickly. And the experiences you have had shape you and change you, and that needed to be brought into the performance." The scene was filmed at King's Cross station, with a steaming, gleaming train and a crowd of onlookers. After viewing the film shot that day, the filmmakers decided to rethink the makeup and reshoot the scene. However, circumstances prevented a return to the real King's Cross. "So, they shot it with green screen, and we had to put King's Cross in," says visual effects supervisor Tim Burke.

Costume designer Jany Temime was tasked with dressing the older characters and their progeny. "But people's choices in styles don't really change that much through time," she says. Temime kept the same color palette she had established for the trio—blues and grays for the Potters; pinks, browns, and the inevitable burnt orange for the Weasleys. Hemione is dressed in a blazer and shirt but with jeans, a style Temime calls "sharp casual." Ron wears something "soft and brown and comfortable." Temime felt Draco would want to dress just like his father and brought out Lucius's tie-pin and ring. Draco's wife, she imagined, "was a trophy wife. But wives always look like your mom. So, I thought about his mom and I dressed her like that."

The scene at King's Cross was not actually the last scene shot for the film. But as the final sequences were filmed, the cast and crew became reflective and nostalgic about their time in the wizarding world. "I thought I was prepared, because we knew the day was coming for so long," says producer David Barron, "but it was surprisingly moving for all of us. Everybody put so much of themselves into these movies, and on [*Deathly Hallows – Part 2*], we all shared the added goal of making it a fitting finale to the series."

"I count myself extremely fortunate to have been part of Harry Potter," says David Heyman, "but none of us would have had this opportunity were it not for Jo Rowling and the world she so brilliantly created."

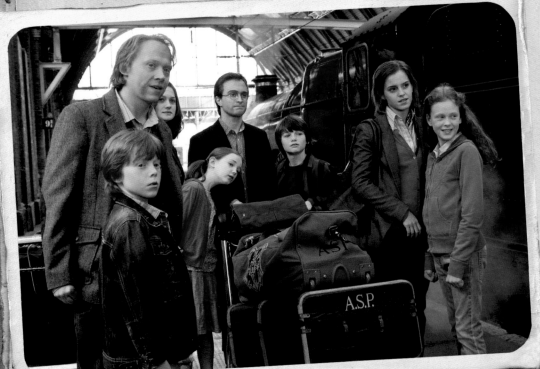

(opposite top) *Harry Potter and his middle child, Albus Severus (Arthur Bowen), on Platform 9¾.* **(opposite bottom)** *The next generation of Potters and Weasleys to attend Hogwarts waits by the Hogwarts Express, accompanied by their parents:* **(left to right)** *Hugo Weasley (Ryan Turner), Ron, Ginny, Lily Luna Potter (Daphne de Beistegui), Harry, Albus, Hermione, and Rose Weasley (Helena Barlow).* **(top left)** *Emma Watson as Hermione Granger Weasley.* **(top right)** *Rupert Grint has his age lines freshened up.* **(above)** *Draco Malfoy (Tom Felton), his wife, Astoria (Jade Gordon), and son, Scorpius (Bertie Gilbert), notice the Potters and Weasleys on the platform.*

171

PROCLAMATION.

EDUCATIONAL DECREE No. 160

Thank you to everyone involved in the production of the *Harry Potter* films at Leavesden Studios who generously put up with my snooping around and asking questions—particularly the art department for giving me a space to work in during my sojourn. At Warner Bros., thank you to Eloise Kay, Victoria Selover, Melanie Swartz, Moira Squier, and Elaine Piechowski. Thanks to Emma Schlesinger. Thanks also to all at The Blair Partnership— and to the magical author they represent, J. K. Rowling.

At Insight Editions, thank you to publisher Raoul Goff; editorial director Jake Gerli; creative director Iain Morris; and Lucy Kee, my hardworking and tirelessly patient editor. Special thanks must go to MinaLima Design— Miraphora Mina and Eduardo Lima, along with their assistant, Lauren Wakefield—for their exciting designs for the book. Lastly, my personal gratitude to Philip Patterson of Marjacq and (as always) to David Weeks for support, encouragement, and understanding.

—Brian Sibley

Published in 2018 by
Harper Design
An Imprint of HarperCollins*Publishers*
195 Broadway
New York, NY 10007
Tel: (212) 207-7000
Fax: (855) 746-6023
harperdesign@harpercollins.com
www.hc.com

Distributed throughout the world by
HarperCollins Publishers
195 Broadway
New York, NY 10007

ISBN 978-0-06-287894-6

INSIGHT ⌾ EDITIONS
PO Box 3088
San Rafael, CA 94912

www.insighteditions.com

INSIGHT EDITIONS
Publisher: *Raoul Goff*
Creative Director: *Iain R. Morris*
Acquiring Editor: *Jake Gerli*
Editor: *Lucy Kee*
Production Directors: *Anna Wan and Lina s Palma*
Production Manager: *Jacob Frink*

Cover Design by Jon Glick

Insight Editions would also like to thank David Heyman, Stuart Craig, David Barron, Daniel Radcliffe, Rupert Grint, Emma Watson, Miraphora Mina, Eduardo Lima, Lauren Wakefield, Eloise Kay, Vanessa Davies, Elaine Piechowski, Melanie Swartz, Victoria Selover, Moira Squier, Lisa St. Amand, Sandy Yi, Marta Schooler, Signe Bergstrom, Iris Shih, Akram Saigh, Dagmar Trojanek, Lisa Bartlett, Anna Wan, Mikayla Butchart, Jody Revenson, Steven Tice, Maryann Smith, Binh Matthews, Gabe Ely, Kevin Toyama, Ashley Nicolaus, Charles Gerli, Rachel Anderson, Greg Solano, and Judy Wiatrek Trum.

Printed in China by Insight Editions

10 9 8 7 6 5 4 3 2

As Referred to
in **Decree No. 157** of 1924,
formerly known to be the Ministerial
Management of Magical Mayhem Act No. 792/B
& subject to Approval by The Very Important Members of Section M.I.Trx